PHARRELL:
PLACES
AND SPACES
I'VE BEEN

To Helen, Rocket, Dr. Mom & Dad
—Pharrell Williams

First published in the United States of America
by Rizzoli International Publications, Inc.
300 Park Avenue South, New York, NY 10010
www.rizzoliusa.com

Pharrell Williams: Places and Spaces I've Been
Copyright © 2012 Pharrell Williams, with texts and text
contributions by Edwin "Buzz" Aldrin, Jr., Toby Feltwell,
Shae Haley, Chad Hugo, Jay-Z (Shawn Carter), Masamichi
Katayama, Ian Luna, Ambra Medda, Takashi Murakami,
NIGO® (Tomoaki Nagao), Kanye West, Anna Wintour
& Hans Zimmer

Editors: Ian Luna & Lauren A. Gould
Editorial Coordination: Mandy DeLucia & Kayleigh Jankowski
Managing Editor: Ellen Nidy
Production: Kaija Markoe
Translation Services: Marie Iida & Brad Plumb

Book Design: Li, Inc.

For Pharrell Williams
Project Manager: Loïc Villepontoux
Editorial Coordination: Mick Moreno
Editorial Assistance: Ronnell Culbertson

Acknowledgments
The editors and Rizzoli would like to extend their gratitude to
all the contributors, and to the talent and assistance of the
following individuals: Patrick Li, Bettina Sorg, Meriem Soliman,
Shawn Carney, Seth Zucker, Erin Love, Rory Will, Don Crawley,
Lara Holmes, Anne-Céline Fuchs, Valerie Viscardi, Andrew Zack,
Francesco Ragazzi, Brian Donnelly/KAWS, Masako Iida, Brad
Plumb, Sarah Lerfel, Yumiko Shimizu, Rutsu Ikemoto, Héloïse Le
Carvennec, Vadim Yakubov, VERBAL, Yoon, Micah Hayes,
Stan Wooh, Miki Higasa, Mari Fujiuchi, Ben Edwards, Rob Walker,
Richard Lara, Yaneley Arty, Albert Watson, Aaron Watson,
Christina Korp, Seth Goldfarb, Mikaela Gross, Roy Lu, Chrissi
Burnett, Danny Ramos, Matt Takei, Marie Iida, Ryosuke Maeda,
Johnney Liu, Kana Kawanishi, Taichi Watanabe, Arnaud Adida,
Irène Silvagni, Emmanuel Perrotin, Sandrine Segato, Florence
Lanza, Stephanie Le Badezet, Benedicte Mesny, Aude Mesrie,
Loraine Devaux, Isabella Capece Galeota, Camille Miceli,
Julien Guerrier, Casey Kenyon, Pietro Beccari, Guillermo Tantoco
& Hindrika Weber Tantoco.

This book would not have been possible without the
intercession and support of Loïc Villepontoux,
Ronnell Culbertson, Mick Moreno—and the stunning
generosity of Pharrell Williams and his family.

Pharrell Williams (& Loïc Villepontoux) would like to especially
thank our contributors for taking the time to participate:
Buzz Aldrin, Toby Feltwell, Zaha Hadid, Shae Haley, Chad Hugo,
Jay-Z, Masamichi Katayama, Ambra Medda, Takashi Murakami,
NIGO®, Kanye West, Anna Wintour, and Hans Zimmer.

Additional thanks to Sk8thing, Brian Donnelly/KAWS, Emmanuel
Perrotin, Ronnie Newhouse, Sabina Belli, Bruno Domeau &
Philippe Pérès, Bernard Arnault, Delphine Arnault, Marc Jacobs,
Camille Miceli, Yves Carcelle, Pietro Beccari, Remo Ruffini,
Francesco Ragazzi, Domenico Gallucio, Craig Robbins,
Terry Richardson, Arturo Sandoval III & Samuel Borkson/
FriendsWithYou, Patrick Li, Brad Rose, Steve Shapiro, Erin Love,
Rob Walker, Caron Veazey, Mimi Valdés, Amanda Silverman,
Ron Lafitte, Irving Azoff, Alex Pirez, Rene Garcia, Tom Cabrerizo,
Kate Rosen, Beau Benton, Phillip Leeds, Mick Moreno, Alexandra
DePersia, Ben Edwards, Drew Coleman, Mike Larson, Stacey
Lopez, Rob Grubman, Sarah Lerfel/Colette, Yutaka Hishiyama,
Tyson Toussant, Tim Coombs, Joe Avedisian/Brooklyn Machine
Works, Rob Stone, Jon Cohen, Diageo, Jacob Arabo, Vadim
Yakubov, Adriano Berengo/Studio Berengo, Charles Miers,
Ellen Nidy, Mandy DeLucia, Laura Bresolin, Keita Sugiura,
Leland Melvin, Carole Wagemans, Christina Korp, Rory Will,
Seth Goldfarb, David "Shadi" Perez, Craig Ford, Fumi, Mr. Zone,
Lauren Gould, Stephanie Durning, Mimi Choi, Richard Lara,
Damien Zapotocki, the BBC/IceCream NYC Flagship Store staff,
and Ronnell Culbertson, our super-intern, for helping us put this
book together.

Thanks to Rizzoli for the great opportunity, and to Ian Luna
for his endless knowledge.

Printed in China

2012 2013 2014 2015 2016 / 10 9 8 7 6 5 4 3 2 1
Library of Congress Control Number: 2012939536
ISBN: 978-0-8478-3949-0 (Deluxe Edition)
978-0-8478-3589-8 (Trade Edition)
Cover photograph: Stephan Würth
Endpaper design: Sk8thing

PHARRELL: PLACES AND SPACES I'VE BEEN

Pharrell Williams with
Buzz Aldrin
Toby Feltwell
Zaha Hadid
Shae Haley
Chad Hugo
Jay-Z
Masamichi Katayama
Patrick Li
Ambra Medda
Takashi Murakami
NIGO®
Loïc Villepontoux
Kanye West
Anna Wintour
Hans Zimmer

Edited by Ian Luna
with Lauren A. Gould

RIZZOLI
NEW YORK

New York · Paris · London · Milan

SEEING AND BEING

A foreword by Pharrell Williams

As a child I would see things on television and dream. I wondered what it was like, being in that two-dimensional world behind the screen.

It was packed with as many vivid colors as there were sounds. I wondered then if there was a wizard who controlled that two-dimensional Oz. Was he or she the same person who put the stars in the skies at night, stars that seemed to speak only to me? They twinkled on cue for whatever question I had, even to the chord structures of the songs my parents played.

It did not matter whatever else was happening. TV seemed to be what I'd run back to. It was my best friend. It shared my interests. Cartoons, music, Muhammad Ali, live shows, and scripted shows. And then there were the movies. Classic movies. In Technicolor. Even the ones that I later found out had been hand-tinted. It was through those films—especially the ones that wove pictures and music into memorable stories—that I'd learn how to fly. And boy did I soar. When my parents were at work, and I was home from school, it was my best friend, TV, who taught me about another world. A world where you could be whatever you wanted to be. All you needed was to be curious, be attracted to something. I could best define the things that interested me by what the theme music sounded like. I'd often beat on those poor couches with my grandmother's cake-stirrers as I hummed the melody. It was so much fun.

TV can tell you a lot about yourself. What you like, what you don't, and what you can't stop watching and won't leave the room for. Michael Jackson in "Shake Your Body (Down to the Ground)" did that to me. I didn't know what it was exactly. He was amazing—and so was that voice. Why could I not get that song out of my head? And why was he so different in that two-dimensional world? Or was that it? Was he just different?

As I grew older and went to school, I met friends and cherished having them, as I wasn't allowed to play when my parents weren't home. So school was more about a place to talk and meet people. You know, a place to discuss how much we loved our favorite TV shows and music. And then,

how much I loved the colors in my head as I listened to the music. That's when they'd say "what do you mean?," roll their eyes, or flat-out walk away.

That's when it clicked. I was different too.
And TV and I became even closer.
So naturally, my grades took a dive.
Why would they be any better?
I was only concerned with making friends—
even if it meant being the class clown.

And then there was seventh grade.
Band class.
The drums.
I was addicted.
I played music, saw colors, and got decent grades for it.
I met people that I could finally relate to.
And before I knew it, our ambitious group got discovered at my high school talent show. Together, we were chasing those exotic colors that leached out of the music.
That's where it all began.
Song after song was made for the feeling and the color they provided.
Cascading, rushing, like all the stuff pouring out of that two-dimensional world behind the TV.
Not only did the spaces and places I'd seen on television as a child exist in three dimensions. Some were even real.
I knew then that I was too. I made music, and I felt it.
I felt my existence.
I knew I mattered. What brought me to this journey was my curiosity.
It seemed that way to every person I looked up to.
These songs were to be my vehicles. With them I chased what I desired to know.
I too would cross over from that two-dimensional world.
Music was my pass, my ticket to a world that first acquired color and form through sound.
So many spaces and places I've been.
Please enjoy some of the wonderfully vivid folks that I've picked up along the way.

TABLE OF CONTENTS

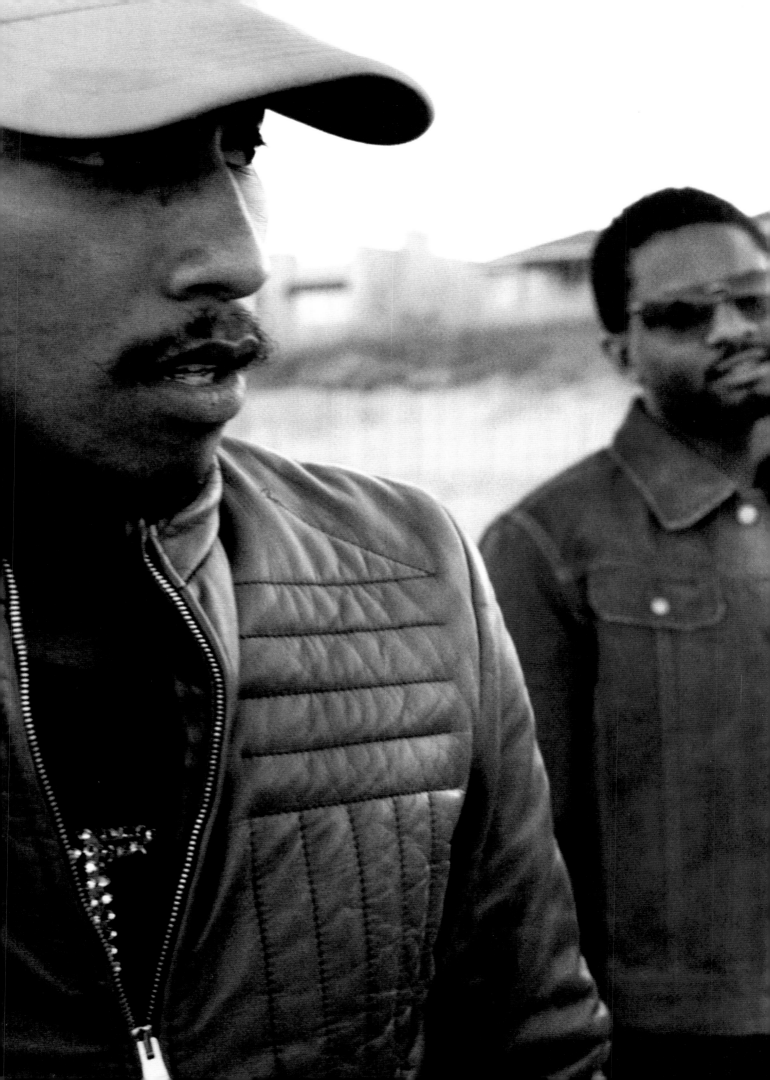

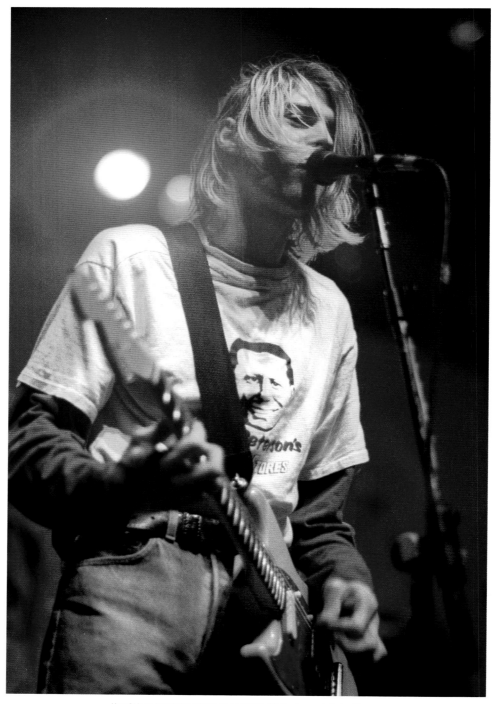

Kurt Cobain, lead singer of Nirvana, performs at Salem Armory, in Salem Oregon,
Dec 14, 1993, four months before his death on April 5, 1994.
(previous spread) Pharrell Williams, Shae Haley and Chad Hugo, Virginia Beach, 2000

IN BLOOM

A conversation with Pharrell Williams and Jay-Z

In 1995 an up-and-coming rapper named Jay-Z appeared on the Stretch Armstrong and Bobbito (Garcia) show on New York's WKCR with the late Big L (Lamont Coleman). A year before the release of *Reasonable Doubt* and in the waning years of hip-hop's backpacker era, this radio show appearance acquired mythic status, forming an indelible impression on hardcore rap fans—and auguring the sound of things to come. At roughly the same time, Pharrell Williams and Chad Hugo formally established themselves as a production duo in Virginia Beach. As The Neptunes, they would craft what arguably became the defining sound of the first decade of the twenty-first century. Sharing an unabashed love for the music of the period, Jay-Z and Pharrell recall the achievements of the mid-1990s, one book-ended by the tragic deaths of Kurt Cobain in 1994 and The Notorious B.I.G. in 1997.

Jay-Z: Those are hot. [Referring to Pharrell's sneakers]
Pharrell Williams: They're called "Nothings"…"BBC Nothings."
PW: So, where were you mentally and physically when

grunge music hit? Like where were you when you first heard, "Smells Like Teen Spirit"?
J: Virginia. You know what, the great thing about grunge was…[pauses] First, we got to go back to before grunge and why grunge happened. The "hair bands" were first. "Hair bands" dominated the airwaves and rock became more about looks than about actual substance and what it stood for—the rebellious spirit of youth… That's why "Teen Spirit" rang so loud because it was right on point with how everyone felt, you know what I'm saying?
PW: Yeah.
J: So, um. It was weird because hip-hop was becoming this force, then grunge music stopped it for one second, ya know? Those "hair bands" were too easy for us to take out; when Kurt Cobain came with that statement it was like, "We got to wait awhile." I was somewhere in Virginia, one of those spots.
PW: I used to see you in Newport News.
J: I was somewhere in one of those states. I have always been a person who was curious about music and when those forces come on the scene, they are inescapable. Can't take your eyes off them, can't stop listening to

them. He [Cobain] was one of those figures. I knew we had to wait for a second before we became that dominant force in music. That's how I look at things in terms of hip-hop and in terms of culture.

PW: Yeah, yeah.

J: I base my timelines off it: how hip-hop happened, and why it happened, and when it happened.

PW: Yeah, that's exactly right. It's funny because I look at things like that too. I am starting to recognize the rhythms of life in cyclical terms, when you know something is coming, it's like, "OK, get out of the way, let that come in," and you jump in the third quarter, when it's about to burn down.

J: [laughs]

PW: I never looked at life like that before. I just thought, "Oh, you just make records, or you just make clothes or design chairs." Timing is everything. Pressure erodes, bears down on something, and before you know it, there is going to be a diamond in there...

J: Yeah, absolutely. And I think you *have* to look at the rhythms of life... not looking at it is *very* music industry. We're the only industry that just thinks we can avoid that, because for everyone in the music business, the biggest saying is, "Oh, it's just about the song." And yeah, that is true, but when I throw the song out into a big hole in the universe... I mean, the Internet didn't exist before. It does now.

PW: Yeah.

J: We have to pay attention to it. There is something out there. Like Kurt Cobain. There is something out there we have to account for.

IT'S LIKE IN ARCHERY. YOU ACCOUNT FOR THE WIND. YOU SHOOT OVER TO THE LEFT A LITTLE BIT. EVERY INDUSTRY, EVERYONE ACCOUNTS FOR THESE...

PW: ...various forces.

J: Yeah, various forces! Except the music business: "Oh, it's all about the song."

PW: In some instances they have been right.

J: Yeah and that's the problem.

PW: I don't think they were paying attention to the fact that the timing was right.

J: Exactly and it's sad. All these people you thought were geniuses were relying on dumb luck. [laughs] Right? But that's how powerful music is. Music is so powerful that you don't really have to be good at what you do to be really successful. You have to be better at what you do *now*, because there are other things—there's the Internet and it's a shrinking industry. You know, before it was so much money, everybody was

looking at it like it was a big party with big steaks on the table and champagne everywhere. Now things have changed significantly. Now we have to be great at what we do and we have to be good at how we present it. You know, as well as in the 90s.

PW: That's a good one. 90s hip-hop...

J: Yeah, the greatest.

PW: Is that your vote?

J: Yeah, everyone would say '88, late 80s. Late 80s had a strong case, but you got to give it to the 90s, you had the spill over from that. As well as Snoop, Nas, 'Pac, Big and Busta'. It was a special time in hip-hop, and then also because of the levels it reached, ya know? Beyond just the art of making a great song and how dominant it became. It wasn't really a force in the late 80s—it was great music, but it wasn't a force. You have to account for impact. Based on impact alone, there were great albums made [in the 80s], but you got to give it to the 90s. Because that was when hip-hop was the dominant force in music. Period... period. Outsold every genre of music.

PW: Yeah, that's right.

PW: Yeah. For example, in my life, there is not one reason why Jadakiss should not own NYC, with the exception of yourself.

J: Right.

PW: There is *no* reason, and the fact that that's not the case shows me... it's a sign of the times, because he's supposed to, for all intents and purposes... I mean come on!

J: Great records have melody in them. It's just great to know.

PW: Yeah.

J: "A Milli" didn't have a chorus.

PW: Yeah.

J: It was like, one of the biggest records of the year. It was on the fucking Top 40 chart, and I am sure the intention wasn't to make...

PW: He didn't think he was making...

J: ...a record that was that big. That's melody in the track, and great production. It's hard because rap is just words. It's so wordy that in order for it to reach globally, it needs melody, or some sort of great production or structure to it, and that is what I think is missing from Jadakiss to take over and run NY like Biggie Smalls. There were melodies in his ad-libs. [laughs] "Ughhh, ughhh, what, what." [imitates Biggie] "What." Listen to that melody!

PW: "What, what." [mimicking Biggie too] I tried to attribute it to him being a Gemini, being Jamaican, I don't know. "Ughhh." To me, you know what? That's a good point. ...But what the fuck was he thinking when he did "Who Shot Ya?" You knew I was going to ask that.

J: [laughs] Right?

PW: What the fuck, that was the most unorthodox

BBC Nothings
Season 11, 2011

melody of all time and he said the wildest shit ever.

J: You know what Biggie's great thing was? He was a big fan of Richard Pryor; when you look at stuff like that, it really makes sense. Like, the shock and the self-deprecation and the rawness of how Richard Pryor made those records. You think about it and you hear it when you hear a song like "Who Shot Ya."

PW: Listen, I make comparisons like that all the time, but that is so far out. I can usually catch it. Like, he saw "dadadada" and sang "such-a-such." I would have never guessed in a million years, but that's exactly right. That is what he did; he was unafraid, black and ugly as ever. However, right back at ya.

J: Richard Pryor. "Ya know he whoop my ass, you know I'm skinny."

PW: That's good.

J: "...He hit me so hard and my knees were shaking, right not afraid to say Nigga got punched in your face. Hahaha, someone punched you in your face. Big was black and ugly as ever, however."

PW: "...I stay Gucci down to the socks, rings and watch."

J: "Who Shot Ya" was just a tale of brutality. [starts rapping Biggie] "Your heartbeat soun' like Sasquatch feet, thundering, shaking the concrete, then the shit, stop, when they foiled the plot, neighbors call the cops 'cuz they heard mad shots."

PW: [chimes in]

J&PW: "...Slaughter, electrical tape around your daughter. Old school, new school, need to learn though, I burn baby burn like Disco Inferno."

J: Listen to the melody in his verses.

J&PW: "Old school, new school...I burn baby burn like Disco Inferno, burn slow like blunts with ya-yo, I peel more skins than Idaho potato."

J&PW: [laughing, then continuing to rap] "...The lyrical molestin' is taking place, fucking with B.I.G. it ain't safe, I'll make your skin chafe."

J: Why you using those words anyway—who "chafed"? That's official. I didn't cut you; I made your skin "chafe." That is official wording.

PW: He hurts me. You did that to me on, you know which one? "Cough Up a Lung."

J: That was vivid imagery.

PW: That, and "Lucifer."

J: That's sick imagery right there.

PW: I'm jealous of "Lucifer," I have to say that.

J: A lot of that shit came out of pain. Drake called me up and was like, "What the fuck were you thinking?" I was like, "Man, that shit was pain... Niggas was deal-

ing with pain, for no reason. That's where the whole shit came from. When I heard it, I was like, "I know where I am going with that." It was for Big, all those people that had gone too soon. I said something about California. I forget the first verses... "Lord forgive him he got those dark forces in him..." That makes you dark. When dark shit happens, you start thinking, "Fuck everything." It's very easy to lose your faith.

PW: Yeah, it is.

J: You know shit starts happening. You know you ain't supposed to be there. When Big got killed for nothing.

PW: And they found out...

J: He didn't do anything. I'm not saying he didn't do anything his whole life, but he didn't do anything to provoke that whole situation.

PW: Were you there?

J: No, I was in New York. I actually spoke to him that night. He was like, "Come out to LA." I spoke to him at the party; Irv [Gotti] gave him the phone, Irv called me from the party. You could hear the music in the background. "Hypnotize" just came out so they were playing it in L.A. and he was feeling like, "This shit is over, you know what I am saying? You got to come out here, come to L.A." Right before it happened.

PW: What did you say to him?

J: I was like, "I am coming, I'm on my way," some shit like that. I don't know what I was doing—something in New York and I couldn't go.

PW: God, are we still taping? Oh, God, can we use this?

J: To hear his voice, like that whole shit, you know he didn't want to do anything to provoke it, like "Who shot ya."

PW: Go back at him.

J: It was one of those moments where it was like: "Enough. I got to get this shit off my chest." You know, he was staying away from this shit, because it is dangerous and he doesn't have anything to do with that shit. In fact, he tried to warn 'Pac. He tried to warn him—that part of the movie is real. He was telling him, "Stay away, that shit is going to end badly." 'Pac was like, "Ya know, they tell me the same shit about you." That type of shit, and it continued down that path. But um, back to our shit...

PW: I liked the part about where you were.

J: To wrap it up, "Lucifer" is about those moments. You know, this guy was a charming, funny, witty guy, and he had a nice crew around him... to be honest with you those were my best memories of Big.

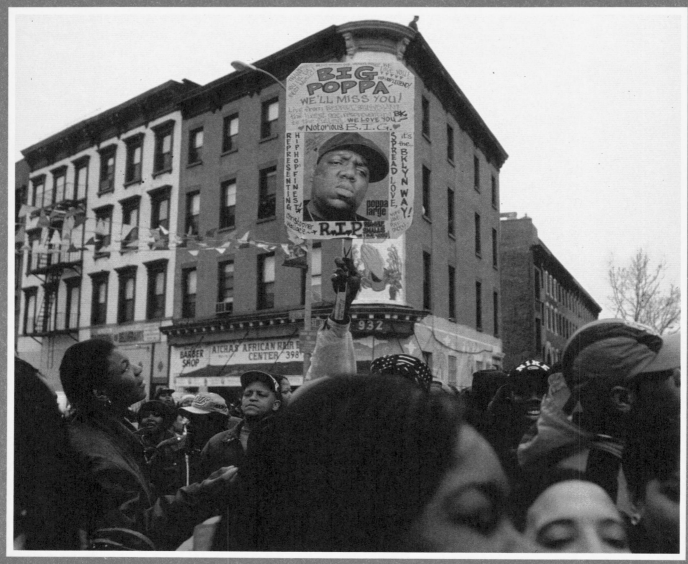

View along the funeral procession for Christopher Wallace, aka Notorious B.I.G., in Clinton Hill, Brooklyn.
(Biggie was murdered ten days before, in Los Angeles. March 18, 1997)

JOCKS AND NERDS

A conversation between Chad Hugo and Shae Haley, with Loïc Villepontoux

One half of The Neptunes and a third of N.E.R.D., Pharrell Williams counts Chad Hugo and Shae Haley as his two oldest friends and collaborators. Chad and Shae recounted their early days as teens in Virginia Beach and shared some essential history with Loïc Villepontoux.

Shae Haley: Sheldon Haley!

Chad Hugo: Chad Hugo, I go wherever you go…

SH: How you been man?

CH: Good man, I guess that's the conversation so far. [laughs]

Loïc Villepontoux: So when did you guys all first meet?

SH: Oh, you're doing the questions?

LV: Yeah.

SH: Chad and Pharrell met… I don't know, what year did you two meet? Pharrell and I met in high school and I met Chad shortly after.

CH: Yeah.

SH: Which was like 1989 or '90…Naaah, I'm fucking with you!

CH: It was middle school, seventh grade, but it felt like boarding school. We wanted to be rebels. Between class, we'd hang out at our lockers and pick up chicks.

LV: And you guys created N.E.R.D. when?

SH: In high school.

LV: And whose idea was it originally?

SH: Ummm…It was something that just happened naturally.

CH: Shit started popping off when Shae came into the group because we were just making musical sprockets that led nowhere but when Shae entered the group, we broke out with the Neptunian pact and devised our own code-lingo and not-common attire.

LV: So did you and Pharrell already come up with The Neptunes as a name or were you guys all messing around trying to figure out where you were going with the music?

SH: The Neptunes worked. Pharrell and Chad were definitely creating when I stepped into the picture but I don't think they really knew who they were or what they were going to be called. When we started out Pharrell and Chad were doing jam sessions—as Chad would call it—and it was originally four members in the group, Chad, Pharrell, myself and then another kid [Mike Etheridge] who was the singer and we were just going around doing local talent shows in the area.

CH: We were local troubadours, with our socks pulled up to our knees.

SH: With raincoats on and rain hats…

CH: Helly Hansen coats.

LV: When you started this you were N.E.R.D. or did you go by a different name?

SH: We went by another name. There were four members in the group. So we went by another name. We didn't realize we were N.E.R.D. until—

CH:—D.P.S., we were the D.P.S.'s

SH: Yeah.

LV: What did D.P.S. stand for?

CH: The Dead Poets Society. I think we were just a fan

of Robin Williams and his manly, nanu-nanu antics, so we tried to roll with that. We thought it was dope and that we'd get chicks with that...

LV: Did it work?

CH: That helped us get some change in our pockets, which kind of helped us with our swag and built up our confidence enough to be appealing...to chicks. [laughs]

LV: So who came up with the name N.E.R.D. and when did that come together?

SH: N.E.R.D. was birthed right before the *In Search Of...*(2001) album. You know Chad and Pharrell were getting a lot of momentum at the time and we were always a band first—and being that we sound weird nobody ever got it. So right when Virgin signed us we had to figure out the concept of the project and the title for the group and I think Pharrell was the one that came up with N.E.R.D., and then we thought it would be cool if it was an acronym and we just tried to make up a cool definition behind the term N.E.R.D.

LV: Do you guys remember what the first song from *In Search Of...* that you guys worked on together?

SH: I don't know, was it "Lapdance," Chad?

CH: Yeah it was "Lapdance." We also were losing a lot of our friends. We had some friends who ran into trouble—you know [to Shae], Shampoo, rest in peace. There were a lot of people that we knew that were dying and it kind went with "No One Ever Really Dies" to try and keep their legacy. We would lose hope, but I guess that our association and our joy in making music and sampling records... and sharing a interest in jazz, The Native Tongues, and progressive music, that's when we came up with N.E.R.D. The "Lapdance" and "Rockstar" were some of the first joints. We also segued with Kelis album *Wanderland* [2001], and after working with her and some of those songs that kind of morphed into the N.E.R.D. sound.

LV: If you had to pick one, what was your favorite song from that first album?

SH: I think "Stay Together" would be my favorite, and the most appropriate for what we're going through right now.

LV: Chad?

CH: Yeah, I would agree. I like "Stay Together." The song "Tape You" was on the album? I think "Tape You" was a dope song. Being the soul of music, I was always into the recording aspect of it so I think that song applies. It was just taping people, people recording memories. Other people may look at the song as if it's this nasty thing about you making porn but that's not what it's about. It's about capturing memories, song, music and the groove, it's just danceable, futuristic—that was my favorite groove. But "Stay Together," by far, was a classic.

LV: It's probably hard for you guys to say as you guys are humble, but *In Search Of...* is a classic N.E.R.D. album, with a serious cult following and influenced a lot of people. You guys started working with some cutting-edge people back then. This was twelve years ago and you all had Shepard Fairey do your logo and Terry Richardson do the photo shoot. It's a pretty interesting mix, and really defined the start of a new era.

SH: Yeah, no listen. I mean, it's crazy how much

N.E.R.D. WAS AHEAD OF THE TIME IN TERMS OF TASTE-MAKING, THE TASTEMAKERS OF THE GAME, FROM MUSIC TO DESIGN AND PHOTOGRAPHY, YOU NAME IT.

N.E.R.D., we definitely set the bar. That's something that a lot of these big musicians can't deny.

CH: The funny thing about N.E.R.D. is that wasn't so much... I mean the music was part of it but it was also just lending a [hand]... I remember one time Shae was upset about something and we just couldn't open the door, I don't know if he wants me to tell that story, I won't say too much about it but he'd locked himself up and became a recluse. We were banging on his window and throwing rocks at the window just to get him out to say hello. Once we did it was peace, and I think that's one of the just big aspects of being in a band, lending a helping hand, a word of advice, just to say what's up. Achieving and maintaining friendship, in itself, was like artistry. What better way to do it but to make an album and play it. That's hard work.

SH: What's pretty amazing, I know that *In Search Of...* definitely got a lot of critical acclaim. There's a lot of people, from all walks of life, that always give you praise and tell you how the album changed their life. That the album is still one of their top albums, or that the album cover is one of the sickest album covers they'd ever seen. It's 2012 and that album came out over a decade ago and it still affects and resonates with people. I think it's just a beautiful thing, man. When we recorded that album, we honestly didn't go in the studio with those intentions. Nothing was thought out. It was just Pharrell, Chad and myself just jamming out with a close circle of friends. I think

Character designs devised by longtime *A Bathing Ape® collaborator Mankey date back to 2003 and were subsequently modified as the decade progressed.

Promotional sleeve for N.E.R.D. first album, *In Search Of…* (2001).
The logo, designed by Shepard Fairey is overlaid on photography by Terry Richardson,
and signaled the earliest collaborations between both artists and N.E.R.D.

about this last album and how it was just so much pressure and it felt like this was do-or-die. Like if you don't hit the mark you're going to be deleted. It was crazy. I don't think a group who just put out three albums prior should ever feel that pressure.

LV: But you guys didn't have any pressure on the first album right?

SH: Exactly, and it's personally my favorite album out of the four so...

CH: I agree.

LV: You guys should start working on a new album soon. I think the pressure is gone at this point which should get you guys to a good creative place, and you'd probably catch a lot of people off-guard.

SH: I would love to get back in the studio with them but I don't want to make happy music no more, I'm angry. [All laugh]

LV: People make good music when they're angry.

CH: That's true. Well you just can't make angry music by itself, that's the thing.

LV: There you go. You know, the interesting part about that first album—

SH: What's that?

LV: Was that you guys originally turned it in, the production was all digital. Then you guys went back and rerecorded the whole album using a live band. It created a frenzy because people couldn't get their hands on the digital version but some copies were out there.

SH: You know back then you didn't think about those things. When we decided to do it live we weren't thinking about it ever being a hot commodity and becoming this hard-to-get item. We did it because we felt like the digital sounds, the synth, restricted the music and the more organic instruments would allow it to breathe.

CH: I think it was cool about going from digital to live cause we always had roots at making music anyway. Shae was into DJ'ing, and Pharrell and I were in a marching band so it wasn't anything to make it and do the unplugged version. It was just fun and we were trying to embrace technology at the same time by doing the synthetic version.

SH: Most importantly, there weren't no restrictions back then, you had freedom to do whatever you want. Whereas nowadays you can't do live drums because it won't work with certain radio formats. N.E.R.D. always faced with that, but we did what we wanted and with each album the fan base grew. A lot of that was due to touring and traveling all over the world but once people got

a taste of what the N.E.R.D. sound was all about, they couldn't help but join.

LV: You guys should probably stay independent and just release whatever music you guys feel is good, and not have anyone from the outside telling you how they feel.

SH: I would love to man. I think with the amount of people we all know, we could make a lot of things happen from an independent standpoint. I think it would make our jobs much easier—and we would enjoy it a lot more. As opposed to speaking to the president of the label, and he's telling you he doesn't get it and he thinks you should do a song with this guy and that guy, add a female vocalist, then

ADD A BABOON TO THE GROUP... AND IF THE BABOON DOESN'T WORK YOU SHOULD GET A GIRAFFE, AND IF THAT DOESN'T WORK THEN JUST GO AND GET THE RINGMASTER.

CH: Actually that might work, that might work nowadays. People just want to be entertained. You never know.

SH: Yeah, you're right.

LV: [To Shae] What was your lasting memory from that first album?

SH: For me it would be our first show in New York, the first show I've ever done at the Hammerstein Ballroom with the Beastie Boys. This was years ago. I didn't even know what I was getting myself into. Everything was a blur until I walked on stage and I do remember my brain coming on and I was like "What the hell am I doing here?"

Pharrell Williams (center), with Chad Hugo and Shae Haley, Virginia Beach, 2000

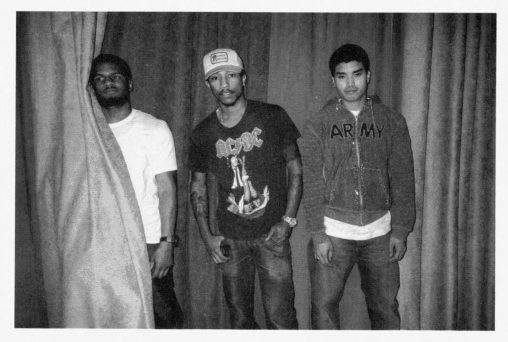

Pharrell Williams,
Chad Hugo,
Shae Haley, Virginia
Beach, 2000

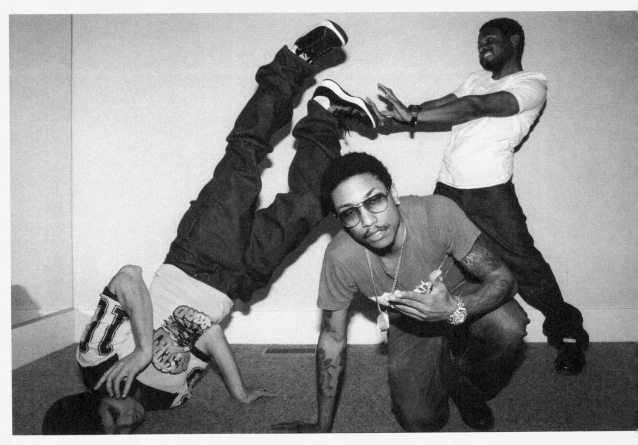

LV: That was the first show with a band?

CH & SH: Yeah.

LV: What about you Chad?

CH: *In Search Of...*, that was a crazy experience, I think that was the first time I started touring. I wasn't really into the tour thing, so jumping on stage was a great experience for me. Just seeing places. The cool thing was that it was really a homegrown, VA-based album from the get-go. My son Chase, who's fourteen in a few days, was in Virginia. It was pretty much VA-life because it was standard for music on the East Coast and all over to go tour. Seeing how it kind of radiated to the rest of the world was amazing.

LV: Yeah because as homegrown as that album was, it took you guys around the world.

SH: Yeah it did for years, for years. My whole career, I mean our encore was that entire N.E.R.D. album. We closed out the show every night with "Lapdance." That was, hands-down, our biggest record next to "Maybe Maybe."

LV: "She Wants to Move" was probably the biggest radio hit, no?

SN: Right, well yeah, that was pretty nasty too.

CH: Yeah it was.

LV: Do you guys have anything else you want to add?

SH: Yeah, I'm looking for my royalty off of each book sold. [Laughs]

LV: Yeah, I'll put you in contact with the proper person.

CH: I'm hoping that N.E.R.D. could reestablish its roots and go under another anonymous name, where we dress up as characters and do this crazy cyber hip-hop but we're actually all playing instruments, all of us. And we'd switch it around, and we'd get the giraffe and the acrobats, whatever we need, to end up on Broadway.

SH: That should be your side project, Chad.

CH: D.R.E.N.

LV: What's that stand for?

SH: Do you really...[laughs]

CH: I don't know.

LV: What do you think Shae should play?

SH: The banjo or kick-drum.

CH: Yeah, the banjo.

LV: One last thing. I think this is important. Shae, how do you spell Shae so everyone knows how to spell it correctly?

SH: S-H-A-E, I don't always go by Shae though. I got my Sheldon Toliver Haley, but from now on call me Toliver.

LV: What about you Chad, change of name?

CH: My name is DJ Nawphk... N-A-W-P-H-K. I have eight bands...

LV: Eight bands?

CH: I'm with the Missile Command collective, with the electro-freeze movement, the Sheldon Haley movement. I'm the garage for Mansions on the Moon. Naaah I'm just standard. DJ Nawphk is my alias. Chad is just Chad.

LV: Alright. [Laughs]. Well, thanks for your time!

CH: Sheldon Haley!

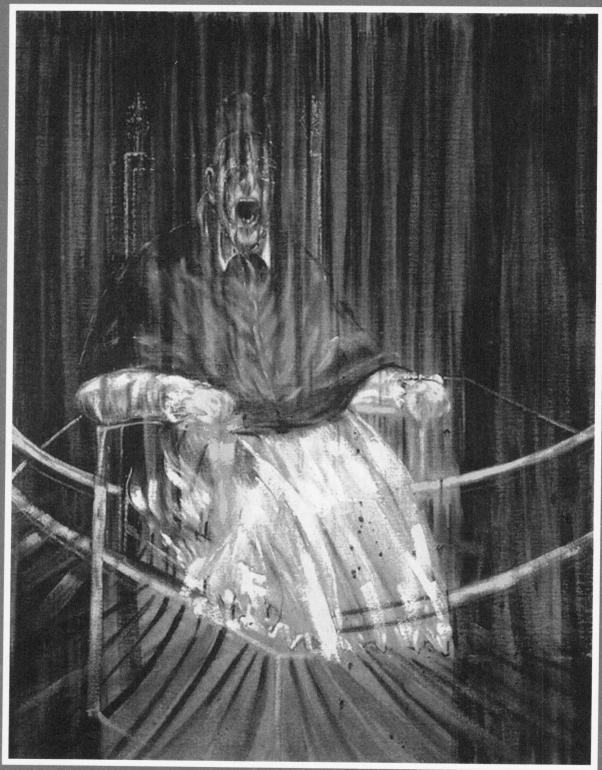

Francis Bacon, *Study After Velázquez Portrait of Pope Innocent X* (1953)

THE WELL-TEMPERED CLAVIER

A conversation with Pharrell Williams,
Hans Zimmer & Ian Luna

Hans Zimmer and Pharrell Williams have over half a century of combined experience in musical composition and production. They occasionally collaborate on a number of high-profile projects, having first partnered to create the score for the animated film *Despicable Me* (2010). Fresh from their most recent commission, which involved scoring over one hundred musical cues for the live telecast of the 2012 Academy Awards, they sat down for a far-ranging exploration of contemporary trends in music—both classical and popular. Taking stock of each other's work, they describe the transformative role of technology in their respective and collaborative processes, and its implications for the future. The conversation was moderated by Ian Luna.

Ian Luna: Congratulations are in order to both of you for the other night. [Addressing Pharrell Williams] I wanted to revisit that informal conversation that I had with you in Miami and it ended with my attempt at describing your sound. Your work in the Neptunes, with Chad Hugo, was distinct from the work of your peers as it tended to avoid typical pitch material (pre-set frequencies, as in a piano) and uses more percussion, non-pitch material (slide whistles, blips, beeps, etc…) as well as silence—especially in between beats. What attracts you to these sounds—and the occasional absence of sound? What do they contribute to your music?

Pharrell Williams: I like doing what hasn't been done. That's what really perks up my ears. These atonal sounds become musical once you hear the entire ensemble. It's a new way of listening to music. Your ears detect these funny tones, they start to catch the rhythm and they start to form a mosaic. But like what Hans [Zimmer] did in *The Dark Knight* (2008), it first starts with a weird, eerie sound…

IL: Musically are they part of a framework you've already thought out? In your typical song writing process, do you already have the final sound in your head? Are these elements keyed in or is it trial and error?

PW: Sometimes I go in with loose blueprints as to how I'm going to build the soundscape, and then there are other times, as Hans can tell you, where we think we're going in one direction and we stumble across something and we're like "oh wait a minute! Okay, what's that?" and you just go with it. And then you look up, five to ten minutes later, and this whole thing came out of nowhere just because a sound that you mistakenly put, that like a button you mistakenly pressed, just took you somewhere else.

IL: You feel that those accidents happen more often than you anticipate?

Hans Zimmer: I don't know if they're accidents. You know what I mean? And Pharrell you can disagree with me, I mean let's have an argument, instead of a conversation. I have a feeling that what happens with most artists is that we try to figure out where we want to go, what we want to say, and we stumble across things… Yeah, we stumble across things but it's recognizing their worth. People stumble over things all the time. Take the opening notes to Beethoven's *Fifth*. I mean every kid at one point just sat down at the piano and went "da-da-da-daaa." So how did he know that by stumbling across those two really simple, childish notes it would open up a world of art and beauty, and meaning? So I think when Pharrell is stumbling I think he is one way or the other ready to recognize that the stumble has meaning.

IL: Is that a comment on your own writing process? I mean, as I asked Pharrell earlier, what would your typical song writing process be?

HZ: I would give you a different version of the same.

Yeah I hear a sound in my head and it usually doesn't exist but I know what I want to say, I just do not know quite how to say it. But then I go, hang on a second. There is an easy way of doing this. Let them supply you with images and pictures and then you can go from there. I don't think I am giving a secret away when I say that on *The Dark Knight*, I had a little Xerox copy of a Francis Bacon hanging next to my computer while I was writing. You know?

IL: Which painting in particular, do you remember?

HZ: It was one of the Velasquez screaming...

IL: ...Screaming popes? [Bacon's 1953 *Study after Velázquez's Portrait of Pope Innocent X* and related paintings]. I hadn't read that in interviews. So that's kind of...

HZ: Yeah, nobody quite knows that. But if you look at the movie again with that in mind...If you think of the Joker, I think you'll get it.

IL: Yes, that explains quite a lot. As for your work with Pharrell, you've mentored a number of young film composers, including Jeff Rona, John Powell, and others—

HZ: Yeah, I've heard of that...

IL: You've heard that too? [laughs] I'm sorry. How has working with Pharrell been different than with other musicians? What about his work made you want to work with him?

HZ: Well... certainly selfish reasons, of course. I like working with Pharrell and we've done other things since the *Despicable Me* episode of our lives...What happens is somebody walks into the room and you wouldn't instantly know, "oh hold on a sec something interesting can happen if the two of us just sit down." Maybe not even talk so much, just maybe play a note at random, and something will grow out of this. Something will happen with the two of us in the room that wouldn't have—with just each of us by ourselves. Those are the situations I find very interesting, especially the sort of awkwardness in the beginning because I have great respect for Pharrell's art, his music and his thinking. So you know that's the slight shyness that the situation brings. But it automatically forces you into exploiting yourself in a daring way. You have to have courage to play a note in front of Pharrell, and I think it goes the other way around as well.

IL: Are there specific passages in his work that you found inspiring?

HZ: Without getting specific, what I love about Pharrell is that I do think he comes from a sort of painterly, and at the same time, a child's inquisitive mentality, where nothing is off limits. Everything can become something, and at the same time he has got a really incredibly strong sense of aesthetics, and that's really the thing I am responding to the most, that even though we come from different cultures and backgrounds, at the end of the day, the unspoken thing—

that thing that you do not put into words, which is in the music, is what makes us go "ooohh, wow, you two can actually do something!" It's the no-one-else-has-done-this-before, you know, the carte blanche, tabula rasa, that's the stuff that is exciting.

IL: [to Pharrell] Do you find that the responses from other people you've collaborated with are very similar? When artists started coming to you and Chad for that "Neptunes sound," was that something you wanted, or was it something you dreaded?

PW: I appreciated it. But you know what, I also like using the allegory of the phoenix to describe how [my work] evolves. The bird sets itself on fire... and in the embers is an egg. What I'm saying is that in order to do great things, you must be unafraid to detach yourself from where you think you've had some interesting successes, because you've got to recreate yourself again and you can't do that holding on to a glory from yesterday. You've got to continue to reinvent yourself today, all the while thinking about tomorrow. Once it was done it was done. It was like, "okay cool, what's new?" What would excite me is when I hear new and different things that were completely left of everything that was going on. I was like, "ok wow that's great!" You know somebody once asked me what inspires me, and I said "all of the things that don't exist."

IL: I wanted to actually ask a similar question to Hans. I would think that in some respects, in the way that people characterize Pharrell's work as the "Neptunes sound," your film scores have become so successful that they've helped define a "Hollywood sound." Is this something you would want to cultivate or avoid?

HZ: You know, I feel relieved...I mean they [my film scores] are all really, really different from each other, because if people actually sat down and went "oh, what does Hans Zimmer sound like?" You know, he sounds like a kid in a really messy room full of toys. Now it's going to be a little bit of Legos, a bit of race cars, and later, a bit of splashing paint on the walls.

PW: For once in my life I think I will be able to answer that question. I may be able to outdo his answer even though that was a very loaded answer. But to me, what does Hans Zimmer sound like? Hans Zimmer sounds like everything he hasn't done before.

HZ: Ha! The thing that keeps us going is the idea that there is something out there that we haven't experienced, or we haven't made into something yet for other people to experience. The hunt, that's the interesting part. I felt that it was like that for Pharrell as well. The reason I got into films, and I think the reason it is interesting for Pharrell to get into films right now is because he has carved himself out this enviable position I was never able to do, where he is involved in many other things. He's involved in many visual things... and in many humanitarian things. And I don't mean

humanitarian in a self-serving, philanthropic way, but genuinely involved with humanity, communicating with humanity and bringing humanity into his life. For me, when I was in a band it was incredibly dull because you know songs were always the same you know verse, chorus, verse, chorus and then you would put a fade on the end of it. And talking to other musicians, it usually ended with stuff like why didn't the drummer get laid, and what new guitar is the guitarist going to buy. And so, entering the film world became this huge other thing. Directors actually read books and looked at paintings and have conversations. I mean every movie gives me something. Even with *The Da Vinci Code* (2006), just being able to spend nights by myself at the Louvre, or *Hannibal* (2001) standing in front of Michelangelo's *David* at night by myself is a very different experience than being surrounded by people. Just for a year, disappearing and learning about something... for *Frost/Nixon* (2008), it was incredibly interesting. I got to spend months looking at old tapes of Richard Nixon. I know one of the things Pharrell likes is the adventure of learning, being exposed to things and being able to tell a story.

PW: One hundred percent accurate.

IL: [To Hans] I realize that now that you've established something like a methodology. If I were to ask you to look back to when you began your career as a film composer, did directors ever expect you to create certain styles of music that you wanted to avoid?

HZ: Well not really... uhhh, yes! Ok, well I will give you an example in a second. The first filmmaker I ever worked with was Nicholas Roeg. He was pretty out there, in the best possible way. I didn't know what to do. It doesn't matter what the movie was. I said, "so Mr. Roeg, what is it that you would like here?" He looked at me as if I was a complete imbecile and said "the sound of the earth being raped, my dear boy." And I knew I was in the right place. Nobody was saying to me verse, chorus... I mean the sound of the earth being raped was, umm... more interesting. And that was really the beginning of that journey. They don't speak in semiquavers, in adagios, a language like that. When they speak to you their language is visual. The other thing I realized very quickly was the filmmakers I was working with were expecting me to come up with ideas. The process between the director and the film composer is a very strange one because the director really has control over every aspect of the movie. He can probably write a good line of dialogue, he could look through the camera, he could tell his actors how to act. But when it comes to music, what are you really going to say to me? "A C major chord would be good here?" [laughter] So the relationship between a composer and a director really is one of trust, of reckless trust because they hand over their movie to you. So there is an acknowledgement

of freedom, and with that freedom comes the responsibility that what you're supposed to do is not what they expect you to do. You're supposed to go and surprise them. You're supposed to do the thing that they couldn't imagine that you would do. That's the job, and to go back to your question, I probably have my process down. After Pharrell and I did Oscar night and after we had our little party I went back to the studio. You literally caught me right now in the middle of a long day. I need this theme today and I have a blank page.

IL: Pharrell, what about you, do artists sometimes come to you wanting a particular style? Your style changes over time and you've made that very clear. Do you find yourself with people that have very different expectations but have learned to evolve with your musical tastes?

PW: I think that's natural when people start to learn who you are. They understand what gets you going. You understand what gets *them* going creatively. Like Hans said, it's always great to watch someone want to go along with the need to discover new experiences musically. But that's not quite how he said it.

HZ: You said it better.

PW: I can say it over and over again. It is an honor and such a privilege to work with Hans because he can turn his imagination into scores, into a language. How many people can say that? I mean, we all as human beings can say it, because our imagination is where all of our conversations come from. But it depends on the vernacular we speak, the range of our vocabulary.

WE SHARE THE SAME WORDS, BUT THE WAY YOU ARRANGE THEM IS YOUR IDENTITY, YOUR PERSONALITY.

But when people really just pull from the ether and bring forth things that there are no audio references for, new experiences like *The Dark Knight*, that's awesome. That's all I ever wanted to do. That's what I was thinking when I made "Grindin" [with Clipse], that's what I was thinking when I made "Like I Love You" with Justin [Timberlake], what I was thinking with Madonna's "Give It to Me," "Fun, Fun Fun" from *Despicable Me*... It's all about pulling from nowhere and being happy that you can just put it into shape when it comes to you.

IL: Right.

PW: It's like earlier when Hans was talking about Legos. Imagine having all those pieces and not really being able to put it all together. But when you do, you don't hold your balls for it, you give thanks. That's the difference.

IL: That's an amazing attitude. It explains a lot in understanding and positioning your work. Much ink has

been spilled in analyzing your approach, especially in comparison to the work of DJ Premier, Dr. Dre, J Dilla, Madlib, 9th Wonder, Just Blaze and RZA. This does not necessarily need to be on the record, but among your peers, whose work did you and Chad find was the most compelling or challenging?

PW: Oh, all of the above.

IL: All of the above?

PW: Yeah, I mean because it's not a fabric when there's only one thread. You must consider all of the threads that make it up for it to be a fabric. And that's what we are. The music industry is really one big quilt...

IL: I want to commend you. That description of hip-hop music production is probably the most generous anybody's ever put it.

PW: Well thank you. We're basically a mini version of the collective unconscious. If you don't have that, then there is no "we." And when people forget that, things fall apart. And unfortunately, it happens a lot. [pauses] Bringing it back to Hans' film scoring, you know Hans is very consistent in his inconsistency. And when I say that I'm talking about...

HZ: I know what you mean...

PW: He goes left, he goes right, he goes up, he goes down, he goes diagonal, he goes fourth dimension, he comes back. That's the best thing, it's the fact that you can't put your finger on where he's going to go next. He is consistent in that. He just reinvents himself. That's what I want to do.

HZ: When you were asking Pharrell, "don't people expect certain things of you? They go to me like, "hey are you going to write the next *Gladiator* (2000)?" No we are not going to give you *Gladiator* again because that would be boring and the most dangerous thing that can happen to us is to be bored, to fall into complacency. Pharrell and I are in a similar position in a certain way, whereby I get sequels, he gets the same artist again and its very important not to fall into the trap to think "oh it's a sequel" therefore I can just warm up what we had before. It is important to treat each project as an autonomous piece of work. The first thing I do when I get a sequel is I try to throw hand grenades into the middle of the room and see if we can explode every preconception we had from the time before... man, I really love scaring producers.

WHAT SERVES THE REST OF THE WORLD IS REALLY THE ENEMY OF WHAT WE DO.

Because repetition, repetitive action using the same sound and using the same idea again, is absolutely the death of art, the death of creativity.

IL: Pharrell, what are your favorite scores by Hans? What about them in particular appealed to you?

PW: *Gladiator* just made you feel like you could conquer the world. Take out all of the dialogue and the sound effects. Just listen to the music and watch the scenes. When you felt wounded you feel like a hero who was wounded. When you felt locked up, you felt like a hero who was going to get out pretty soon. Hans is really good at putting compositions together that evoke the feeling, the range of human emotion. And *The Dark Knight* is just meant to keep you on the edge of your seat. There is suspense, a thriller aspect to it, and it is ultra, ultra badass. It's like he put a lot of pressure on the set designers to make better cars and gadgetry because the sound was just exhilarating.

IL: I thought about that too because I recently "listened" to the movie without watching it and I always felt that my favorite sequence in it was listening to that bank heist in the very beginning.

PW: Right.

IL: ...With Heath Ledger, William Fichtner—and that long, slow cello glissandi. That to me really captured the essence of the movie. Maybe it isn't the scene Christopher Nolan would ever hang his hat on, but to me—

PW: Oh my god! That to me, in the weirdest way, was what it felt like the first time I heard "Shook Ones" by Mobb Deep. It was just like, whoa! So anything that they said on top of it you completely believed. In the scene you are referring to, ok, you just knew that Heath's Joker had always thought out of the box. He's working with a wholly different numeric system. You think prime numbers and this guy is working off of a decimal system that probably exists in a couple of dimensions from this one. He was completely left of whatever you thought you understood or that you could figure out. And then there is that music...

HZ: That was the key scene. You know the fun part about that movie, or the interesting part about that movie, is that the only person who always tells you the truth is the Joker—the only fearless person. Of course that's the character I loved the most. I mean, sheer anarchy. And it's a quiet scene. You have to lean in a bit to actually hear it and it draws you in and it's a little unexpected. It comes from Chris Nolan's writing and the reason I love working with him is because there is a big difference working with writer-directors as opposed to directors who work from somebody else's script. With a writer-director, when you ask a question you are actually talking to the right person. I enjoyed it tremendously, especially the way we *were* working, which was in great privacy. [That] aspect is really important. Here we are talking and the spotlight is on us, but I bet Pharrell is the same way. At the end of the day you just have to lock the doors, roll up your sleeves and—

PW: Get to work—

HZ: ...in privacy. And you're going to fail a few times because that is the only time you actually learn something. You know, you discover new things and you're back to stumbling all over the place. And nobody likes the whole world watching you stumble because the whole world doesn't understand that the stumble is actually the moment of creativity.

IL: Which is precisely why making sense of your [Pharrell's] work is always a work in progress. Knowing that much of your work resides in frequencies "in between" a standard Western scale, such as the long glissandi in Britney Spears' "Slave 4 U," I'd imagine you'd always had an instant affinity to Hans' work, in the *Thin Red Line* (1998), for example which weaves Western orchestration with Japanese instruments and traditional Melanesian music. By the way, Hans, I just have to say that that's my favorite soundtrack—

HZ: Ok, all right, I have to admit that is my favorite soundtrack too! Terry [Malick] kept dropping dialogue. He kept saying this whole things works much better with just images and music. Which did put a bit of a burden on me.

IL: It reminds me so much of how you integrated Lisa Gerrard's vocalizations in *Gladiator*. Or even your first score with Ridley Scott [*Black Rain*, from 1989], with echoes of the work of [Toru] Takemitsu. Pharrell, you are also very comfortable serving as a bridge between cultures. To many artists, combining Western tropes with other influences remains a novelty. But with the musical production you've done in Japan with Ape Sounds, and are now doing in South Korea, China and even in Southeast Asia, you continually immerse yourself in it because you're really convinced of this role as mediator, and the way it has always worked its way into your own music... Do you still feel that strongly about it?

PW: Yeah, I think I'll always feel that way. I will always be honored to do it over and over again.

HZ: Hey, I am a foreigner, I grew up in Germany listening to Mozart and Sly and the Family Stone. When I was growing up, there was a large American occupation force there. So at night I would be listening to AFN [Armed Forces Network], which was just James Brown etc., all black music. And during the day, because my family was that typical family, we'd go see classical concerts. These two countries merged in my growing up, and when you hear me speak, my accent is all over the place. That's the same with my musical accent. The bottom line is that, as a foreigner, when you go into a different country you often bring something to that country that the country forgot, things that they see and hear every day, and are a little bit bored about it. Here we are at the Grand Canyon with Ridley Scott for *Thelma & Louise* (1991) and we think it's the most amazing thing we've ever seen. And the Americans

kids go, "Whatever"...[All laugh]

So part of what I think Pharrell does by working in foreign countries, with those artists which is what I do with Americans: taking things that everyone takes for granted and showing them in a new light. It lets you appreciate your culture again, not commenting on it, really. In *Black Hawk Down* (2002) or *Tears of the Sun* (2003), for example, I never got interested in the idea of doing musical research and figuring out what African music was...all that happens is you just go and steal all the clichés.

PW: Right!

HZ: What I think both Pharrell and I do is we have our point of view and we get going with that point of view. We have our cultures and we love it when our culture and that other culture make contact, explode and something new comes out of it—which gets us back to Pharrell's phoenix analogy. You know I went to Africa having written as a European and my good European harmony was thrown in the middle of the room with an African choir, and they're like "OK, now its yours, go and do with it what you want." And suddenly with the two cultures colliding, something new comes out of it, and that's always exciting.

PW: Very exciting.

IL: We gotta get technical for a bit. Your career has straddled many different types of music technology. From analog synthesizers, to digital sequencers, to software-based instruments, from analog tape, to digital recorders, to Pro Tools systems. Have these changes affected—

HZ: I lost years of my life waiting for tape to wind back. You know the thing I am probably the most angry about is waiting for the tape machine to wind back. I'll never get those hours back.

IL: You won't! So these changes have made things more convenient, let's say, but has this technology affected your musical style? Did all of that time that you now save—

HZ: It's not about saving time; if anything it's the opposite. Pharrell knows this. We actually build a lot of our own technology because the instruments out there are never quite enough for what I want to do. So part of my compositional process has always involved taking into account of where the technology is. If you start with Bach's *The Well-Tempered Clavier*, obviously he was writing for a specific piece of technology, and he was absolutely trying to prove a point about going from equal temperament to well-tempered, so in one way or the other, composers by the nature of their work, have always driven technology forward. The problem that exists now is that there is such a wealth of sounds so the way I work—and I wonder if Pharrell works a little bit like this as well—is the first thing you do is you go and figure out what you are going to leave

out. Because now anything is possible, so you now have to limit your palette right away. You have to make a decision very early on to determine what is appropriate for what you are trying to say. Because otherwise the amount of time I spent waiting for tape to wind back I can now spend going through useless presets on synthesizers. So I never use presets because, to be really honest, by the time I'm at preset twenty, I'm sort of bored and I would have forgotten what I was actually trying to say. So it's much easier to just make the sound up from scratch.

PW: I agree.

HZ: ALL I CARE ABOUT IS THAT I HEAR SOMETHING IN MY HEAD, AND WHAT I HEAR IN MY HEAD SOUNDS REALLY GOOD.

And then comes this process of erosion, where through the translation into the computer, or in trying to explain it to an orchestra how to play that phrase, you're always giving up a little bit of that sound. It always sounds best in my head and I'm just trying to figure out a technology or a means of communication, or just talking to a player: "hey can you make it sound the way it sounds in my head, please?" That's been the constant underlying theme, literally, of my life. It starts off very pure and somehow every generation of communication degrades it a little bit. Sometimes you get new things though. That's why I like hanging out in a room with Pharrell. He suddenly plays a chord and I'm like, "oh, that wasn't in my head. It's much better than what I had in my head. I'll have a little bit of that please, thank you very much." Yes, I am using the technology to get closer to the way I feel about things...

IL: [to Pharrell] You obviously love learning new methods and you're learning a lot from him and he's learning a lot from you. I heard that you guys are working on a classical album together. Is that correct?

PW: No, that's something that I was working on, and once I'm finished I am going to send it to him so he can tell me what he thinks.

HZ: I think we have some songs laying around here that we need to finish. I keep forgetting about them. It's not that they are no good it's just we've been very busy.

PW: Yeah, I think we've done what? Seven or eight of those songs?

HZ: I think we have half an album sitting there.

PW: [to Ian] I think you're probably blending those two stories together.

IL: My bad, but either way, I'm looking forward to it. I was thinking of the number of musical cues I heard

at the Oscars the other night, and it must have been over a hundred.

HZ: 120!

IL: 120? Oh man... I'll end with the most predictable line of inquiry. How did you guys meet and what was that first musical experience like?

HZ: Kathy Nelson.

PW: Yeah, she was the music director at the time for Universal.

IL: This is for *Despicable Me*?

PW: Yes. She supervised it, and she said, "listen I know exactly who you need to meet, this guy is going to teach you everything you need to know" and um...

IL: Was that to you or to Hans?

PW: No, it was to me! Of course!

HZ: We were talking across each other. Which is typical. I could never shut up. I think it was very simple. Kathy knew that Pharrell was absolutely their person for *Despicable Me*. But we're talking to people that had reservations of putting a two-hundred-million-dollar movie on the shoulders of somebody who may not have written a hundred scores. So I think Kathy knew that I could respond really well to him. I wasn't going to try to take over. I was the person who could say to them, speaking with some authority—but you know this is Hollywood, so you can make things up as you go along. I could reassure them that this man was definitely the right man to do this. Pharrell, you're working after this, aren't you?

PW: You know what? Today is a rare day because I am actually off.

HZ: Awww, man I am so envious. I have to get this theme written by tonight. Can I use [this book] to say one thing to my friend? Pharrell it was a pleasure and an honor to work with you on this crazy little Oscar show. It just goes to say how much courage you have because you must have known this, you must have known that I have never done a live television show in my life. So for these crazy people to hire us, it could have gone really wrong but I don't think we fucked it up.

IL: Not at all.

PW: Yes, we had a really good time.

HZ: I would never have done it without you. See, the way this came about was that Andrew [Zack], my assistant said to me: "you should do the music for the Oscars" and I "said oh no, it's boring, it's always the same thing. But if it was Pharrell and I ... and I lifted up the phone... Here's the thing, let me say one more thing about Pharrell. It's just so rare, it's a rare thing in this world to have somebody who is a true artist on so many levels. He is, to me, *so* the real thing. *Time* magazine always does this "100 most influential list" and to me, he should always be the first guy up there. See, I don't have to blow smoke up his—

PW: Well thank you sir!

This conversation was conducted with the invaluable insight and assistance of Micah Hayes and Mick Moreno.

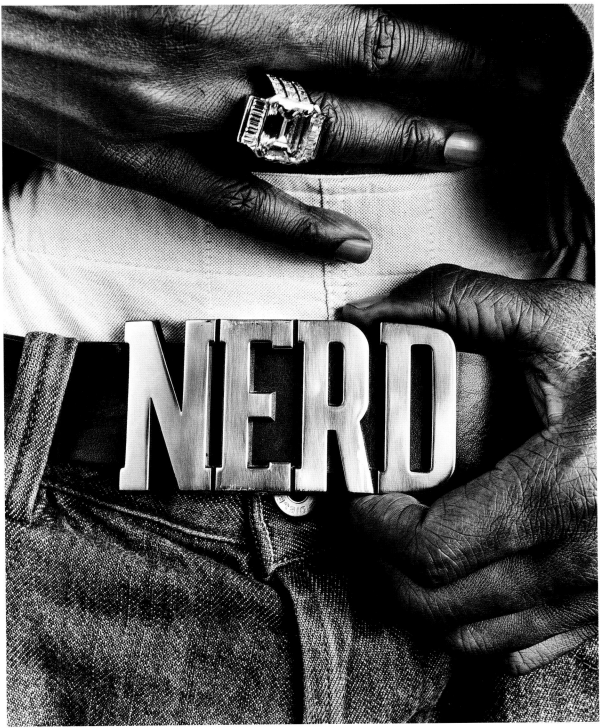

N.E.R.D. belt & buckle, designed for Pharrell, 2003

THE LIVE SHOW
by Pharrell Williams

When we started performing with N.E.R.D. it was surreal, I couldn't believe people were actually there for us. It seemed like a cruel cosmic joke. Luckily, my imagination as a child came in handy, and it allowed me the privilege of zoning out on stage. Having a live audience of fans who are there just to hear your music, seeing them sing along to the lyrics is really amazing. The feeling is incomparable.

Performing is its own dimension, It is completely different from anything involved in creating the music. It really is about that moment, the interaction with the fan. The work involved in producing and writing a song finds a unique, fulfilling expression in a live show and often leaves a lasting memory. As a whole, the experience is really quite humbling.

(pages 26–41)
Views of N.E.R.D. in performance, from a number of concerts from 2004 through 2009; N.E.R.D. Logo, drawn by KAWS. Ink on paper, dimensions unknown, 2008

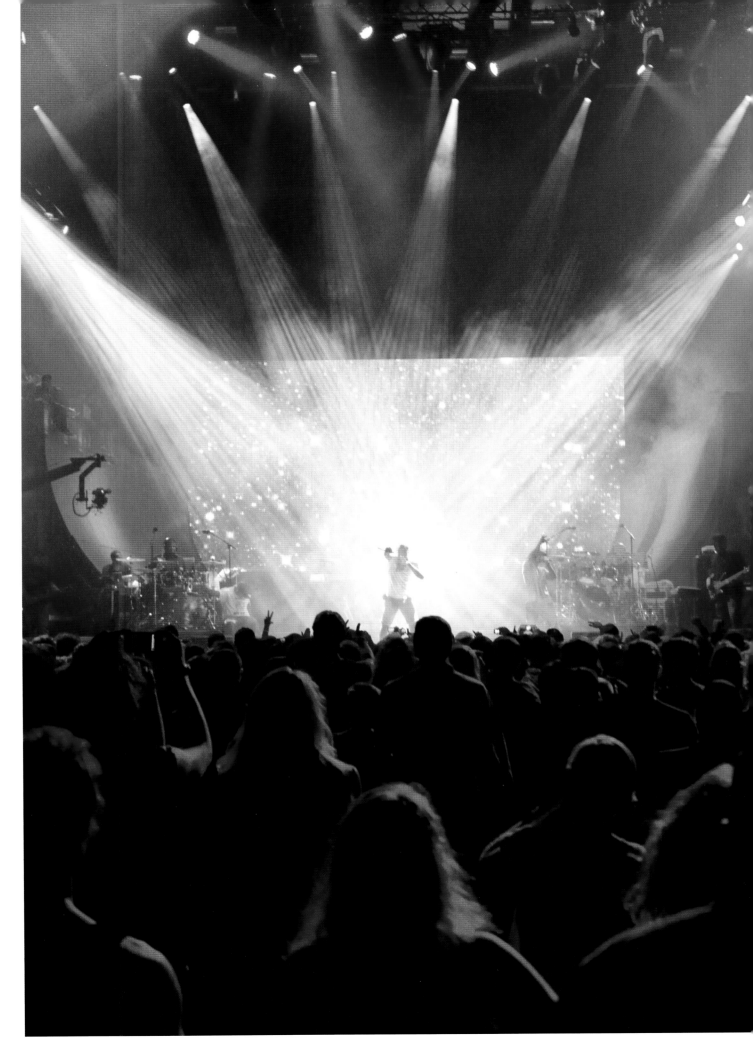

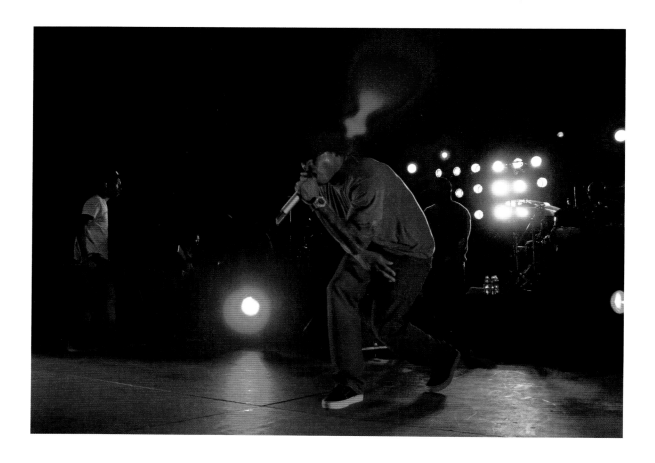

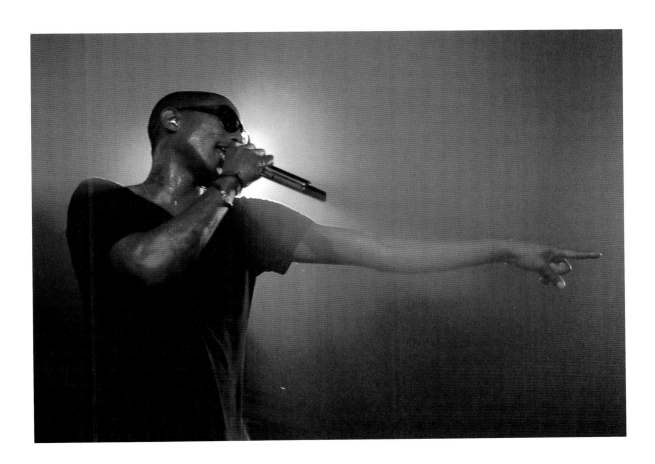

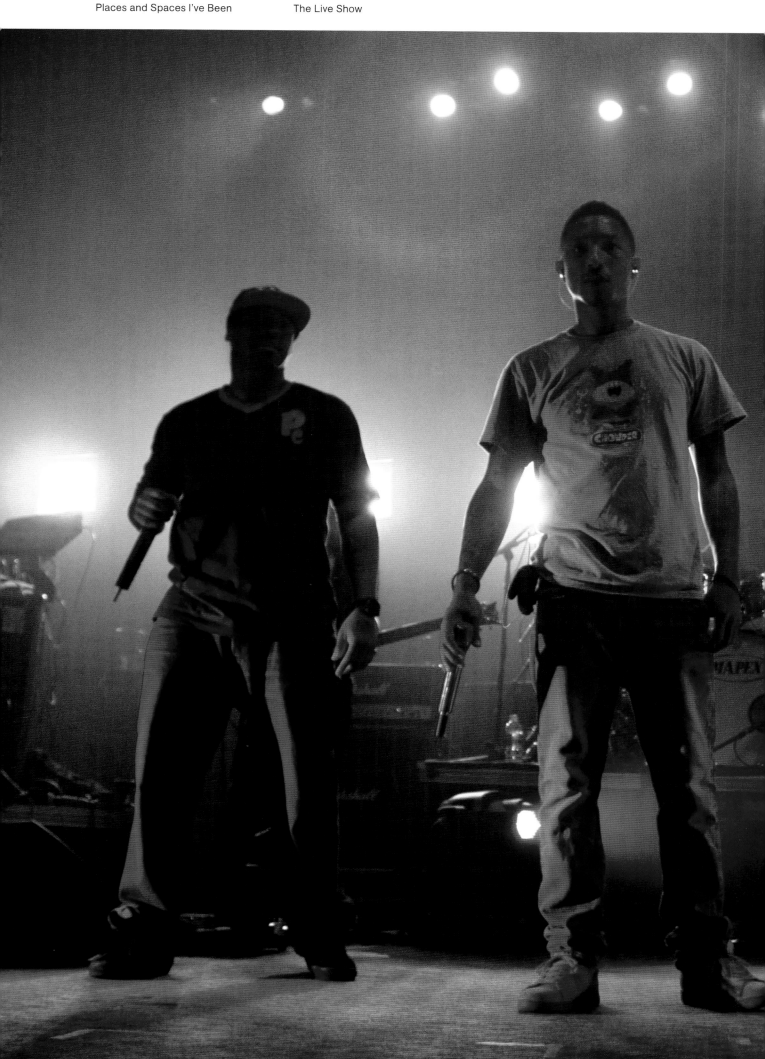

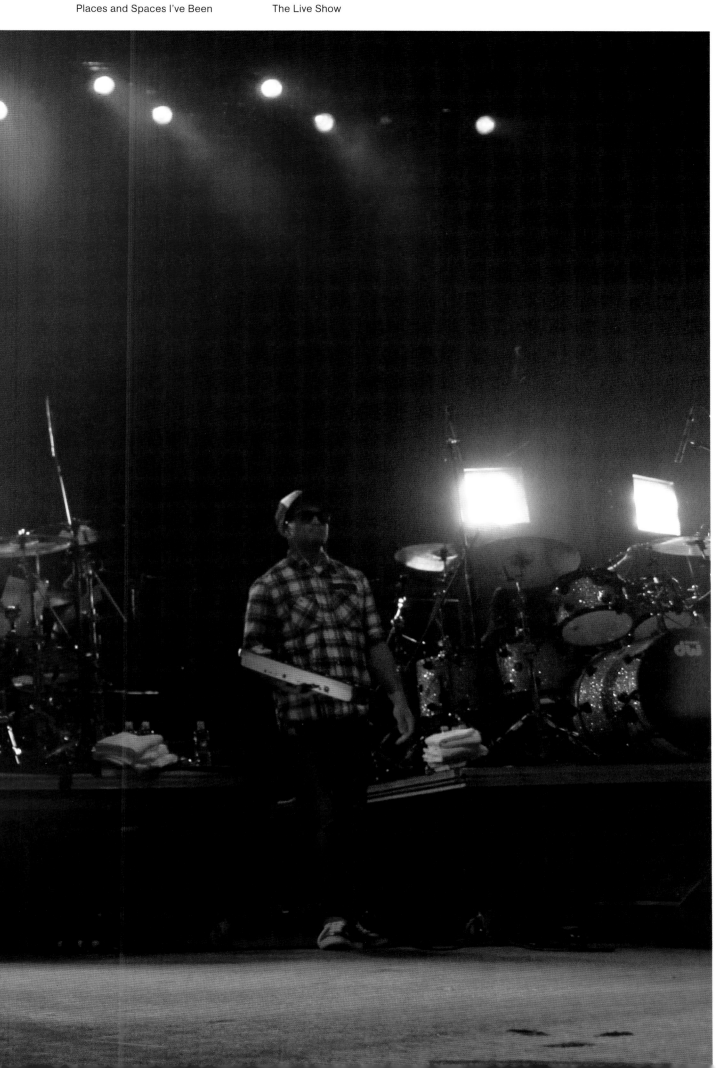

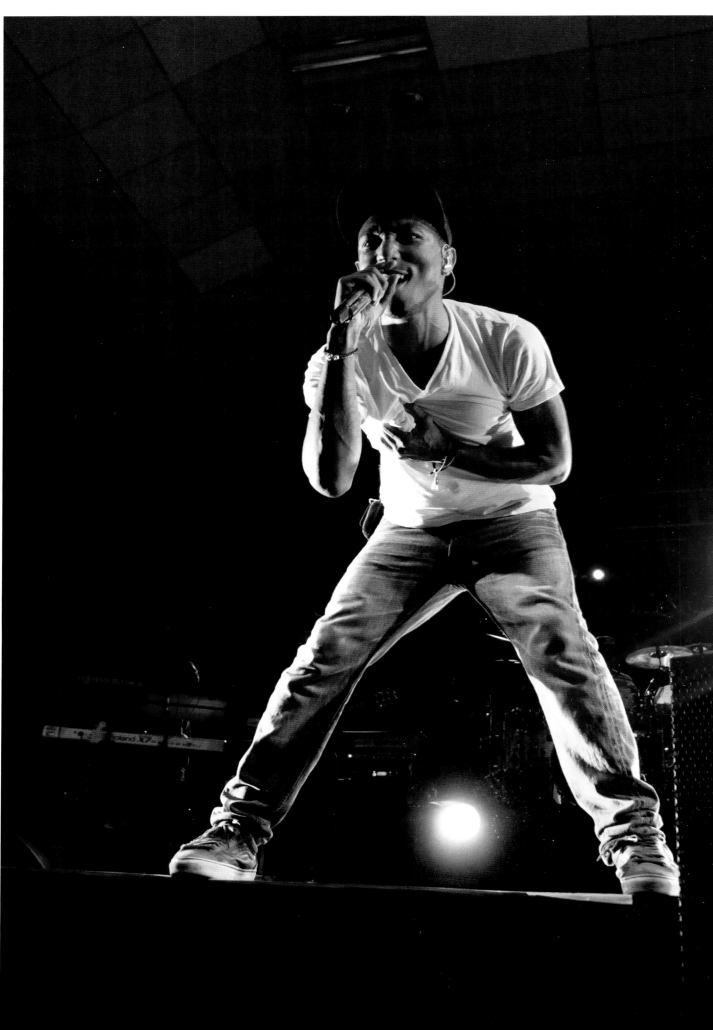

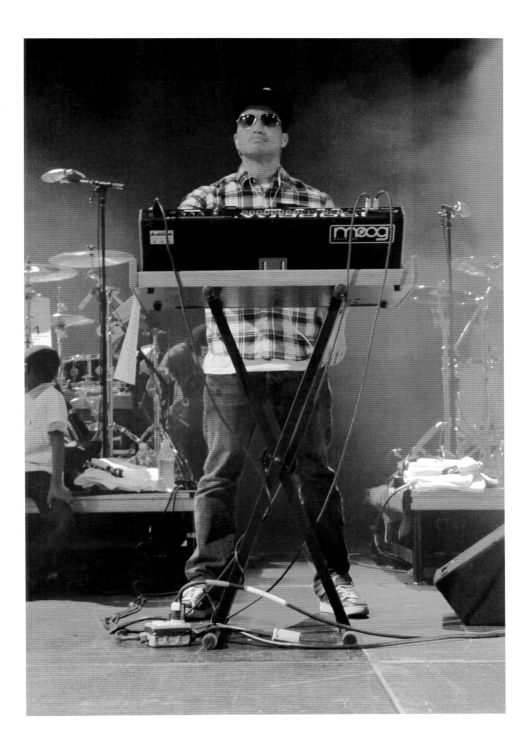

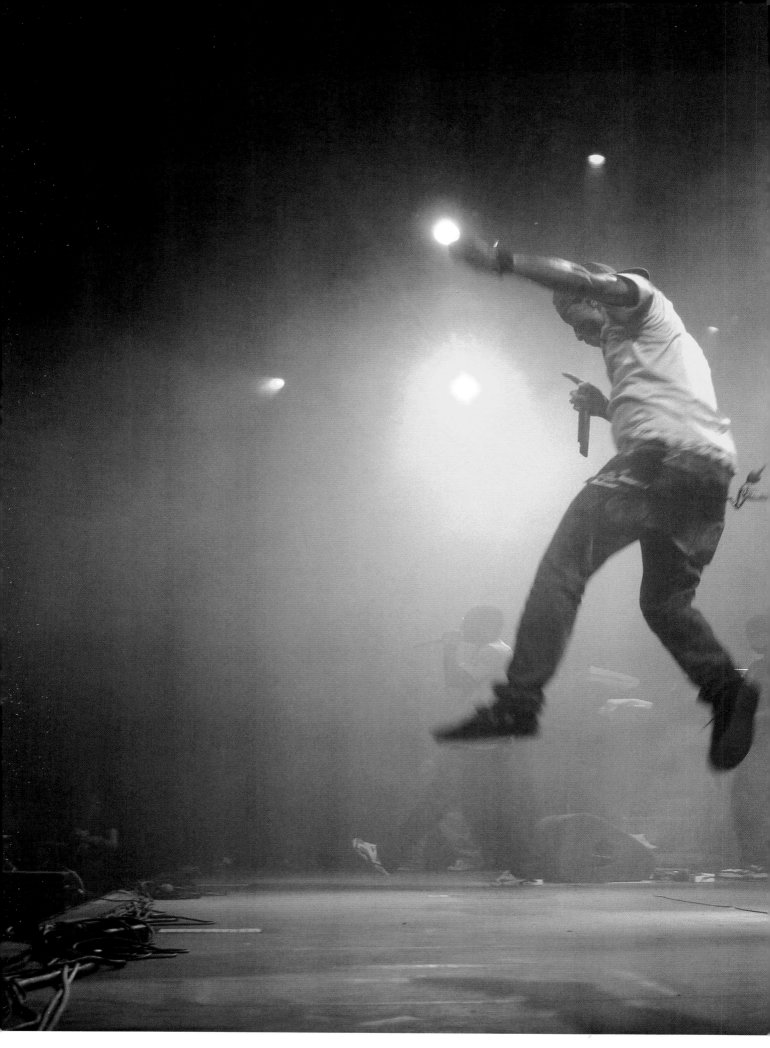

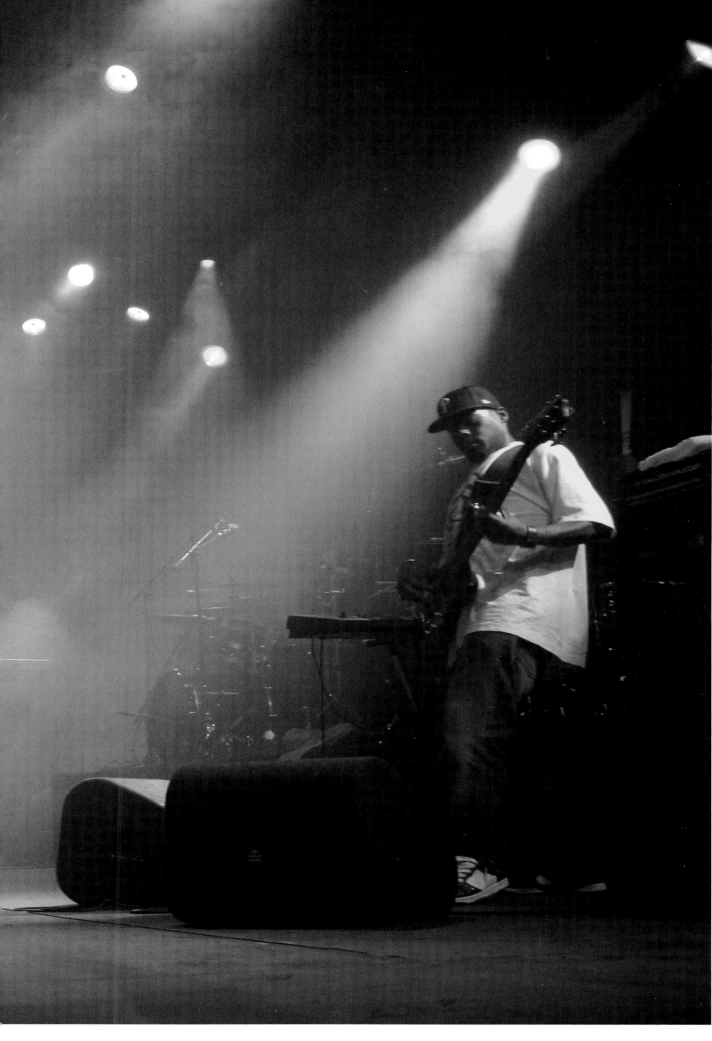

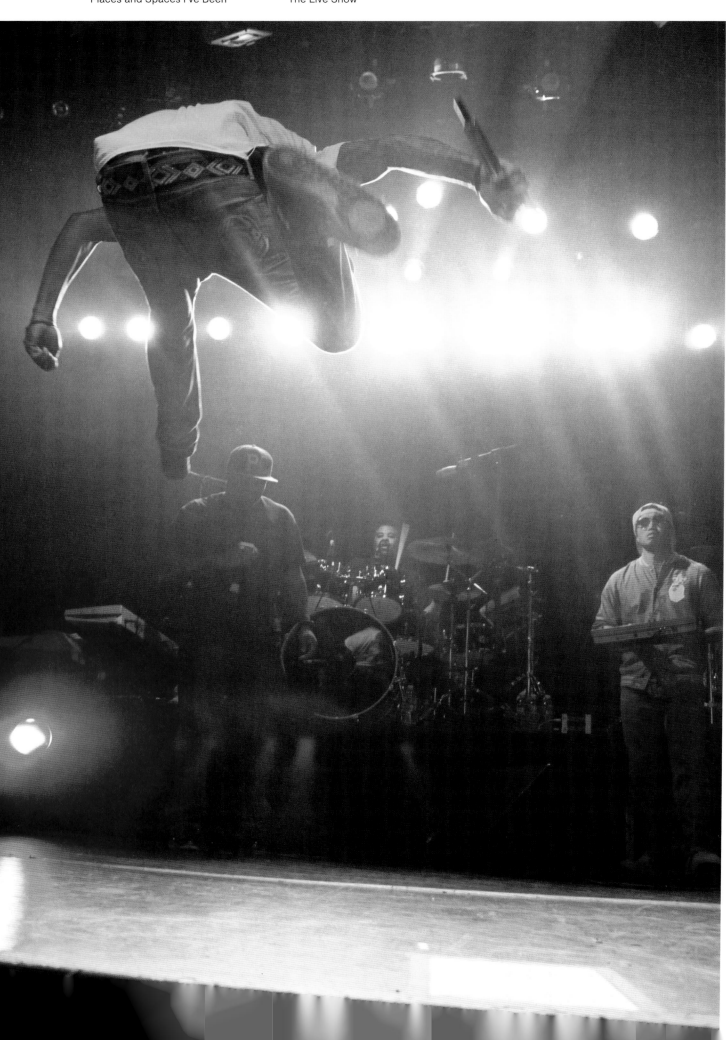

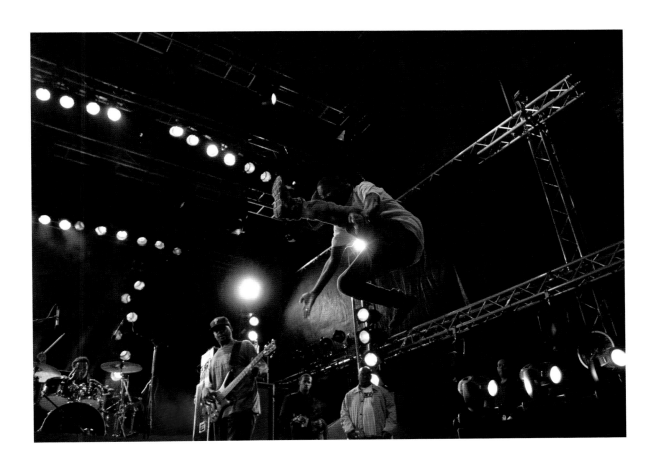

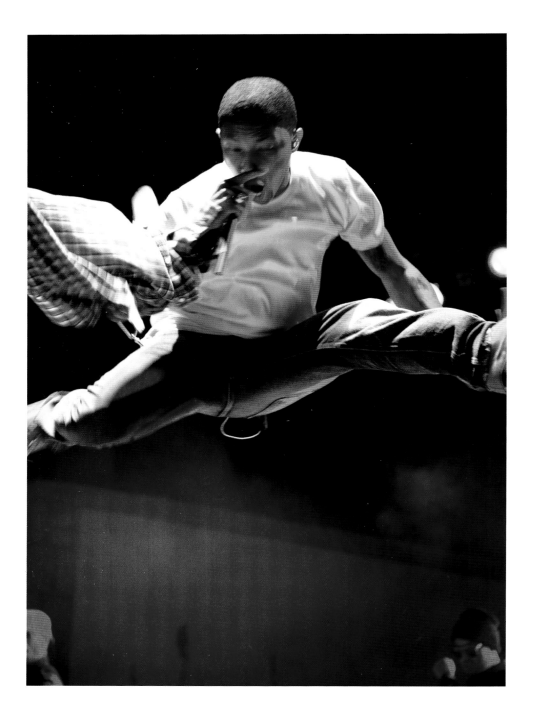

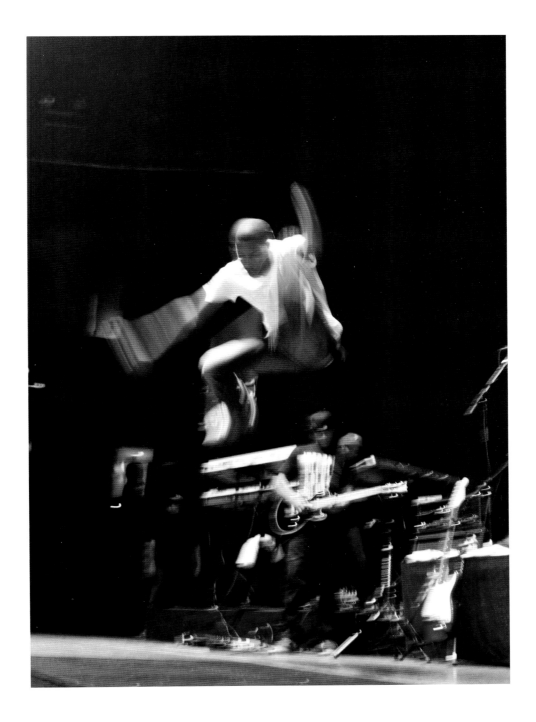

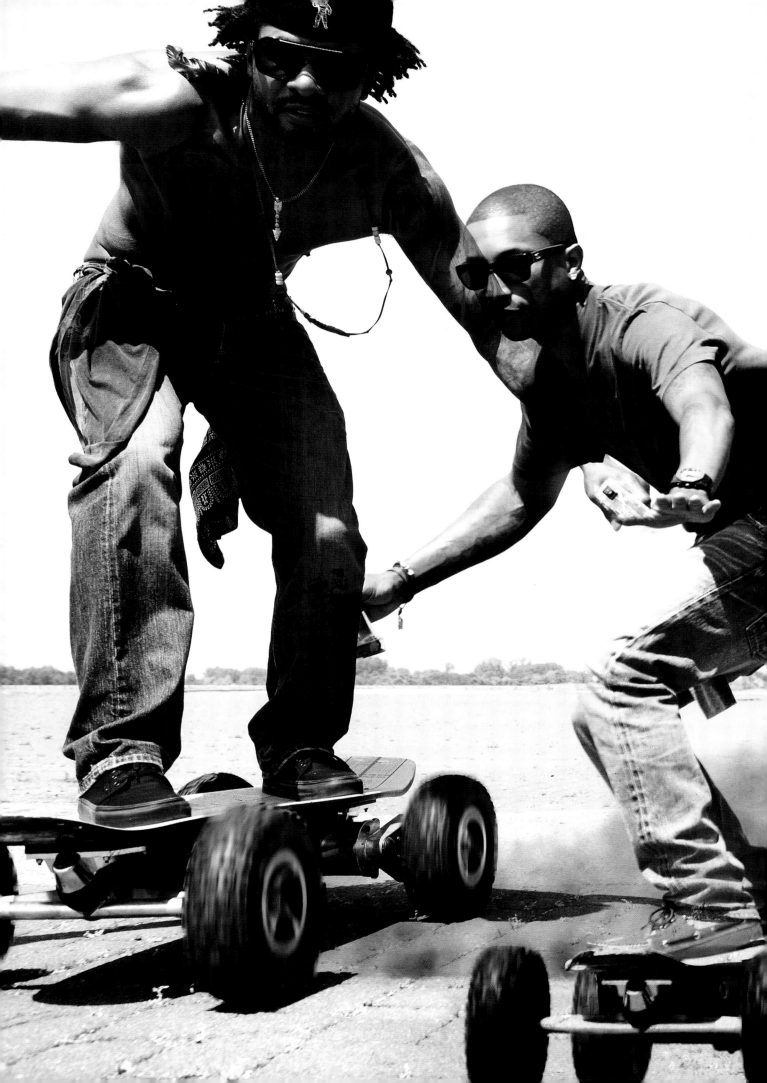

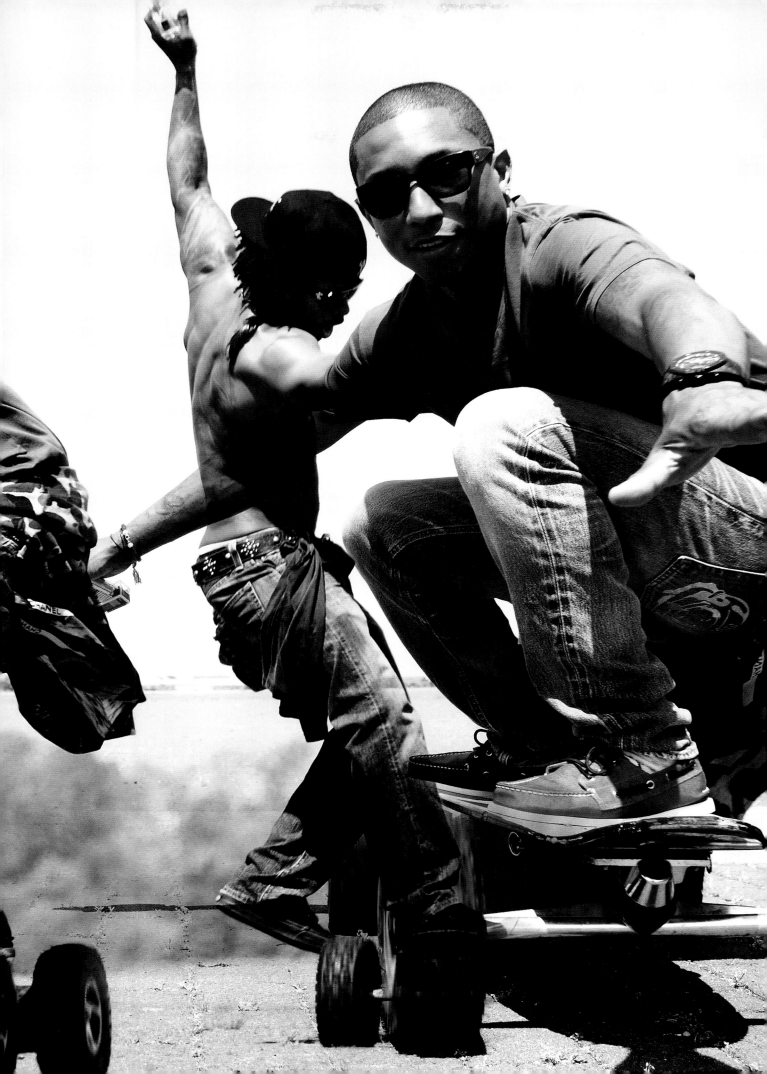

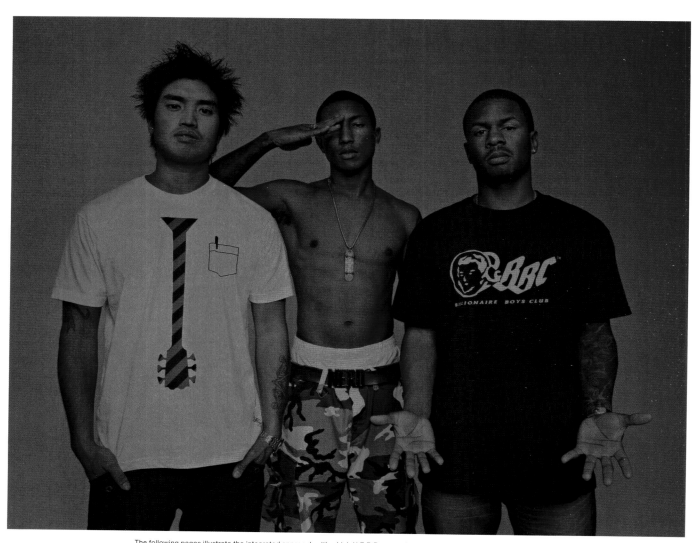

The following pages illustrate the integrated approach with which N.E.R.D. created iconography for the album *Fly or Die* (2003).
Unusual for an American album of the period, the release of *Fly or Die* included a number of promotional and limited edition items, sold through select retailers.
Built around images of the band, some of the wares include a midrise Nike "Dunk High" designed by Pharrell in 2004;
a special N.E.R.D. camouflage pattern by NIGO® of *A Bathing Ape®; and an action figure manufactured expressly by Toy2R, in a quantity of 50.
These promotional strategies, unique for their application here, are de rigueur in the Japanese context.

(pages 42–43) N.E.R.D., 2010
(pages 44–45) Chad Hugo & Pharrell Williams of the Neptunes, 2001
(pages 46–47) Shae Haley & Pharrell Williams, *Interview*, August 2010

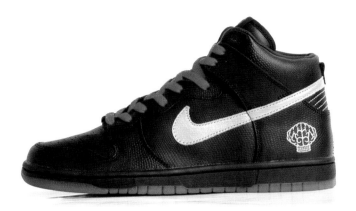

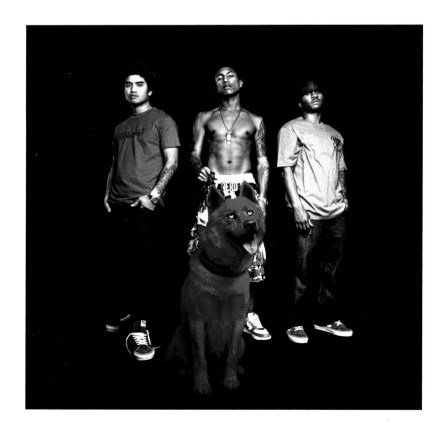

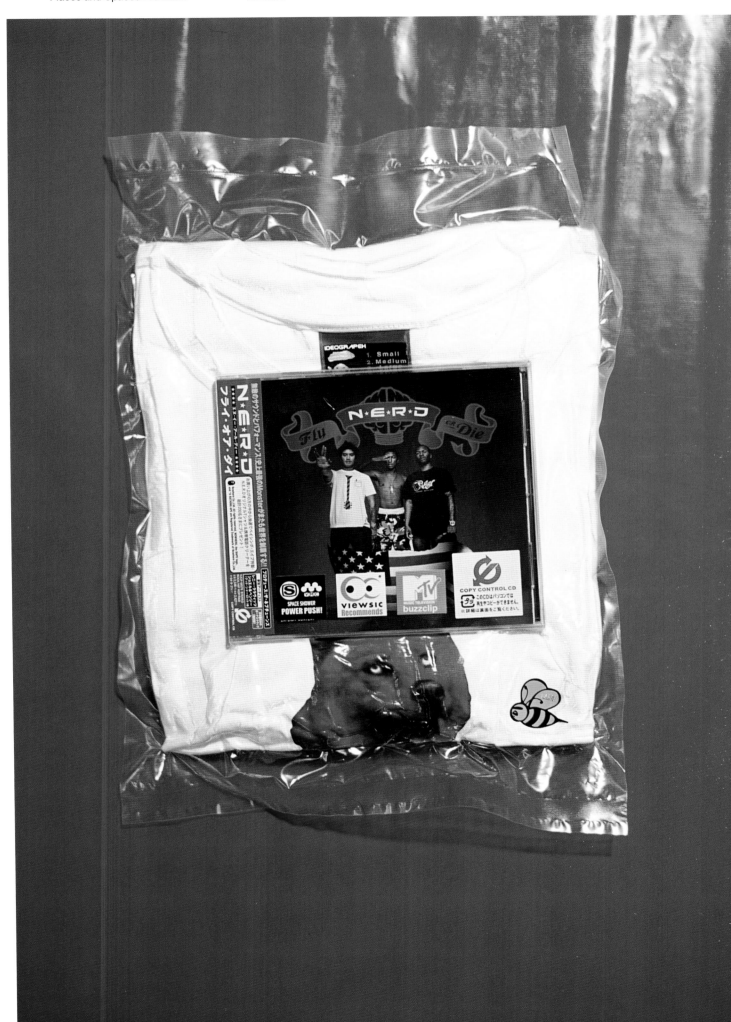

*A BATHING APE®

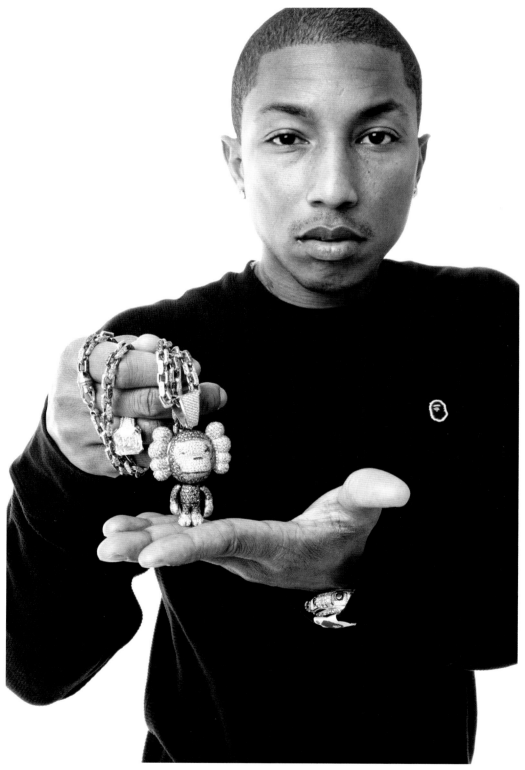

Pharrell in BAPE Fall/Winter 2007
with a *KAWS Milo* by Jacob & Co, 2007.

Spring/Summer 2006 Roadstas, featuring Mankey's
character design of Pharrell Williams.

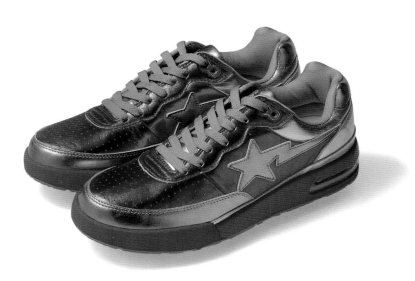

Spring/Summer 2006 Roadstas, featuring Mankey's
character design of Pharrell Williams.

(opposite) Pharrell in head-to-toe BAPE, 2004.

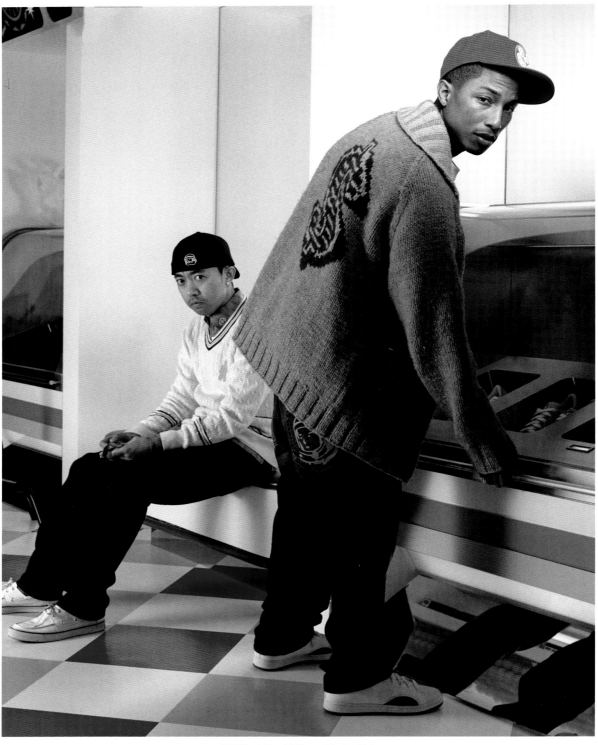

NIGO® and Pharrell Williams, at the New York
BBC/IceCream store, November 2007.

HEARTS AND MINDS

A conversation with Pharrell Williams, NIGO® and Toby Feltwell

In 2005, Pharrell Williams partnered with Japanese fashion icon NIGO® (founder of *A Bathing Ape®) to launch two lines of luxury clothing, BILLIONAIRE BOYS CLUB (BBC) and IceCream.

Produced in limited quantities and employing the unique visual language of Sk8thing—a graphic designer crucial to the success of *A Bathing Ape®—the two collections were originally conceived as high-end sportswear. Initially all produced in Japan, the lines now consist of T-shirts, polos, sweatshirts, knits, denim, suits and shirts; outerwear in leather, down, cotton, and technical fabrics; hats, sneakers, underwear, socks and accessories. Adopting the guerrilla marketing tactics that proved so successful for BAPE, which imposed scarcity and created strong word-of-mouth to spotlight collaborations with artists and other influential brands, BBC/IceCream fulfilled the modest intentions of its founders, and the united brand has now become an irresistible force in streetwear—with an appeal and an influence wholly disproportionate to its retail footprint.

In the winter of 2012, Pharrell Williams, NIGO and Toby Feltwell (formerly Nigo's chief-of-staff at A Bathing Ape) met in Miami Beach to discuss the origin and development of BBC/IceCream.

Toby Feltwell: Pharrell, Rob [Walker], Loïc [Villepontoux] and crew came to Japan [in 2003] and we met them when they borrowed the recording studio in the old Nowhere offices in Tokyo to record a song for a video game. We knew they were coming to Japan and were hoping to have the opportunity to meet.

NIGO®: I was a huge fan of Pharrell at that time. I still am, of course, but now we're friends, so it's different. I was really into his style and music back then. I have never been so influenced by anyone since starting my own brand in 1993. I had been influenced by lots of people before then, but after I started BAPE no one had so much of an influence on me as Pharrell. It was really a coincidence that they ended up using our studio. I knew that Pharrell must care about clothes and really understand style, but I had no idea that they were thinking of starting their own brand before meeting them.

TF: The ideas for the brand were quite well progressed. Pharrell and his team had already been talking to Reebok [via Steve Stoute]. At this time you had Jay-Z's S. Carter collection and 50 Cent's G-Unit: so Reebok made sense in the context of 2003-2004. At least, as far as sneakers go...apparel through their system would be an unknown quantity, but I think Reebok saw part of Pharrell's attraction as his abil-

ity to sell clothes as well—which was very smart. We showed them our world, which I think was something different than what they had seen before, and they asked Nigo if he would help or advise. He said he would design the line for them; I thought it was a lot to commit to at the time, and they were surprised that he wanted to jump right into it. I remember asking if you were sure...

N: I wouldn't have done it for anyone else. It was a big thing for me—I would have to give up my secrets.

TF: Yes, I remember you predicted that it would be almost impossible to educate a big company like Reebok:

ALTHOUGH WE WOULD NEARLY KILL OURSELVES IN THE PROCESS, OUR THANKS WOULD BE TO HAVE THEM RIP OFF THE WAY WE WORKED.

The first part of that was quickly apparent—but the second part didn't really come true for Reebok, not at that time. It did in general, though. The big brands watched what was happening and copied some of the ways of working you developed and that eventually changed everything. In spite of those fears, you were so sure it would be the right thing to work with Pharrell. Why?

N: As I said, I had already learned so much from him before we even met, and then when we did meet in Japan he understood everything I was doing so quickly—nothing needed to be explained. His reaction showed me that he got it. I knew we could work together and that it would be important for me to stay open to his influence. When I first went to Pharrell's house I was astonished when I checked out his closet—we had so many of the same things: things I had no idea he was into but that I really liked too. There were subtle, interesting differences as well. It was clear to me that we could work together in a really positive way because we have a lot of common interests, but we arrived at them from different starting points.

Pharrell Williams: And as soon as I met Nigo, I knew I wanted to be family. I recognized what he was doing as something I have felt my whole life. I really miss not having so much access to that, but I'm here in the US and it isn't like he just lives up the block. What if there is another disaster and, just say, you had to leave Japan and live somewhere else. Where would you go?

N: Well a lot of people are saying that another huge earthquake is coming—serious scientists, not just psychics. I've thought about living in Kyoto...

PW: But, outside of Japan?

N: I suppose Hong Kong, but it's very nice here in Miami as well. I would have to think about it.

TF: I'm sure people would imagine that communication would be a big challenge between Nigo and Pharrell, although that wasn't how it worked out. One of the challenges in working with someone like Pharrell, who has a very strong visual sense but was communicating verbally for the most part, could be knowing whether you've got the picture right. If it was wrong he would know right away—so if you don't have a good intuitive understanding of what he's hoping to see, it's like looking for a needle in a haystack. I think Nigo and I were always able to understand his ideas to a degree that actually made it a pleasure to work that way. I remember once P said that "Nigo made his dreams reality"— and that was really how it worked. At first we always worked from conversations and, although P is one of the most articulate people I know, it's kind of magic when an idea becomes a conversation that becomes a sample of clothing that matches the original idea. I remember that the first test of whether it would work out between all of us was the logo. Pharrell had a clear idea and brand concept and the astronaut would be the key to all of it. I knew what he wanted and I took

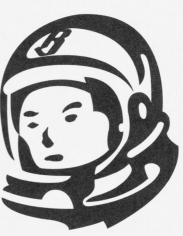

(opposite) Original BBC astronaut & IceCream logos, from 2004, with Pharrell at the launch of the first BBC collection in Tokyo, at BAPE Harajuku.

(above) Original BBC astronaut logo, 2004, by Sk8thing.

(left) Sculpture of Baby Milo & KAWS' Companion, in Pharrell's residence in Miami.

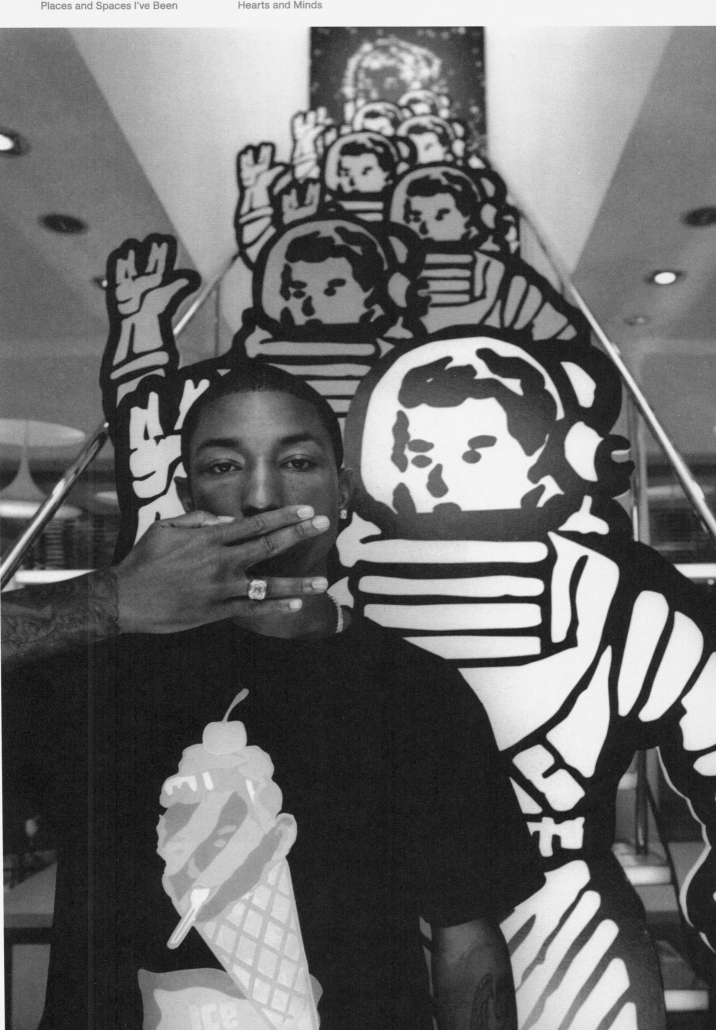

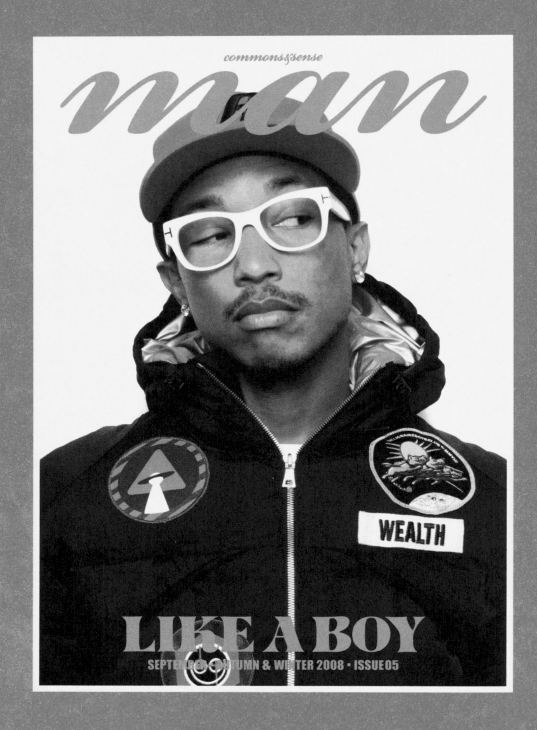

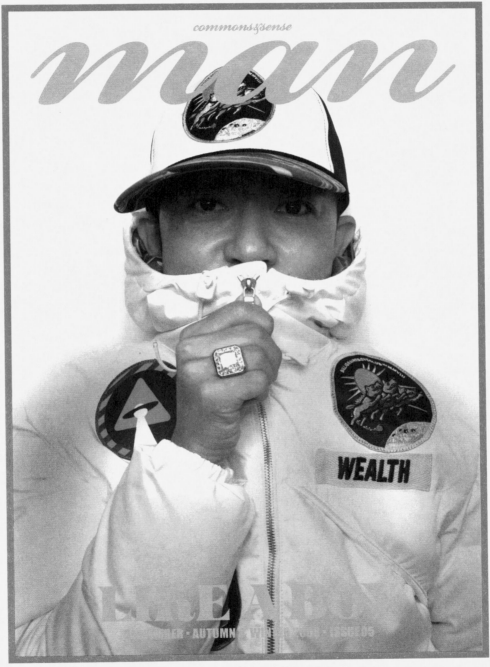

(above and opposite) Pharrell Williams & NIGO® on variant covers of
Common Sense Man, October 2008, wearing Season 7, Fall/Winter 2008.

his instructions to Sk8thing and we worked on it... I took a rough draft to a club where they were at a party the same night, and Pharrell was into it. That kind of sealed the deal. Loïc told me that they'd tried to get the logo done by some people he knew in New York but no one had quite nailed it. The retro, 1950s, coffee shop flavor of the first logos was all Sk8thing. It seemed to be totally appropriate, though. It's something that was in tune with Pharrell's aesthetic—as we found out later when we hung out with him more. Sk8thing's a unique genius at designing logos. Actually Sk8thing was more obsessed than he usually is with Fiorucci at that time and that was a partial blueprint for a lot of the way things looked. The expansion of the motif and its evolution was a real partnership. I think this is always the case, but when we started P had a lot of strong ideas about things he'd always wanted to do, that we did in the first few seasons, and then after that it was an evolution.

PW: I am inspired to create by travel, places, spaces—like the name of this book... And by good conversation with forward-minded people...

TF: So, it's inevitable that things will evolve, then?

PW: Absolutely.

TF: Nigo had the knowledge of how to create a balanced line, and there are always more things to work on than what the creator really passionately wants to make—so there are gaps, and the challenge is how to expand the concept but keep integrity. There were certain areas of common interest between P, Nigo, Sk8thing and myself that made it mostly plain sailing—although we sometimes had to negotiate a bit. Anyway—it evolves over time and once the brand is in the public realm you have to pay some attention to what's resonating with consumers. I like to think that we got it right a lot of the time, do you agree?

PW: Yes. Sometimes Sk8thing would go berserk and it would take me a while, but if I couldn't wear it at the time I eventually would wear it, like, three seasons later.

N: Having built my own brand for over ten years by the time I met Pharrell, I really was in the perfect place to help. We learned everything ourselves, there was no playbook for us when we were starting *A Bathing Ape®.

TF: It was a different world back when BBC started. It's actually amazing to think that Reebok had a contract with Nigo in 2004. They had no idea what they

had—it was too early for them; no one knew where this would all go.

N: Yes, but as I said before—I was confident that Pharrell understood.

I WOULDN'T BE WHO I AM TODAY IF I HADN'T MET HIM AND WORKED WITH HIM. I DON'T THINK I COULD HAVE MADE IT OUT OF JAPAN; THAT WAS SOMETHING I REALLY WANTED TO ACHIEVE.

I don't believe I could have done it without his recognition and collaboration.

TF: The predictions came true and there were problems with the way Reebok was trying to make the clothes. It's difficult for really big companies to change the way they work. You [Nigo] wanted to take on the responsibility of manufacturing as well as design. This was another time when I had to ask if you were sure.

N: Yes. It was more pressure, but it wasn't working the way it was going and it had to be done right. If Pharrell didn't care so much about making the right things, it wouldn't have been possible; but his priority was making exactly what he wanted to make. That's the same attitude I have.

TF: So how it ended up was that Rob, Nigo, and Pharrell set up companies in the US and Japan to do it themselves. The sneakers were still going through Reebok for a while, but eventually we started doing the shoes as well... It really was, and is, more important to Pharrell that the stuff is done right than getting a big check. No other star in his position did something so real at that time—everything everyone else was doing was more or less license business. The brand debuted to the world at large via the "Frontin" video shoot—which was a few months after we first met P and crew in Japan. We had samples of tees and polos and we went to Miami for the shoot. It was an amazing time—Pharrell's debut as a solo artist. The album went to No. 1 in the US... People really watched videos back then.

PW: The first BBC logo, on a sweatshirt is the most classic piece for me.

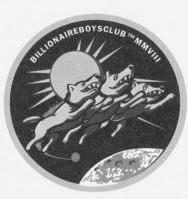

(left) NASA Mission badges. The top badge is the one that flew with *Apollo 13* in 1970; the bottom badge was adopted by Sk8thing for BBC in 2008.

TF: I don't think we had sweats yet at that time...

N: No we couldn't get them ready in time, but I agree—it's a great logo and the sweats were the definitive use of it. I remember we missed our flight on the way back because we'd been out at a club with Pharrell and all of the team and we only got back to the hotel about 2 hours before we were supposed to take off. I remember go-cart racing in Virginia too...

PW: They have that here [in Miami] too, we could go...

TF: It was never intended that IceCream would be an apparel brand—it was supposed to be exclusively the name of the sneakers—but Sk8thing made so many great logos for IceCream that we just had to put them on tees. There was quite a blur between the two brands, especially in the early days. In many ways it didn't make sense from a marketing perspective, but I think people who were into it understood. How do you feel about that, looking back?

PW: I thought that was great. It's mind-blowing to work with people who are great thinkers and are not afraid to execute... no matter how crazy.

TF: Pharrell was always keen to move forward quickly and not retread old ground. Trends were changing quickly but, for example, having established the global trend that became known as the "all-over print hoody" he wanted to move away from it when it started to be imitated (and, frankly, cloned) by other brands. That was great from a creative point of view for all of us—it kept it exciting—but it did raise a little internal tension because I don't think there's any doubt we walked away from a lot of sales. Shin [Sk8thing] and I both get bored quickly and like to move on quickly and P was similar;

NIGO HAS A GENIUS FOR STRENGTHENING AND CONCENTRATING AN IMAGE AND HE'S GREAT AT BRINGING MORE AND MORE OUT OF AN IDEA AND NOT ABANDONING IT TOO EARLY.

I think that BBC was always far ahead of the general perception of it... We were always trying to do the best stuff we could do in the context and it was really not strongly motivated by commercial considerations.

The perception, given Pharrell's popularity at the time and the apparent simplicity of the clothes, must have been that we were making tons of stuff dirt-cheap and charging a massive markup. The reality was quite the opposite—we often didn't charge a full standard margin because we wanted to keep stuff more affordable.

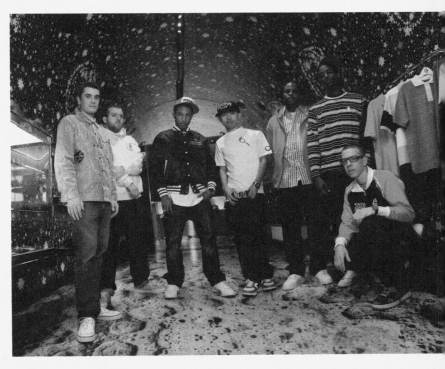

(right) Pharrell, NIGO® and crew on the opening of the BBC/IceCream flagship store in New York city, 2007.

I think it is not unfair to say that there was a mismatch between P's level of public recognition and the small scale, self-owned platform that was chosen to realize the vision. But I think, when things were working at their best, we had a system that was great to be involved with... Ideas got transformed into products with a lot of freedom. I think that's what Nigo and Pharrell wanted most of all—with the understanding that business success would naturally flow from that. In a relatively short space of time, the output was pretty incredible and very varied.

PW: We made everything that we wanted to. And I want that again. The most memorable thing for me is the culture that Nigo introduced me to. I learned about a lot of new things that are important to who I am today. I met someone who believed in me and introduced me to new art, design, fashion, food... Some of the best food ever—I started eating sushi because of Nigo. BBC means the ripening of my taste buds and personality, and the things I like...and I feel like Japan is my second home.

T-shirts from BBC/IceCream Season 8, 2009.

(opposite) Pharrell in "Hunting Jacket" from BBC/IceCream Season 9, Fall/Winter 2009.

BBC/ICECREAM

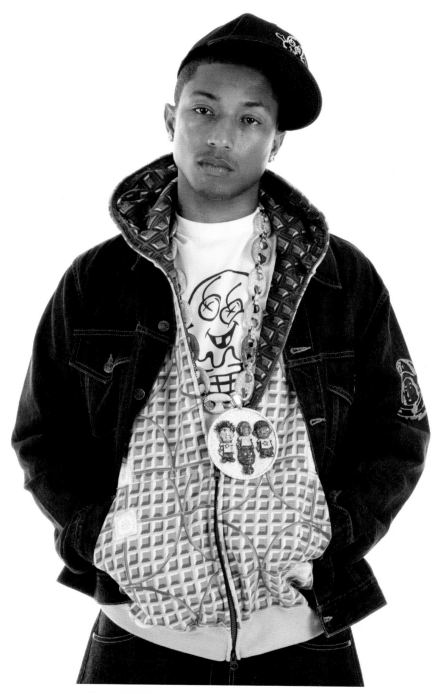

Season 4, 2008; Pharrell wears a pendant by Jacob & Co, featuring character
designs by Mankey of N.E.R.D. from *Fly or Die* (2003)

Season 11, Fall/Winter 2010

(following spread) Looks from Season 8, Spring/Summer 2009

Season 6, Spring/Summer 2007

Season 5, Fall / Winter 2007

(above and opposite) Season 12, Spring/Summer 2011

Season 11, Fall/Winter 2010

Season 11, Fall/Winter 2010

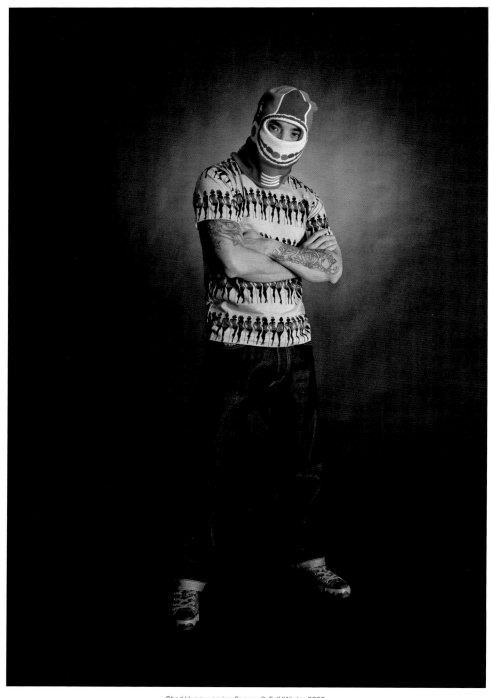

Chad Hugo, wearing Season 9, Fall/Winter 2009.

(opposite) Karl Lagerfeld, wearing Season 7, Fall/Winter 2008.

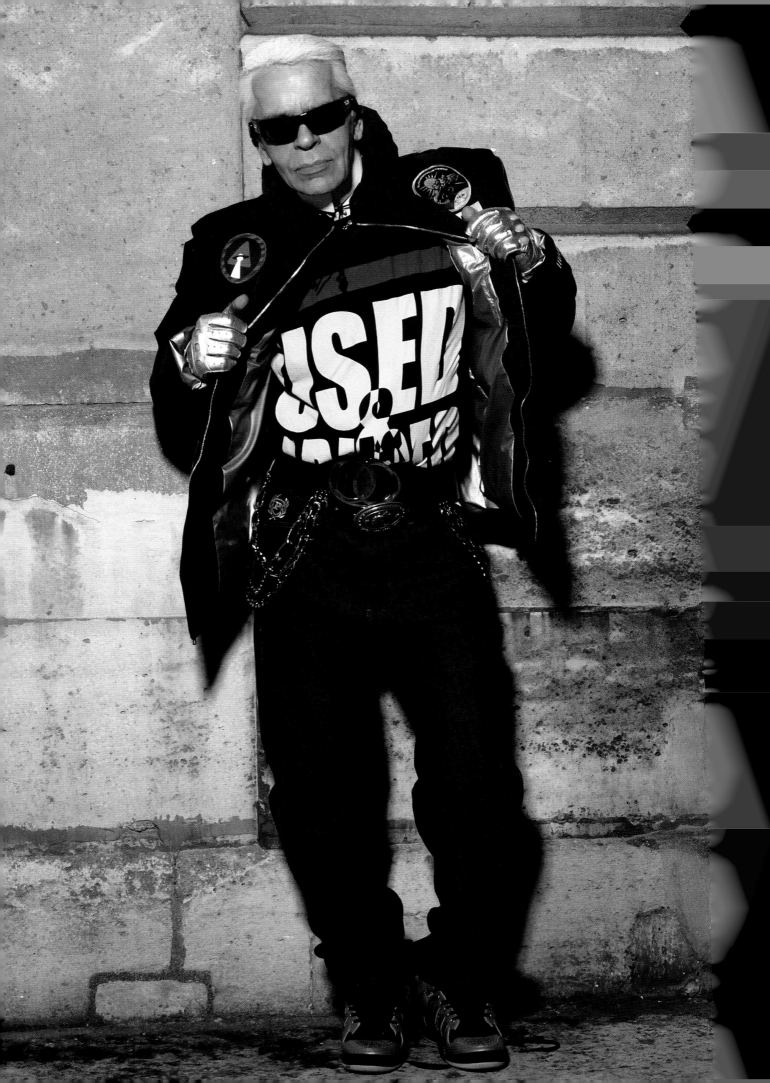

(pages 78–101) Key iconography from BBC/IceCream dating from 2003
through 2011, featuring designs by Sk8thing and
collaborations with Rockin Jelly Bean (pages 87 and 102–103)

ICECREAM

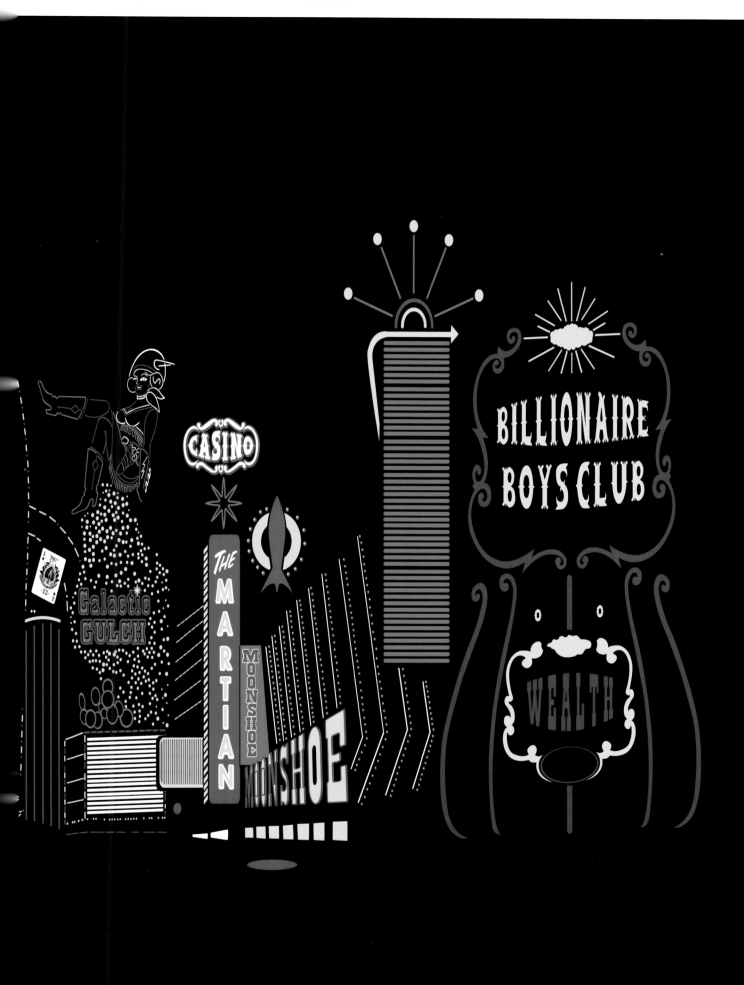

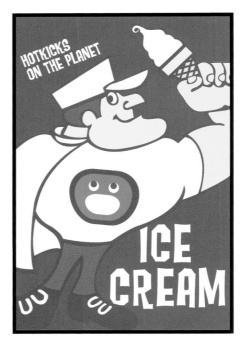

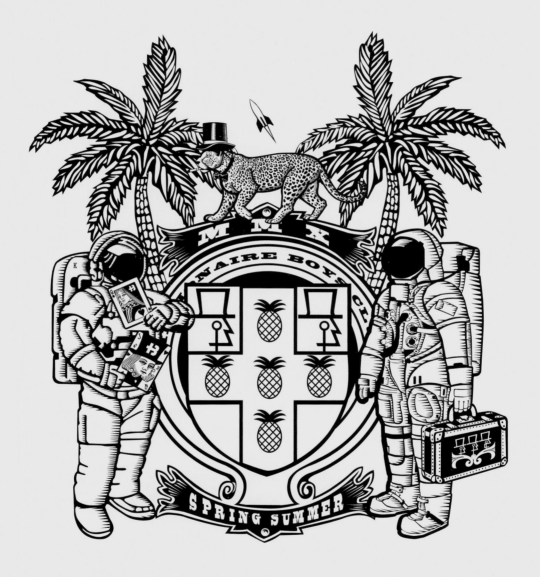

**WEALTH IS OF THE HEART AND MIND.
NOT THE POCKET**

Vignettes by Rockin' Jelly Bean, a Tokyo-based illustrator whose work
frequently appears in limited-edition street wear.

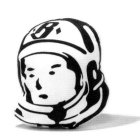

(pages 104–119)
Selected looks and
accessories designs
from Season 4, 8,
9, 10, 11 & 12 of BBC/
IceCream. These
represent a small
fraction of the items
produced for the
two labels. The earliest
date back to 2004.

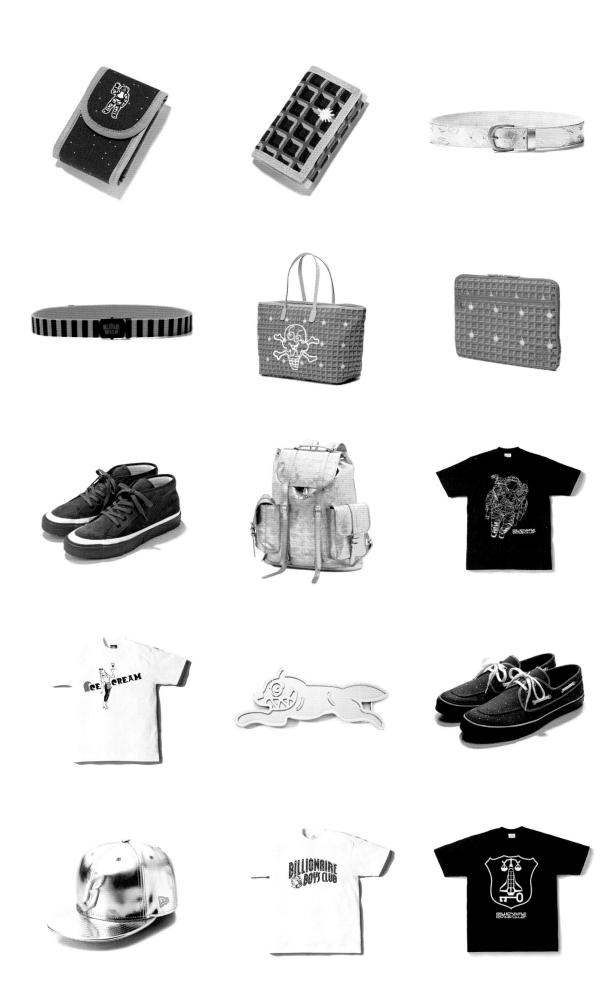

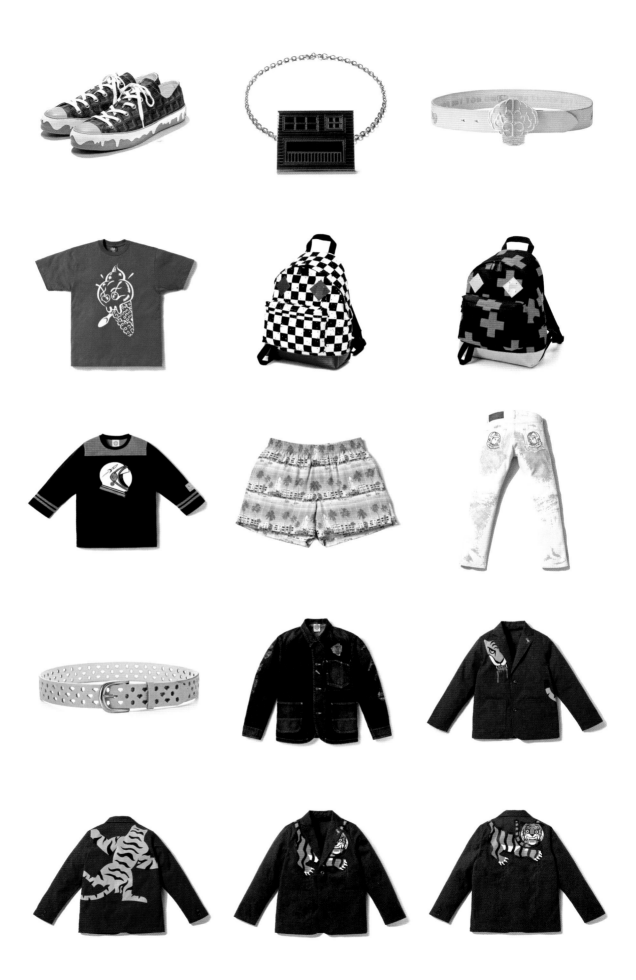

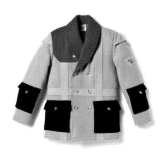 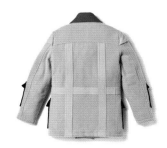 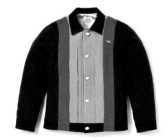

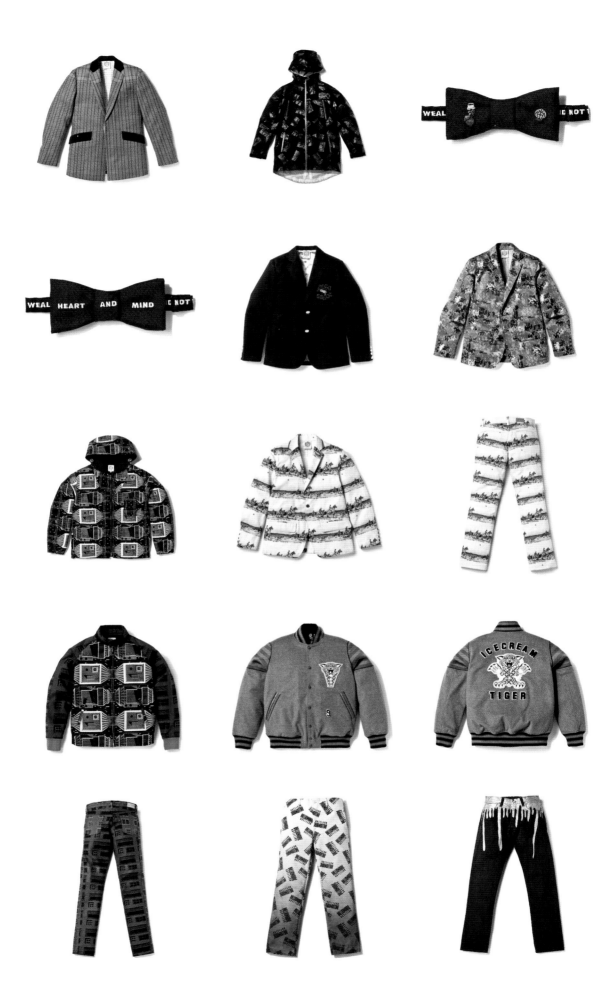

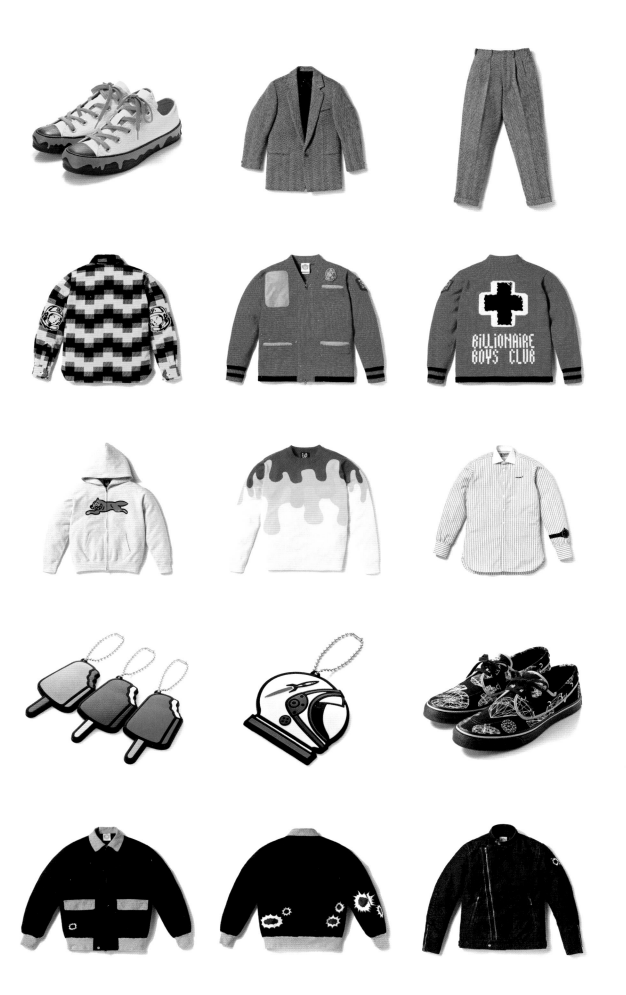

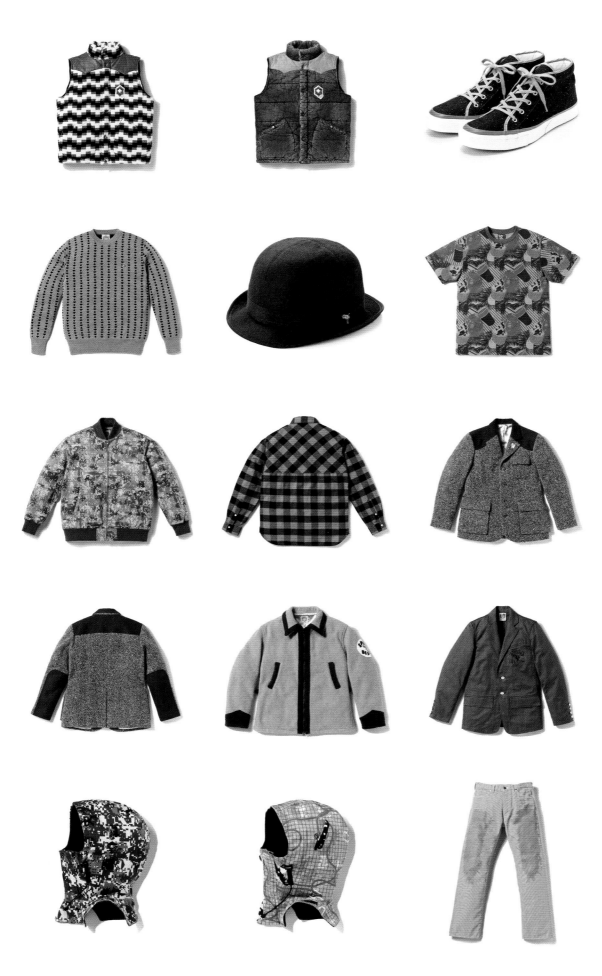

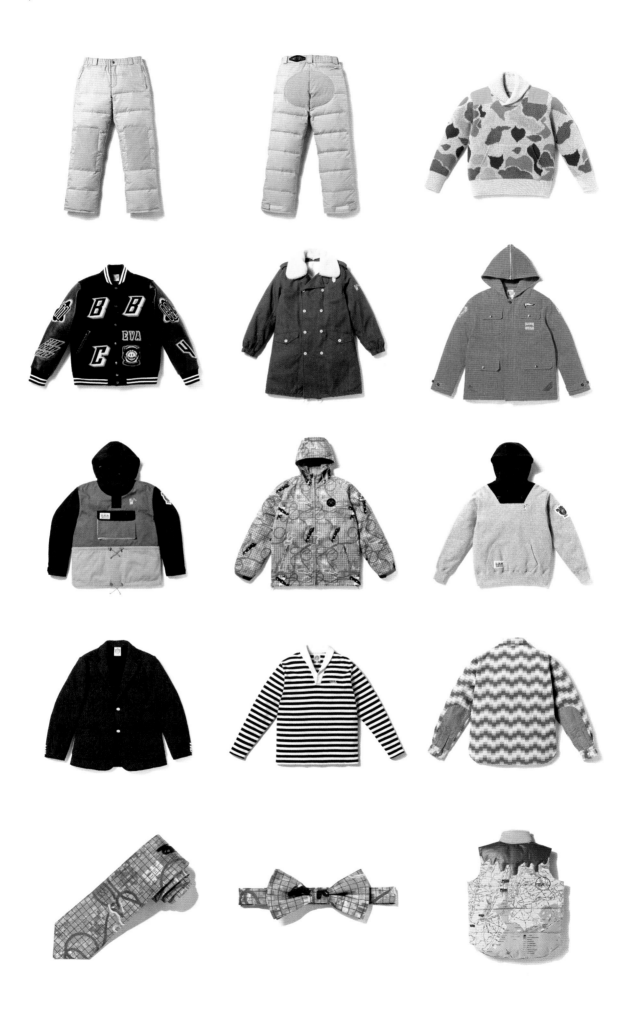

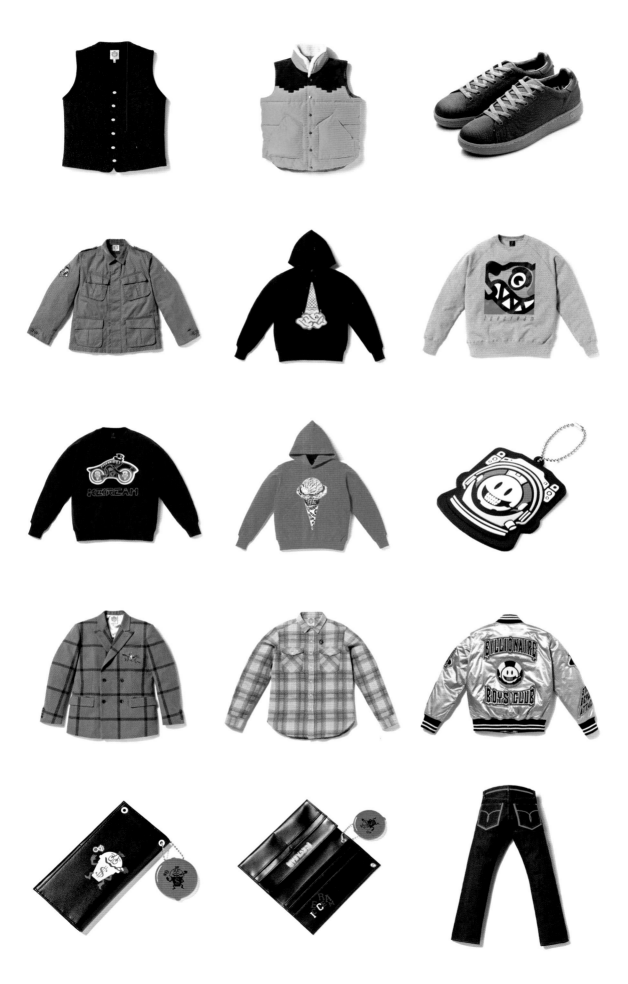

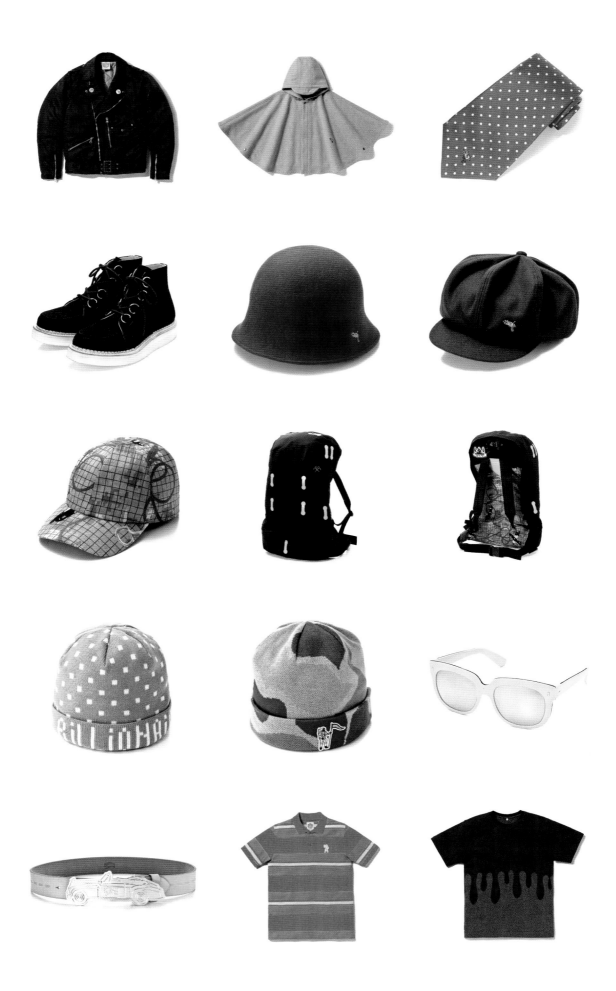

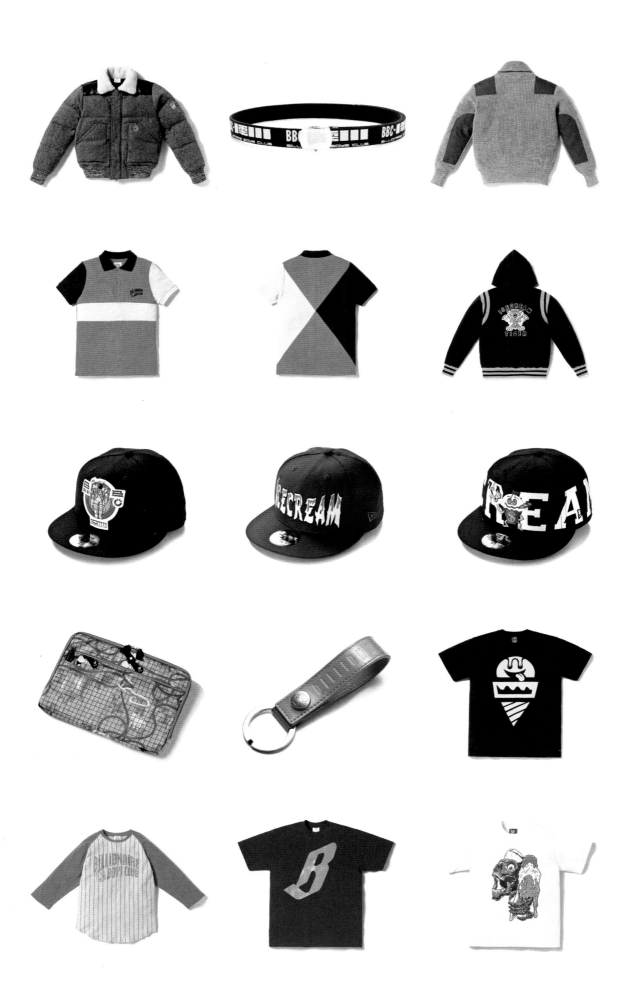

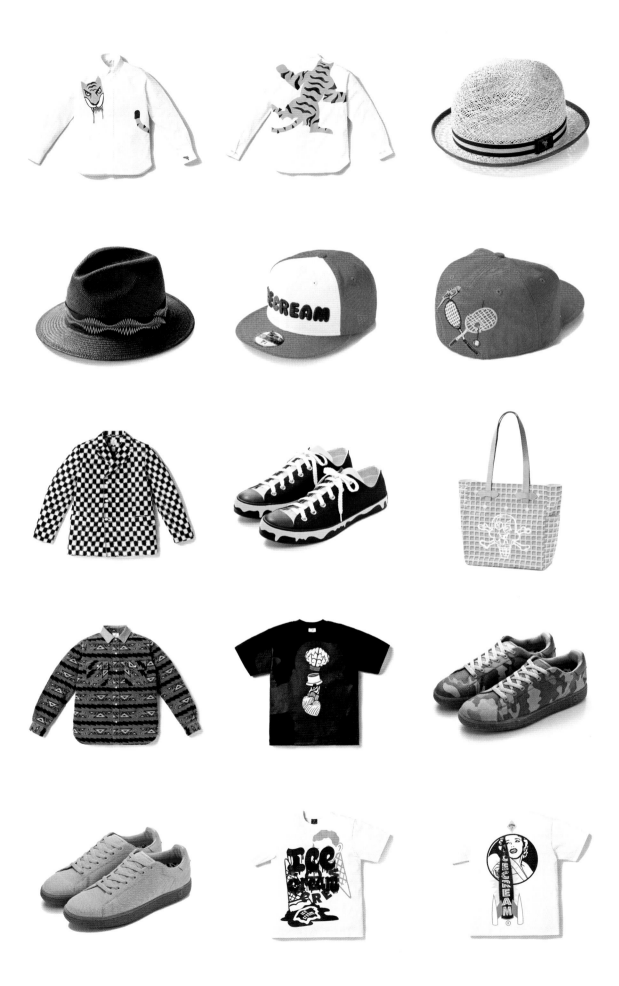

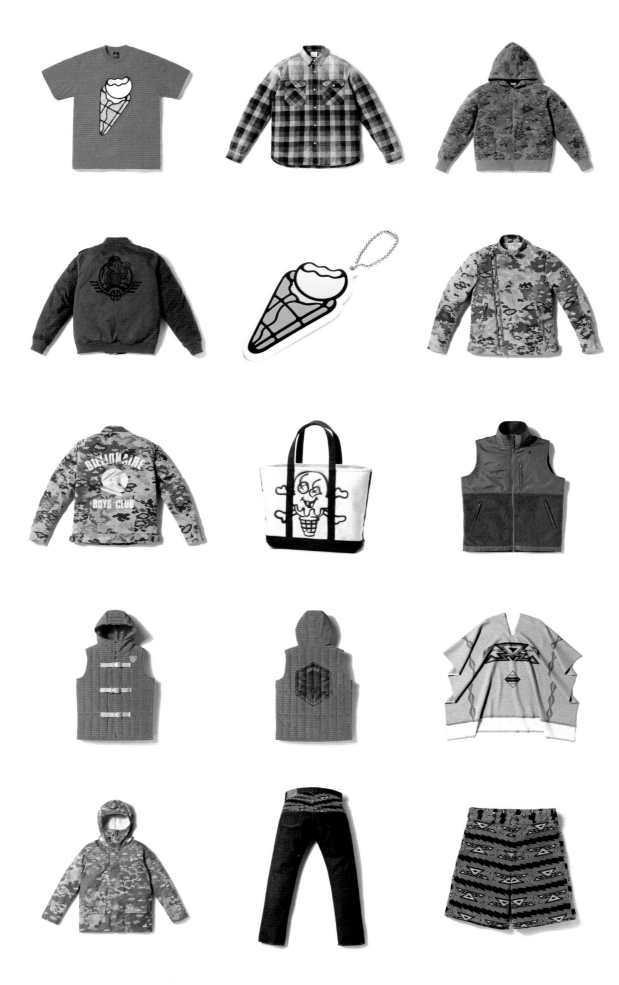

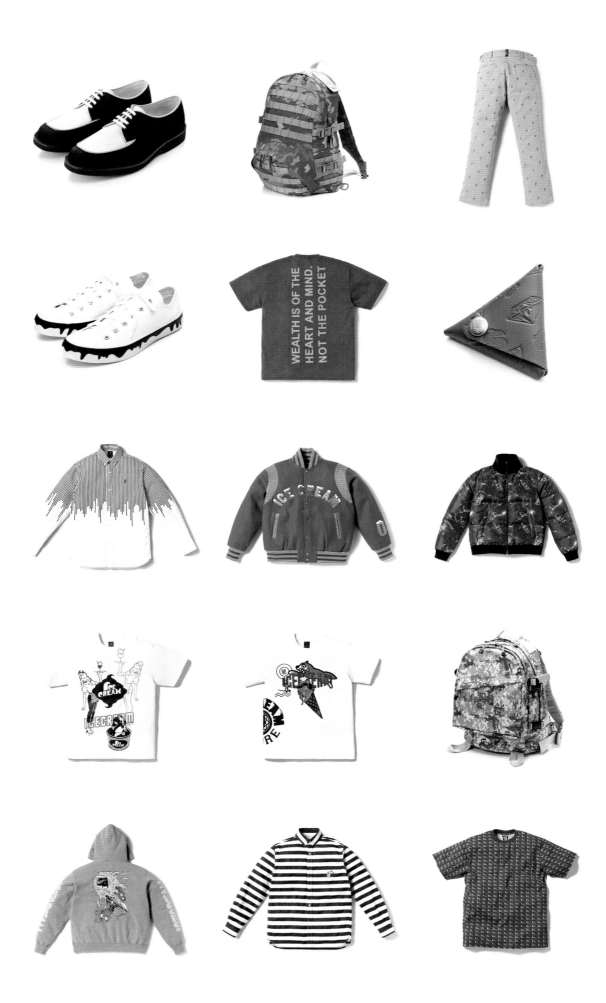

A selection of T-shirts from seasons 8–11 of BBC/IceCream. A number of designs juxtapose images of key NASA technologies and programs, and the acronyms employed by the space agency to describe them. These include MMC (Mission Control Center), EVA (Extra-Vehicular Activity) and Project FIRE (Flight Investigation Re-entry Environment), a program which studied the effects of heat on spacecraft reentering the atmosphere from low earth orbit. The black short-sleeve tee reproduces an image of the gold-plated LP record launched with the *Voyager 1 & 2* space probes, and intended for extraterrestial consumption should the craft encounter intelligent life beyond our solar system.

TO INFINITY, AND BEYOND

A conversation with Pharrell Williams and Buzz Aldrin

Scientist, astronaut, and retired Air Force colonel, Dr. Buzz Aldrin is an aeronautical pioneer and an icon of manned spaceflight. A veteran of nearly seventy combat missions during the Korean War, Aldrin received a doctorate from the Massachusetts Institute of Technology, and was later selected to the third group of NASA astronauts in 1963. He authored a number of docking and rendezvous techniques for spacecraft in earth and lunar orbit—which earned him the nickname "Dr. Rendezvous." He also developed underwater training techniques to increase the efficiency of working in zero gravity, and in 1966, achieved the first successful and sustained spacewalk of the American space program aboard *Gemini 12*. But Aldrin is most remembered for being the Lunar Module pilot on *Apollo 11*, and one of the first men to walk on the moon. The photographs that Neil Armstrong took of Aldrin on the lunar surface are some of the most enduring images of the mission, and indeed, of the golden age of American space exploration. References to Buzz Aldrin and his EVAs (extra-vehicular activities) in space abound in popular culture, from the trophy of the flag-waving astronaut awarded at the MTV Video Music Awards—The Buzzy, now called the Moonman—to Buzz Lightyear in Pixar's *Toy Story* films. An avowed space nut, Pharrell Williams has long admired Aldrin; the astronauts that populate the visual language of BBC/IceCream are in large part homages to him.

Buzz Aldrin: How's it with you, bro?

Pharrell Williams: Good, man! I'm such a huge fan. I know I tell you that every time I see you!

BA: [laughs] Well thank you, I see that you've had discussions with my old friend the astronomer Carl Sagan.

PW: No, I never got a chance to talk to him personally but I do know his daughter and I'm a huge fan of his as well. I know of his involvement with NASA early on, with the anodized gold disk that they sent up there [with the *Voyager 1 & 2* space probes in 1977].

BA: Oh yeah, well the guy who's replaced him, I had lunch with him the other day in New York. Neil deGrasse Tyson, he works at the Hayden Planetarium. He's somewhat known for downgrading Pluto as a planet.

PW: Wow! I know him too and I am a huge fan of his as well. He's on TV a lot.

BA: You bet! Yeah, he's got some great programs that go on. He and I were on a commission together for the future of the US aerospace industry. It's in question right now. There are a lot of politics involved as to just which direction we're going, in space.

PW: Well I thought you guys were headed to Mars next?

BA: Yep, that certainly has been my objective, quietly, for a long time. I think now is the time to become much more specific about it. I've got a book coming out called *The Road Map to Mars*, and in it I think we need to specify and number the different missions that will be required to qualify and develop the capability to eventually get to the moons of Mars. There are two, Phobos and Deimos, and from those we can construct the base on the surface of Mars, before people actually go there.

PW: How would that be done, and how efficient is it, seeing that the radiation is so much stronger?

BA: Well it is. Once we get outside of the radiation belts that surround the Earth. So far twenty-four Americans have been outside of those radiation belts and reached

the moon. Looking back to Virginia Beach in 1973, all of that happened before you were born!

PW: Yes!

BA: So we've got a lot of heritage to live up to but I personally think, along with many other people, that we *shouldn't* make a big, expensive effort to send NASA astronauts back to the surface of the moon. I think that robots controlled from lunar orbit can do most of the science, and then hopefully, commercial mining of the south pole of the moon for the ice crystals that are there in the shadows of the craters. That ice was deposited by asteroids and comets for millions of years, and can then be converted into water in lunar orbit. We can then separate that water into hydrogen and oxygen, and that becomes fuel. We can set up depots around the moon for people that want to go. But for the United States of America, we should bypass the moon, except for robots. We should go on to the stepping-stones, flying by comets and visiting asteroids, proving the transportation systems that are needed to get us to the moons of Mars. And then once we establish a base on the surface of Mars, then we'll send people along with the people from Phobos to put the finishing touches on the assembly—and then those

PEOPLE WILL BEGIN TO BUILD UP A SETTLEMENT, A PERMANENT SETTLEMENT OF HUMAN BEINGS THAT WILL BECOME FUTURE MARTIANS.

PW: That's amazing.

BA: So you're going to create a couple of neat rap songs about that?

PW: Uh, rap songs, rock songs, pop songs, R&B songs, maybe even country songs.

BA: You name it, you can do it huh?

PW: Yes sir.

BA: I did a rap song, sort of, called "The Rocket Experience" and I got Snoop Dogg and Talib Kweli to help with the beat and the music. I had a couple of people from my supporting team, the girls, to sing the song, along with my rapping...

PW: Oh, wow!

BA: Ha, but I don't think it's going to be a number one, and we're not going to make an album... You've

known Quincy [Jones], my good friend Quincy for a long time huh?

PW: Yes sir! He's my mentor-slash-musical godfather.

BA: Well he sure is a sound and stable person! He's had a lot of girlfriends too!

PW: Oh yeah! No one can out-party him! I think it's awesome that you explore so many worlds, and that's pun intended. It seems that we've collaborated with some of the same people, from Snoop Dogg to Louis Vuitton—

BA: (laughs) Louis Vuitton! My girlfriend Michelle and I toured the Louis Vuitton museum in Paris when we were there. We also got to the top of the Eiffel Tower to see the full moon...[*Editor's note: Buzz Aldrin participated—with Sally Ride and Jim Lovell—in Louis Vuitton's "Core Values" advertising campaign in 2009 to commemorate the 40th anniversary of the moon landing.*]

PW: I have a number of questions for you. Physics is based on the laws of each planetary body, so knowing the properties of elements and minerals on earth, would some of these exist in different form since planets [and other bodies] have their own gravitational fields? Might that affect these minerals in some of their properties?

BA: Well, the laws of physics are the same throughout the universe. The stars come in different sizes and sometimes they're in pairs, binary stars. Sometimes they're by themselves, and it looks like more and more of the stars that are in our galaxy—the Milky Way—appear to have planets going around them. When I was born we had no idea at all that there were any planets anywhere else in the universe other than the nine planets, including Pluto. Since then we have discovered hundreds of planets around other stars and they're not close, the closest star to us is Alpha Centauri [...] From the Big Bang, the universe is expanding outward for over 13 to 14 billion years, and in all of that time certain stars have had the right kind of condition to have planets around them. Our galaxy is a hundred thousand light-years across in diameter, and that's enormous in our standards but there are billions of other galaxies and the only way we know about them is that the light from those other galaxies and other stars as they're expanding outward, the speed of light sends the light from those stars everywhere and we happen to receive them and it comes to us at, uh, 186,000 miles a second—

PW: That's right, 186,000 miles.

BA: We get to know what happened in the rest of the universe a long time ago when the light departed wher-

(left) This wax candle cast of Pharrell William's right hand, frozen in the Vulcan salute from Star Trek, was manufactured in limited quantities by Atelier WM, a Paris-based studio founded by Marianne Muller and Wakey, a graphic design practice founded in 2007 by Alexis Atger & Cyril Galmiche. The 2008 collection featured six distinct hand gestures in a variety of colors and was sold at Colette and the Palais de Tokyo.

(right) A close-up view
of an astronaut's boot
and bootprint in the
lunar soil, photographed
with a 70mm camera
during the *Apollo 11* lunar
surface extravehicular
activity (EVA).

ever we're looking at, and has traveled the universe, and has finally reached our eyes. So we get to see a story that unfolded far away from us, before we were ever on this planet. It's really mystifying to think of the enormity of the universe and the rather small place that we occupy in one of those billions of galaxies. It's sort of an average place, not near of the center, and not near of the edge—but on clear nights we can go out and look at the kind of misty pattern of the Milky Way galaxy which is comprised of billions of stars just like our own sun.

PW: Yes, light traveling at 186,000 miles per second, that's the reason why some of the stars that we see, or some of them that they have been able to find, have probably long since burned out. But the light they emitted is just taking the time to travel this way.

BA: Yeah, they may not exist anymore. But all we can do right now at the limit of the speed of light is to send a message via radio waves that travel the same speed as light, and say to that star way out there, "hey you guys, are you still there?" And then thousands

(below) Buzz Aldrin
in front of the *Eagle*
Lunar Module.

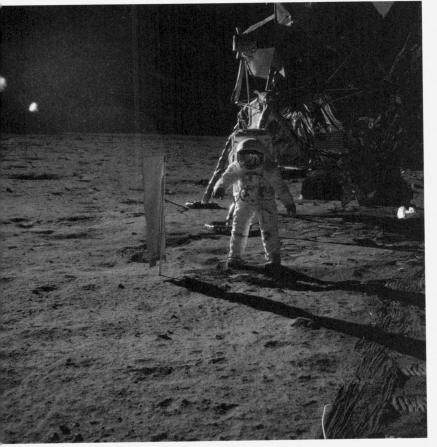

of years in the future, somebody here on earth will get an answer "yeah man, we're still here. What do you want to know about it?"

PW: [laughs] That would be awesome. You know the funny thing is that was going to be my next question. Were we to say to ourselves, what if there are only a billion other galaxies, and then within those galaxies there are a hundred—and we know it's far more—but a hundred solar systems. So that's a very modest equation, not including Drake's equation but...

BA: Oh you know Drake, huh? [Astronomer Frank Drake]

PW: Yes sir. But not including Drake's equation let's say that there are 900 billion planets, I certainly think that it would be crazy to expect that there are no other life forms than our own.

BA: I think you're very good in your probability guesstimate. We just don't have any evidence at all, and as Carl Sagan said, "extraordinary claims require extraordinary evidence." That means if somebody says, "hey, I saw a UFO and it came from outer space," that's an extraordinary claim, and it requires a good bit more than just somebody saying "I think that's what happened." There are many, many things that we don't know, there is a whole world of knowledge out there that we don't know about yet. Look at the magical things that our children's children and all those future generations will have to study and learn about, and hopefully in the process, conditions here on earth will improve for everybody else.

PW: I think if the world knew the vastness that exists beyond our solar system I think that they would begin to behave a little bit differently. But there is not enough respect for space and space exploration, and what is out there. Because if there were, we certainly would not be blowing each other up and creating things that would destroy us, if we really knew what was out there. And I think, even beyond finding other beings, just seeing the vastness of what exists, how could you fight? ...and over what? And why would you not want to help someone else? When you were a child, learning about the nine planets—or eight as Neil deGrasse Tyson says—if you look at it, you were only really taught about the planets and their properties. You don't understand that you're basically just looking at this two-dimensional image on a piece of paper, in a book. If our government and other respected governments around the world were to spend more time taking these

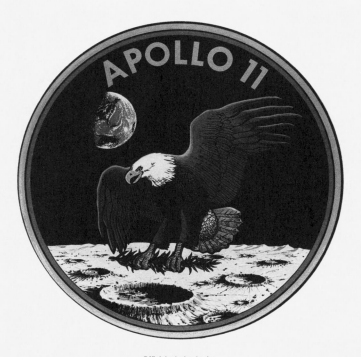

Official mission badge,
Apollo 11, 1969.

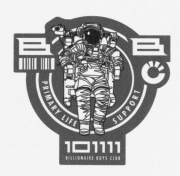
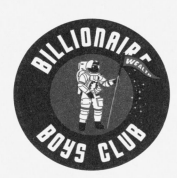
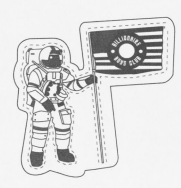

The iconography of BBC/IceCream draws a lot of its appeal
from images of manned spaceflight, and the photographs of Buzz Aldrin on his spacewalk and
on the moon (opposite, taken by Neil Armstrong) inform many key graphics.

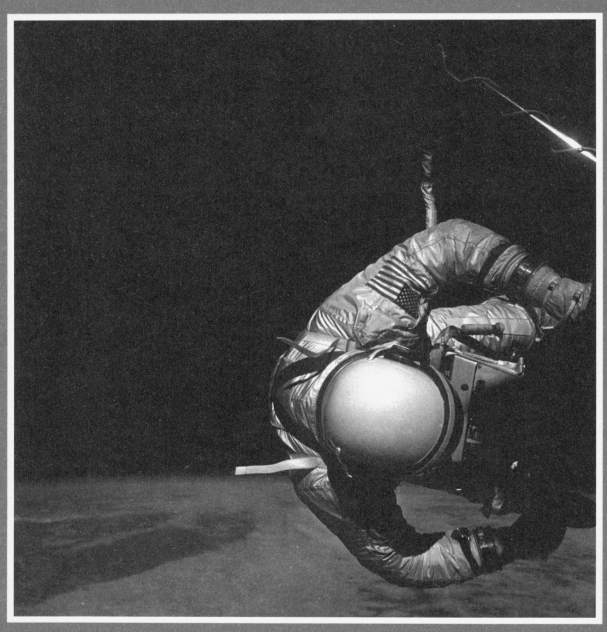

Buzz Aldrin, pilot of the *Gemini 12* spacecraft, performs extravehicular activity (EVA)
during the second day of the four day mission in space, in November 1966.

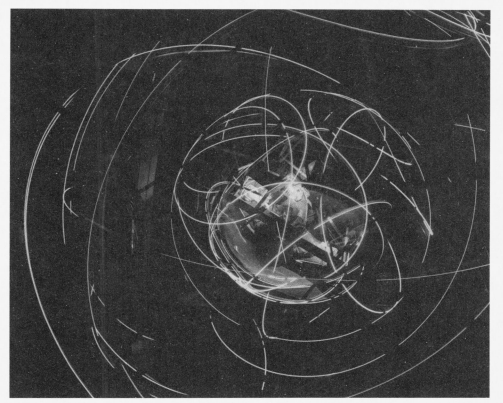

(above) This device
was formally known
as the MASTIF (Multiple
Axis Space Test Inertia
Facility) and was
built in 1962 at the
Lewis Research Center–
now the John H. Glenn
Research Center–
and was designed to
train astronauts
to regain control of a
tumbling spacecraft.

(below) The mission
badge worn by
Buzz Aldrin and James
Lovell on *Gemini 12*.

children to see what's really out there, we would have much more respect for our home, because it's the only one that we have, at least currently.

BA: I couldn't agree with you more. Education is really the key to progress, and progress is what raises the standard of living. And cooperation allows us to increase the quality of life throughout the world. It's out of balance because of the egos of certain people that want to be powerful and control other people. It's been that way ever since the earliest tribes got together for protection. It will probably be that way well into the future but it takes education to improve the cooperative spirit. We should compete to learn more about the world around us, and what makes it work so that we can elevate the living conditions of everybody. We really need some inspiration as to what the future might be. I think that's where space exploration comes in, the possibility of sending robots out to the far reaches of the solar system. And then, when it's appropriate we'll be able to send human beings out there to see what it's really like, and send back those stories, improve our science, technology, engineering and math... Those are the things that really improve education throughout the world. I think that's what our future is all about.

PW: That would be amazing... What is the closest thing, what anomaly have you witnessed yourself or that you've heard of that sounded compelling as evidence, in terms of life elsewhere?

BA: Well I don't know if there's life elsewhere, but that's just me. But there were two experiences that I had that no one else had observed before I reported them. The first was when I was making a very successful space walk outside the *Gemini* spacecraft. I was the first astronaut to train underwater in a swimming pool with a spacesuit on to simulate the conditions of floating around in zero gravity. It's really the same conditions, of falling in orbit that the spacecraft has, so we sort of float relative to it. When I rubbed my two fingers, my thumb and finger together in the space suit, I was able to see little sparks or a glow between my two fingers, and that was in space where there is no air. That was judged to be a very unusual observance of static electricity that occurred in a vacuum. The second observation that I made was going to the moon and coming back, when we turned the lights out and blocked off the sun from coming into the spacecraft I was able to see flashes of light and streaks in the darkness inside the spacecraft and the other two guys, Neil Armstrong and Mike Collins, didn't say anything about it. But I'd asked them to look the last night as we're coming back to earth and Mike said that he didn't see anything. But Neil said he saw about a hundred of the flashes. It turned out in the next flight that the crewmembers going to the moon were able to see those same flashes, the sparks of light, but that they reported that they could see those even with their eyes closed. In other words, the eyelids were closed so that the eyes were not seeing outside the body what was going on inside the spacecraft, but the flashes were indeed inside the eyeball of the crewmember, and this was quite an extraordinary observation. It was explained by the very, very tiny but massive particles that are out in space and penetrate the spacecraft and penetrate the human body. They go through the eyelids, hit the retina, and cause a discharge. So that was another Buzz Aldrin original observation.

PW: Are they, by any chance, Z particles?

BA: Yeah, they are high Z particles. When they hit

LINE-OF-SIGHT GUIDANCE TECHNIQUES
FOR MANNED ORBITAL RENDEZVOUS

by

Edwin Eugene Aldrin, Jr.
Major, USAF

B.S., United States Military Academy
(1951)

SUBMITTED IN PARTIAL FULFILLMENT
OF THE REQUIREMENTS FOR THE
DEGREE OF DOCTOR OF SCIENCE

at the

MASSACHUSETTS INSTITUTE OF TECHNOLOGY
January, 1963

Signature of Author
Department of Aeronautics and
Astronautics, January, 1963

Certified by
Thesis Supervisor

Certified by

Certified by

Certified by

Accepted by
Chairman,)Departmental
Graduate Committee

(left) The cover page
of Buzz Aldrin's doctoral
thesis, submitted
to the Massachusetts
Institute of Techology.

the stepping-stones a pathway to fulfilling my *Road Map to Mars* and hopefully we'll be able to gradually execute some of the stepping-stones I put forward in that book. So that maybe by the time of the fiftieth anniversary of our landing on the moon a president will be able to say something like what our President Kennedy said, that he believes this nation should send people to the planet Mars and to set up permanent occupancy there within two decades. And if he says that in 2019, then we'll be able to have human beings on Mars before 2040.

PW: I have one last question for you: Is it possible to see the American flag and the moon buggy from this planet? Is it possible with a telescope?

BA: ...I don't know about the flag, all of the flags tipped over because of the rocket exhaust when the ascent stage, the upper stage of the landing craft lifted off, it sent out a lot of rocket blast, put a lot of dust on everything, and tipped the flags over. The orbital pictures we are now getting [from the *Lunar Reconnaissance Orbiter* launched by NASA in 2009] can show the tracks of the rover, and probably with considerable magnifications can probably show the rovers that existed on the missions of *Apollo 15, 16* and *17*.

PW: Wow...

BA: We just took a peek, and you can see the pathway that Neil Armstrong took about 100 feet back behind where the spacecraft was, to look at the crater that we had to fly over and there's this dust-disturbed trail. It's observable now from some of the pictures taken by the *Lunar Reconnaissance Orbiter* that's been sending pictures back from the moon.

PW: I need to get myself a high-powered telescope so I can look at some of those things.

BA: I don't think you can get one powerful enough to take the same resolution which you can get from satellite with a powerful camera orbiting around the moon and then sending back the pictures to us, but more power to you. The bigger the telescope, the more you can see. Let me tell you Pharrell this has been one of the more exciting and enlightening conversations I've had with a real rapper and a producer of many, many musical milestones. I want to thank you very much for asking me to join you in this discussion.

PW: Thank you so much! I have the utmost respect for you and everything that you've done to not only further this country's endeavor to explore, but for the whole planet. There is only one Buzz, and there wouldn't be a Buzz Lightyear without you.

BA: I think you're right, I just think that Pixar needs to recognize that a little bit more, but I thank you very much! I've enjoyed this very much, Pharrell and I send you many, many good wishes for good fortune in the future. Say hello to Quincy when you see him.

PW: I shall. Thank you very much!

your brain they usually cause the destruction of a brain cell. Maybe what we need to have is a football helmet made out of lead so it would absorb those particles. We need a lot of research about radiation, about long-term exposure to zero gravity, and its effects on our bones and muscles. And we're gradually learning more and more about it, so I think we will have the ability to spend a long time outside the radiation belts around the earth that protect us, and to spend long periods without gravity to work against the muscles and bones. In the next twenty or thirty years I really think we'll be able to send the first human beings that will begin to settle on Mars and become the first settlers on another world.

PW: Wow, that's going to be amazing. I know we are going to do it, that's going to be amazing. If I read it correctly I think that bill is passed already, at least for the exploration of Mars. Or am I wrong?

BA: Well we need a lot of government action to begin to recognize what is the most prudent course for the United States. I have a very strong feeling that the United States should lead in these international cooperative ventures at the moon and building the base on the south pole of the moon for other people, and occasionally for commercial people from the US that will be mining the south pole, while China and India and other nations go and send their first human beings to walk around on the surface. We should be preparing

Six aerospace-themed
T-shirts from BBC/
IceCream exhibiting
Pharrell Williams'
obsession with NASA
and manned spaceflight.
From the familiar to the
arcane, these examples
depict everything
from Project Mercury
to the Hollow Cathode
Assembly (HCA) power
processing units in
the plasma generators
that propel the Inter-
national Space Station.

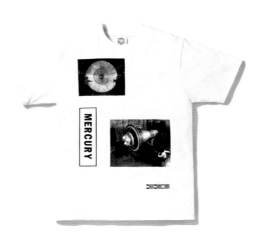

FROM THE MOON TO THE EARTH

by Masamichi Katayama

I was first introduced to Pharrell Williams through NIGO®. I've had a relationship with Nigo for a long time through the interior design projects for the BAPE STORE®, but this time I was both extremely honored and nervous to be involved in a project in which Nigo took on the directorial reins to create the space for a brand produced by Pharrell. I was well aware that both of them have a deep understanding of design, so I felt I needed to reset the approach I previously used and presented a new concept altogether. Billionaire Boys Club (BBC) and the IceCream Store are two spaces with entirely different concepts, but both utilize a 2-D expression within a 3-D space, creating a provocative experience that feels neither ordinary nor extraordinary, as if you have stepped inside the world of *manga*. Since we eschewed the option of expressing through textural means, we needed to conceive of a method of expression on a particularly sophisticated level.

For the IceCream store, we interpreted the form of a ubiquitous ice cream shop through graphical designs, whereas for BBC we embraced the crazy visual expression of walking on the surface of the moon. These were visceral expressions of what I felt after seeing Pharrell's completed designs; they were inspired by the courage with which he takes on new challenges and his refined and crazy sense of humor.

For the project in Hong Kong, I got the idea for an Oreo sofa [which later mutated to resemble a Klondike ice cream sandwich, and was imported to the West Broadway store in New York City]. This further intensified the element of humor in the space and I vividly remember how it helped propel the ideas I had in mind.

The BBC and IceCream stores are unique and special projects that are no doubt some of my most representative works. Pharrell is not only a superstar in the music industry, but he is also a multi-creator I admire who shines in various areas spanning from art to design. I sincerely hope we will be able to work on a project together again in the future. When it happens, I will have an idea for a new, genre-defying space ready for you.

(right) A close-up view of a large boulder in a field of boulders near the rim of Cone Crater, which was photographed by the *Apollo 14* astronauts during the mission's second extravehicular activity in February 1971.

Masamichi Katayama is the founder and lead designer of Wonderwall, an interdisciplinary firm based in Tokyo. This text was translated by Marie Iida.

TOKYO

(pages 132–135) Interior view of the BBC/Icecream store, designed by Masamichi Katayama of Wonderwall. Located in Harajuku, the store was open from 2005–2011. A new Tokyo store is planned for 2013.

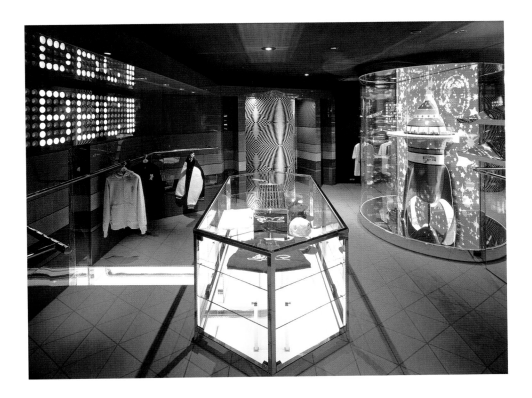

HONG KONG

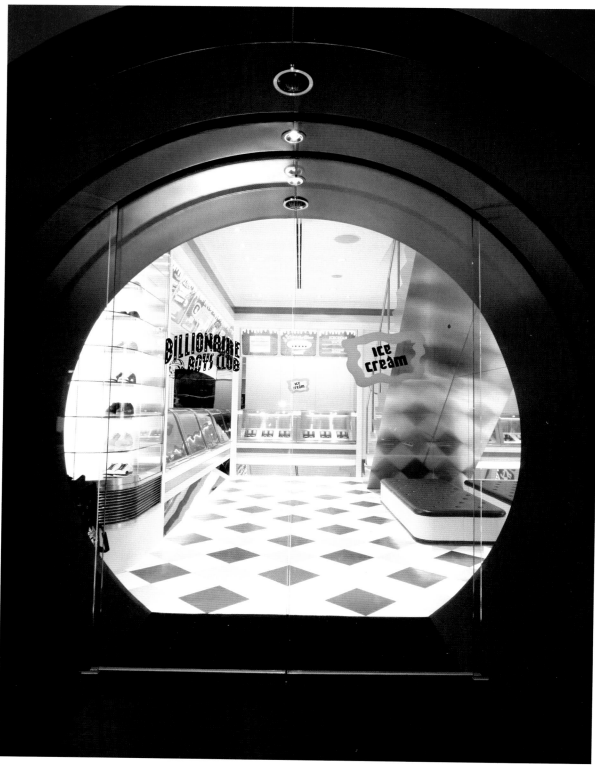

(opposite and above) Exterior and interior view of the Hong Kong store in Central, which opened September 2007.

(following spread) A view of the *Gemini 9* spacecraft taken by Eugene Cernan in June 1966,
during his extravehicular activity (EVA). His umbilical and spacecraft are visible though he is not.

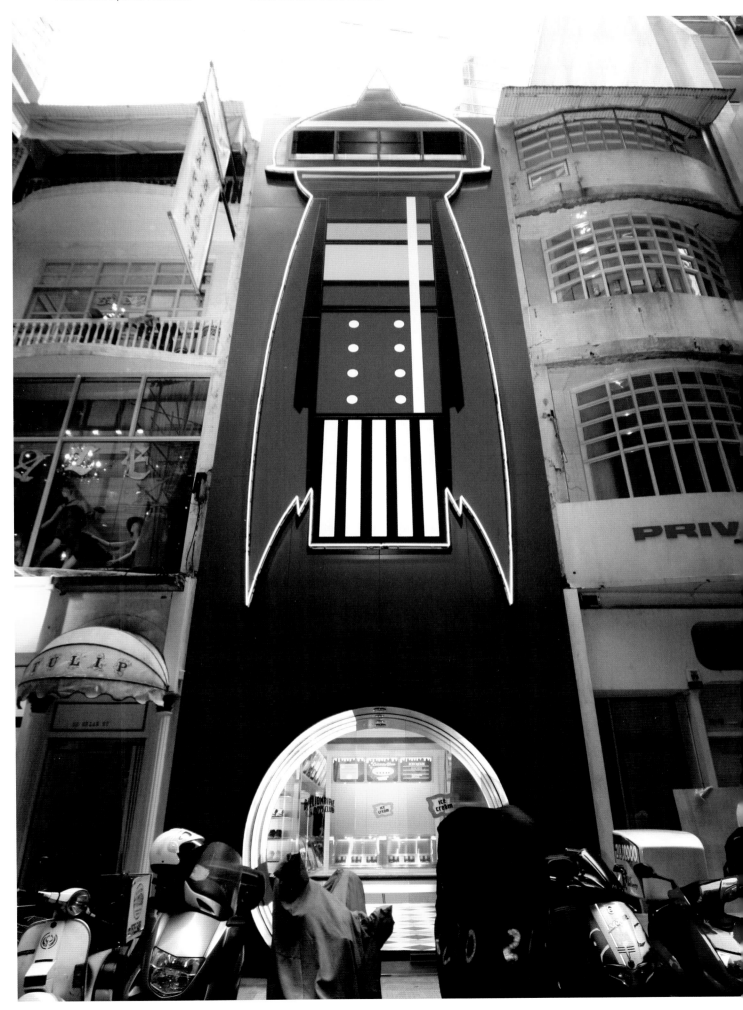

(opposite and above) Interior view of the Hong Kong store
in Central, which opened September 2007.

The store in Hong Kong featured the first application of a lunar landscape adopted from aerial
photographs taken by probes and by astronauts on the *Apollo* program.

The ceiling of the store mimics the nighttime sky.

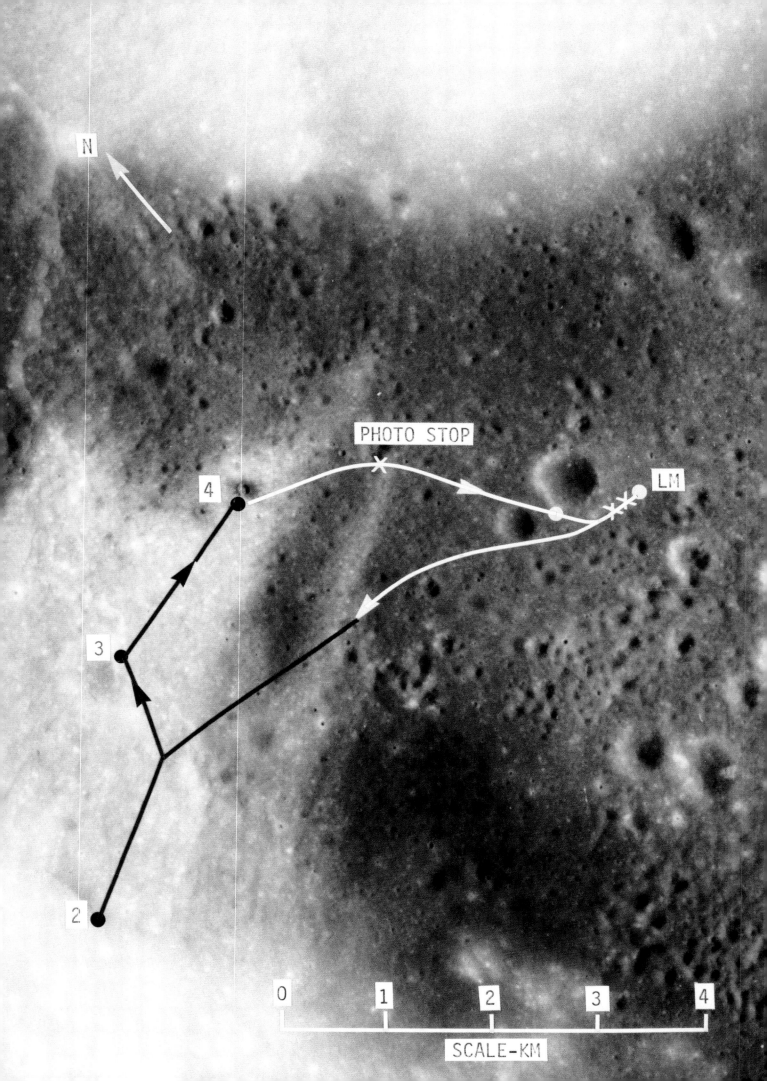

N

PHOTO STOP

LM

4

3

2

0 1 2 3 4

SCALE-KM

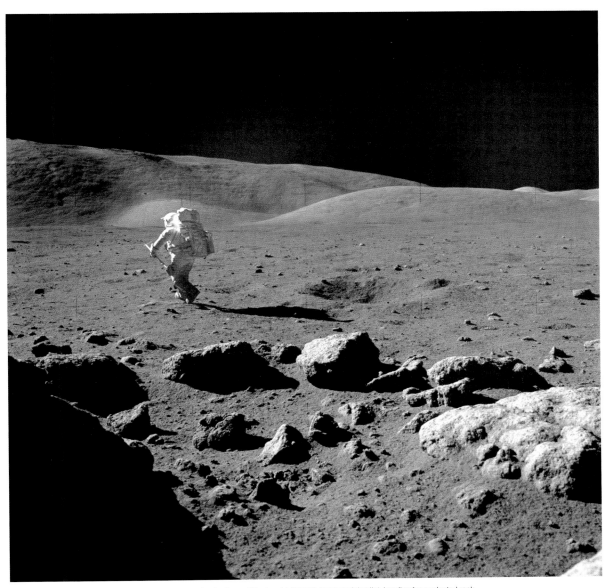

(above) The image is of astronaut Harrison H. Schmitt, lunar module pilot, heading for a selected rock
on the lunar surface to retrieve the sample for study. The action was photographed by *Apollo 17* crew commander,
astronaut Eugene A. Cernan, on the mission's second extravehicular activity (EVA), December 1972.

(opposite) A vertical view of the *Apollo 17* landing site in the Taurus-Littrow area of the lunar nearside, with an overlay
showing the Lunar Roving Vehicle traverse proposed for the second extravehicular activity during the mission.
The scale at the bottom is measured in kilometers. This and related images provided inspiration for the store's circulation.

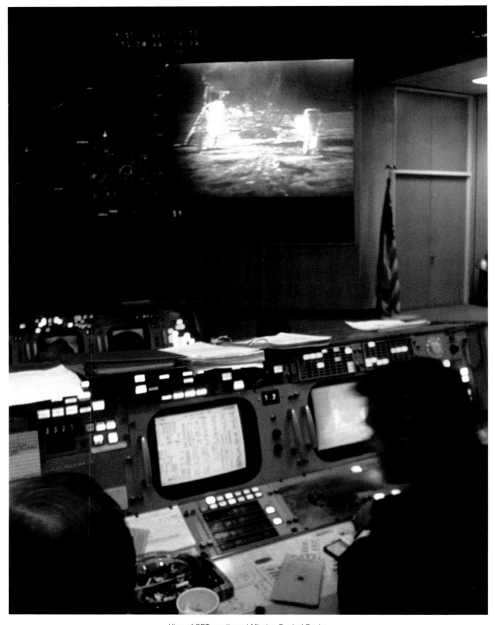

View of CRT monitors at Mission Control Center
during the *Apollo 11* mission, July 1969.

NEW YORK

Exterior view of the New York store, designed also by Wonderwall
and opened November 2007.

(above) View of the barrel vault of the main retail floor.

(opposite) Penetrating 25,000 light-years of obscuring dust and myriad stars, NASA's Hubble Space Telescope has
provided the clearest view yet of the Quintuplet Cluster, one of the largest young clusters of
stars inside our Milky Way galaxy, located less than 100 light-years from the very center of the Galaxy.

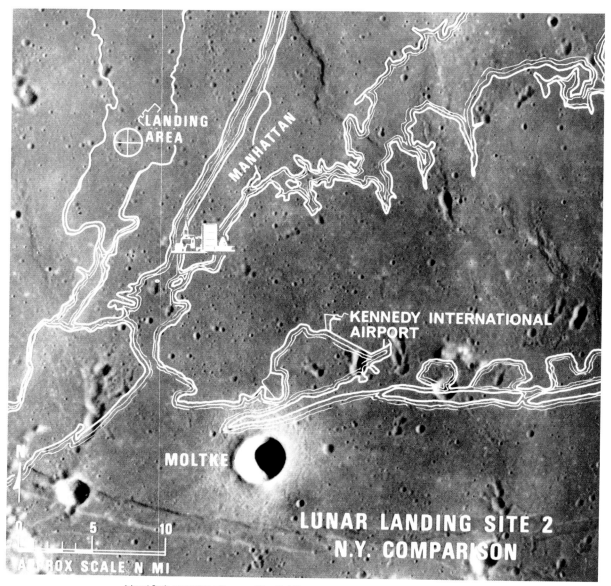

(above) Scale comparison with a map of New York City overlaid over a composite photo of Tranquility Base,
the landing site of *Apollo 11*'s lunar module, July 1969.

(opposite) Interior of IceCream retail floor, New York store.

(following spread) The *Apollo 16* Lunar Module *Orion* in early liftoff phase is featured in this lunar scene at the Descartes landing site. The still picture
is a reproduction taken from a color television transmission made by a TV camera mounted on the Lunar Rover.

LOUIS VUITTON

Pharrell and NIGO ® (of *A Bathing Ape®) were invited by Marc Jacobs to design a collection of sunglasses to complement Louis Vuitton's Spring/Summer 2005 Women's Prêt-à-Porter. Presented in Paris in October 2004 and officially launched in New York in May of the following year, the "Millionaire" line became instant collectibles, and influenced Louis Vuitton's approach to eyewear. Originally issued in red, black and white frames, they were reissued in 2007 with two additional colors: purple and turquoise. Intended for both women and men, the glasses feature a fully-integrated hinge system inspired by the S-Lock, a hardware element used to secure the malletier's leather goods.

On his own, Pharrell's subsequent collaborations with Jacobs include the soundscape for Vuitton's Spring/Summer 2006 Women's Prêt-à-Porter show in October 2005, followed by the "Blason" collection of jewelry, which was unveiled to the public in 2008. Pharrell describes his experience working with Vuitton, and in particular, the "Blason" line, which constitutes his most extensive collaboration with the brand to date.

I've gotten to know Louis Vuitton quite well now. I attend the shows, I've done an ad campaign, I've done two collaborations. What I really like about [Louis Vuitton] is that, though it's a company with a very rich history and lots of tradition, it's very open to new ideas. You can play around with it, have fun—the way Marc [Jacobs] does with the bags and his collaborations with artists. I think that's great. For me, Louis Vuitton is very fun and very modern.

I so much enjoyed designing the "Millionaire" glasses that I said to him [Jacobs] that I would like to collaborate on something else, and he suggested I create a jewelry line with Camille Miceli, who at that time designed Louis Vuitton's costume jewelry as well as a number of fine jewelry pieces. It was a natural choice for me. I'm very interested in jewelry—I love to wear it, I love to collect it. Marc knew that, which is why he suggested I work with Camille. It took us about two years. We'd been meeting up regularly, in the US or in France depending on our schedules, throwing ideas at each other, and moving the project forward.

I really got inspired by *The Da Vinci Code* and the idea of freemasonry and secret societies in general. That was basically the starting point for the "Blason" theme. Camille and I went all around Paris to research ideas, and in particular we visited the Louvre, where I was impressed by Jacques-Louis David's *The Coronation of Napoleon* (1807)—that gave us the idea for the "Crown" theme. We also looked at a lot of books, including ones on the Art Deco period, which I was particularly interested in, and on ethnic jewelry.

There are four themes in all: "Blason," "Crown," "Rock on Cherub" and "Gracious Graphic." "Blason" was inspired by coats of arms and secret symbols. The key piece is an outsize yellow gold signet ring that you can flip around; there's a Louis Vuitton coat of arms engraved on one side, and glittering pavé diamonds on the other. It's like, "Now you see me, now you don't!"

The "Crown" story is a fun way to play with the LV initials. The standout piece is a one-meter long necklace, which is just fabulous. The whole story is very fun, very French, very extravagant—very Louis Vuitton.

The "Rock on Cherub" theme is more personal, because it was inspired by a tattoo of an angel that I have on my neck, but it also ties in with all the beautiful churches and museums Camille and I visited while we were researching the project. It's kind of baroque, whereas the "Gracious Graphic" theme is much more graphic, much more pared down. We reinterpreted the LV initials to make a diamond shape in white gold and yellow gold. The idea came from the history of Louis Vuitton, and from all the wonderful designs they created during the Art Deco period, like the Milano toiletry case they have in the Museum of Travel.

There are 26 pieces in all. Obviously, most are for women, but we do have a few pieces for men, in particular a smaller version of the "Blason" signet ring, cufflinks, and a breathtaking "Blason" belt buckle with pavé sapphires.

I wanted to work with Vuitton because they take a regal approach in designing their products, and they love it. I learned so much and it is a wonderful experience to collaborate with them. I feel fortunate to be a student in the fashion world and have the opportunity to work with the

(left) Blason Bracelet in yellow gold, 2008/2009.

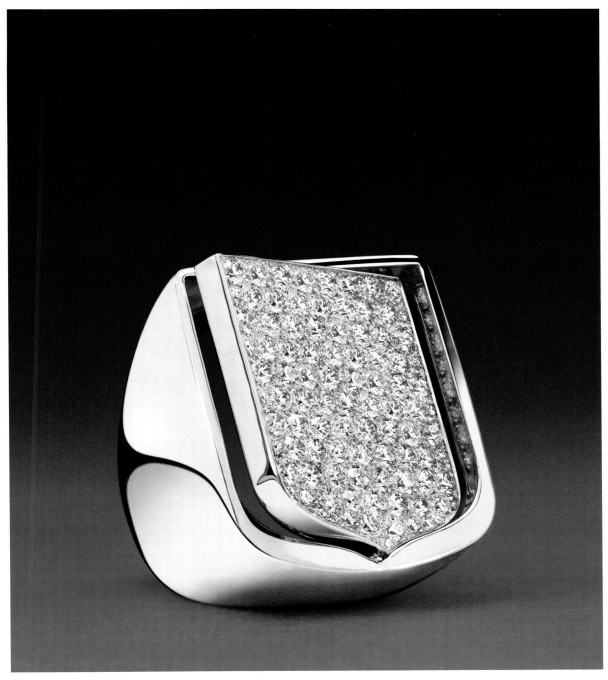

Blason large ring in yellow gold and diamonds.
The crest pivots to reveal two distinct faces, 2008/2009.

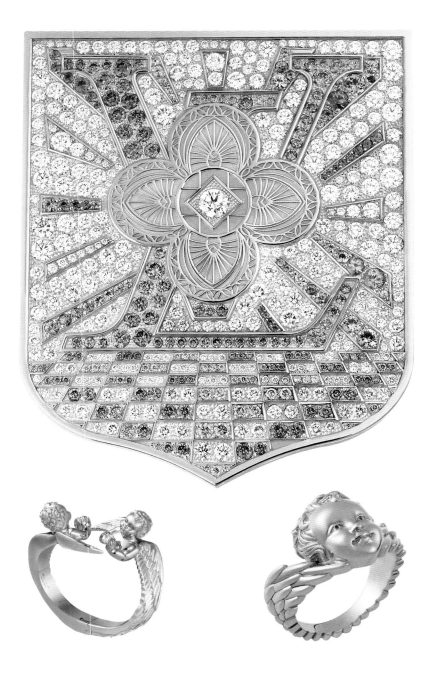

Detail of Blasson belt buckle in yellow gold, set with white and brown
diamonds, rubies and blue and yellow sapphires; Rock and Cherub Bracelet
and Ring, both in yellow gold and white diamonds, 2008/2009.

Pharrell and NIGO® designed the "Millionaire" Sunglasses for Marc Jacobs for
Spring/Summer 2005. The red, black and white frames were released in 2005. The purple and
turquoise were reissued in 2007.

(following spread) Louis Vuitton Malletier, advertising campaign Fall 2006
by Mert Alas & Marcus Piggot, featuring Pharrell Willams in Fall/Winter 2006–2007 Prêt-à-Porter,
with Louis Vuitton jewelry and flanked by Alzer suitcases and the Carryall Shoes bag.

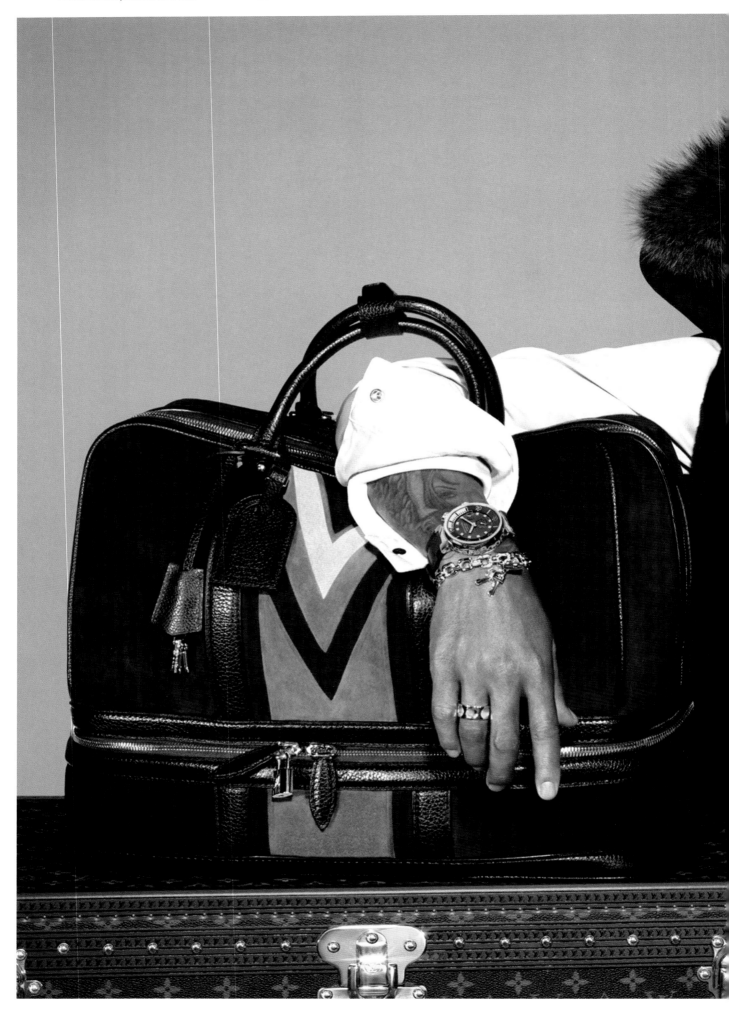

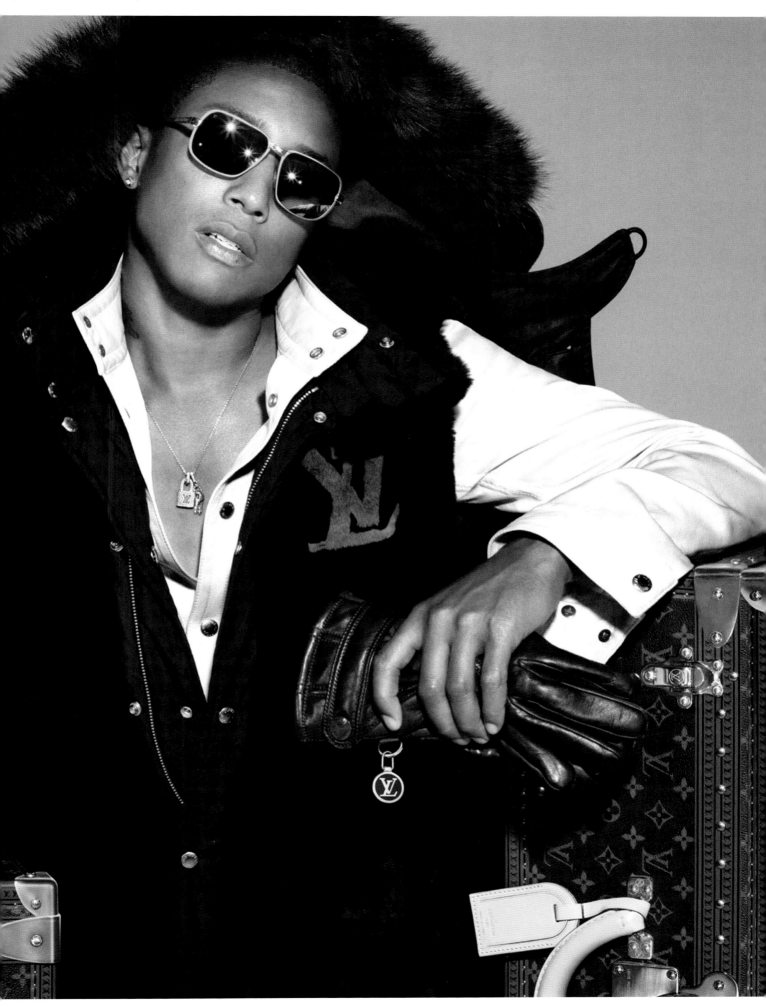

MONCLER

Pharrell Williams developed a line of limited-edition outerwear for Moncler in 2010, and featured the photography of Japanese artist Keita Sugiura. Consisting of down vests and jackets, the key items reinterpreted the bulletproof vest, an article of clothing wholly at cross-purposes with the meditative, even pacifist inspirations for the garments in the collection.

The distinctive all-over graphic that appears on either the lining or exterior shell of the garments were drawn from Keita Sugiura's *Dark Forest* (2008) series of photographs, which were exhibited in New York's Max Protech (now Meulensteen) gallery in 2009. Sugiura, who then resided in rural Okayama prefecture, photographed the forested mountain fastness of the region in high summer. At once romantic and forbidding, his landscapes appear out of the shadows, gathering color, perspective and form upon closer inspection.

The implied environmental agenda behind the collection is reified by the use of state-of-the art fabrics from Bionic Yarn. An American environmental start-up partly owned by Pharrell Williams and founder/CEO Tyson Toussant, Bionic Yarn is a producer of premium yarns and high-performance textiles derived from recycled plastic beverage bottles and containers. The collection was launched at Colette in June 2010 and was sold through select Moncler boutiques that autumn.

Keita Sugiura
Dark Forest (No. 2), 2008.
Archival inkjet print,
edition of 10.
39 1/8 x 29 5/8 inches

(above and opposite) Items from the "Dark Forest" outerwear line for Moncler,
by Pharrell Williams and Keita Sugiura, Fall 2010.

(above and opposite) Items from the "Dark Forest" outerwear line for Moncler,
by Pharrell Williams and Keita Sugiura, Fall 2010.

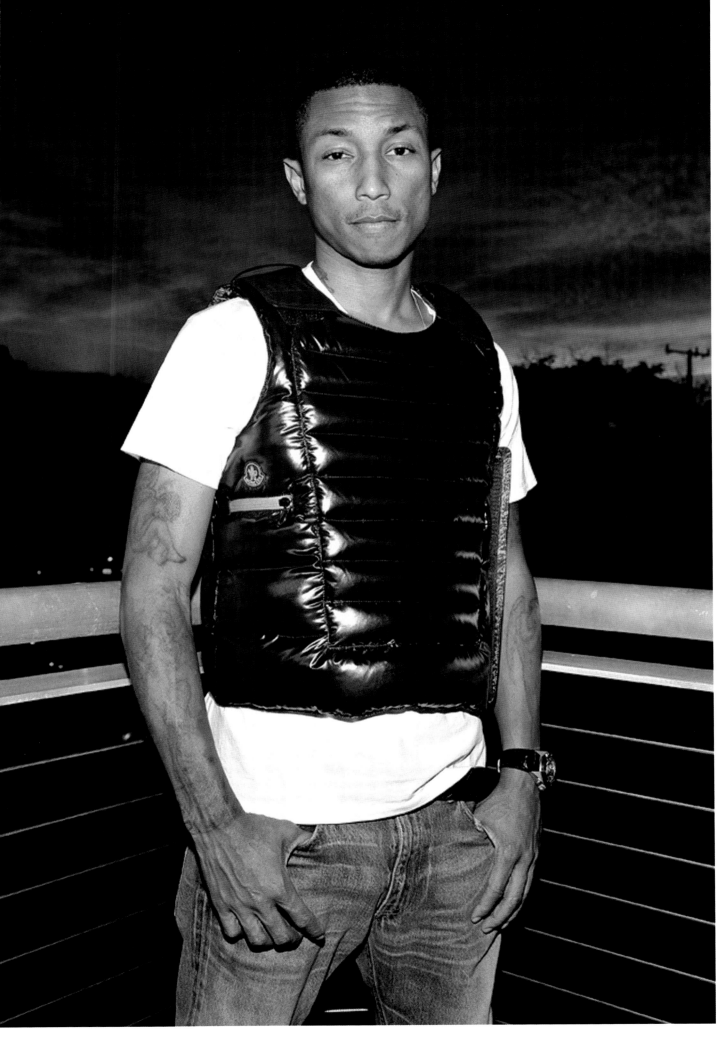

KIEHL'S

Pharrell Williams' collaborations with Kiehl's included the Bionic tote, which utilizes Bionic Yarn, a fiber spun from nine recycled plastic bottles. Launched for Earth Day 2011 and coinciding with the New York-based apothecary's 160th anniversary, the bag was available only through Kiehl's "Recycle and Be Rewarded" program, which encourages customers to return empty cosmetic containers.

Kiehl's also created an Acaí berry-based, antioxidant-rich toning spray with Pharrell in October 2010 as part of a campaign shot by David LaChapelle, and with a percentage of sales to benefit the Rainforest Alliance. The graphics for the toning spray were by Sk8thing, a principal designer at BBC/IceCream. Around the same period, Kiehl's also collaborated with Julianne Moore, Jeff Koons, Malia Jones and KAWS to create limited-edition natural skin care products and packaging designs.

(above) Tote made with Bionic Yarn, April 2011.

(right) David LaChapelle was tapped by Kiehl's to shoot the campaign image for the Acai Berry toning mist, October 2010.

KAWS

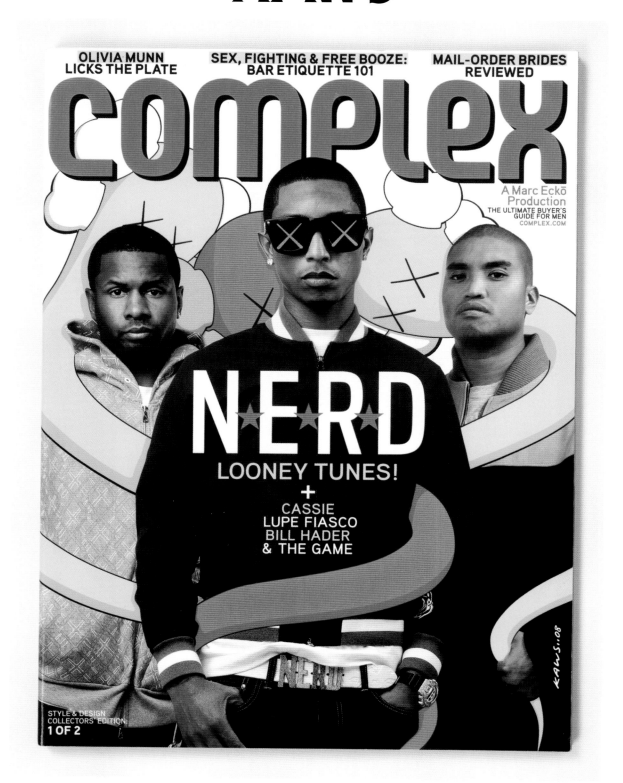

Complex magazine, Style and Design, August/September 2008.
N.E.R.D. Cover artwork, 10 1/2 X 7 3/4 X 1/4 Inches

KAWS, *KAWSBOB3*, 2007. Acrylic on canvas, 72 x 96 inches.
Collection of Pharrell Williams

Pharrell Logo designed by KAWS

KAWS, *KURFS (Cloud)*, 2007. Acrylic on canvas, 68 x 86 inches.
Collection of Pharrell Williams.

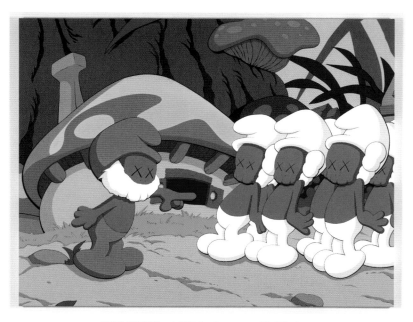

KAWS, *KURFS (Papa)*, 2007. Acrylic on canvas, 68 x 86 inches.
Collection of Pharrell Williams.

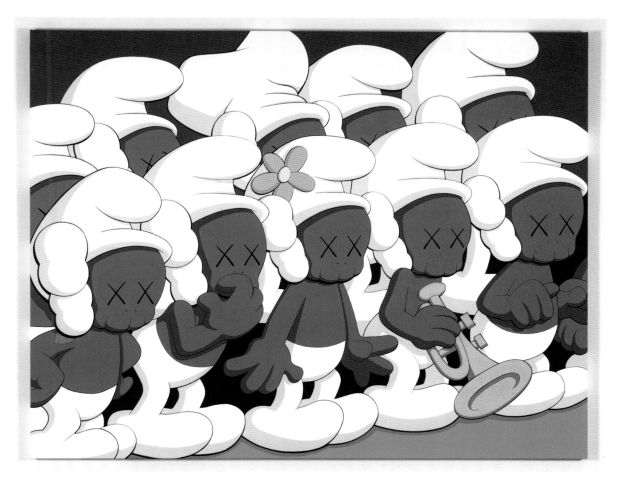

KAWS, *KURFS (Crowd)*, 2007. Acrylic on canvas, 68 x 86 inches.
Collection of Pharrell Williams.

TOKYO RISING

Three months after the twin disasters of the Tohoku earthquake and tsunami that devastated northeastern Japan—followed by the cooling system failures at the Fukushima 1 & 2 nuclear power plants—Pharrell flew to Tokyo to catch up with over two dozen individuals from a variety of creative disciplines. Taking the pulse of a megalopolis, his encounters are recorded in the documentary *Tokyo Rising*, directed by Thalia Mavros, co-produced by Palladium Boots and with help from *Vice* magazine.

Tokyo Rising paints a picture of a city and its people at a crossroads; psychically, if not materially traumatized, but determined as ever to retain its place as one of the world's great engines of creativity and innovation. Organized in part through the assistance of VERBAL—a close friend and long-time collaborator of Pharrell—and his partner Yoon, Pharrell's journeys wind through the fabric of the city, including a memorable exploration of the city's monumental sewers. Included in the documentary are the insights of Yuka Uchida, of the band Triple Nipples; Kunichi Nomura, the art director and editor of Tripster; Sebastian Masuda, the founder and art director of 6%DOKI DOKI; Mitsunori Sakano, an artist and communications director at 3331 Arts; and Chim Pom, a collective of six artists and activists critical of the nation's unquestioned reliance on nuclear energy.

I wanted to come back. Tokyo is my second home. I find such inspiration here, from the people, from the culture. The way the Japanese regard matter, flesh, spirit and technology, to me, is unmatched.

Coming here now, after 3/11, I can't tell you how the government operates, but I can tell you that these people are so strong. This [trip] reminds me of everything that I've always thought about Japan: it will not accept no for an answer. That remains part of what is so inspiring, and part of the magnetism that brings people to Japan. Seeing old friends, meeting new friends, experiencing the various subcultures…it's the very thing that first brought me here, which I love, I've always loved.

I love Tokyo.

(pages 182–187)
Stills from the documentary *Tokyo Rising*, featuring Pharrell Williams, with VERBAL, Yoon, Chim Pom Art Collective, and Yuka Uchida.

FRIENDSWITHYOU

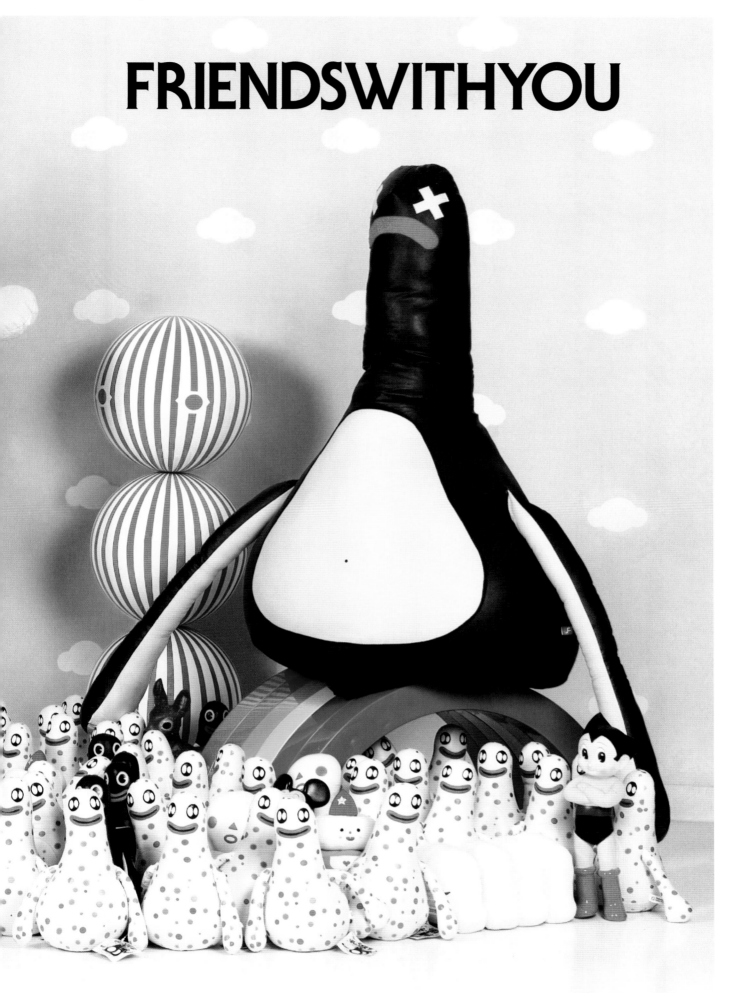

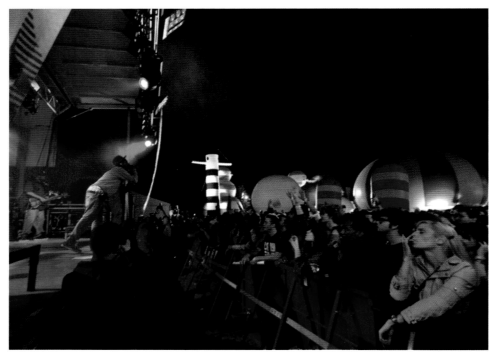

Pharrell Williams performing at "Rainbow City," a collateral event of Design Miami
and Art Basel Miami, December 2010, and held at galleries in the design district and at an adjoining park.

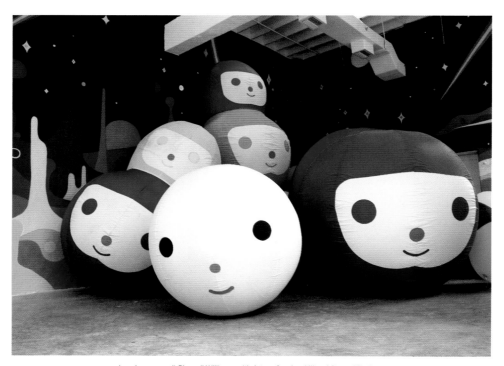

(previous spread) Pharrell Williams, with Arturo Sandoval III and Samuel Borkson
of FriendsWithYou, a Miami-based art collective.

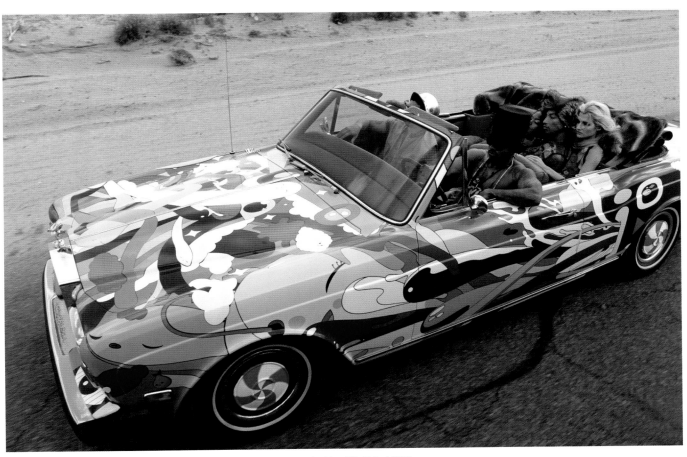

Still from the video of "Hot & Fun" (2010)
with an overall transfer design on the car by FriendsWithYou.

PERSPECTIVE CHAIR

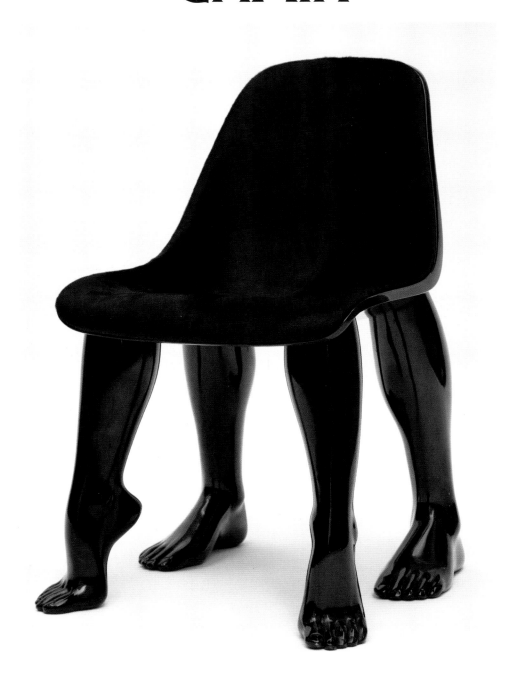

(pages 192–195) Pharrell Williams, *Perspective* (yellow, blue, black, red), 2008.
Resin and different leathers. 33 1/2 x 21 1/2 x 23 1/2 inches each. Courtesy Galerie Perrotin, Paris.

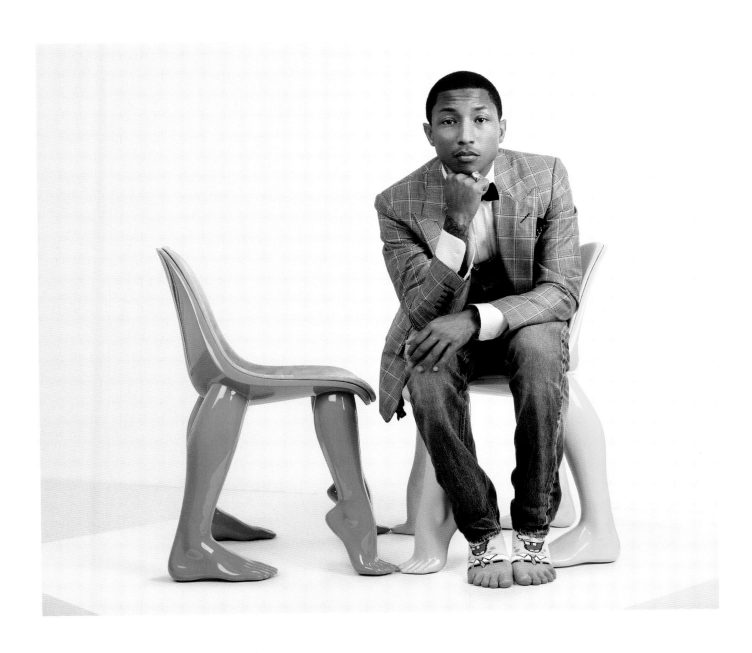

TANK CHAIR

(opposite and above) Pharrell Williams, *The Tank* (baby blue, transparent, baby pink, black), 2009.
Plexiglas and different leathers, each chair: 32 3/4 x 20 3/4 x 24 inches. Courtesy Galerie Perrotin, Paris.

THE SIMPLE THINGS

Takashi Murakami recounts his collaboration with Pharrell Williams on *The Simple Things*, an installation Pharrell presented at the opening of Art Basel 40, on June 6, 2009.

I can't quite remember how Pharrell and I met but I know that the key persons involved in the introduction were NIGO®, Kanye West, and Emmanuel Perrotin. I'm not sure when or where the first meeting took place but I do remember Pharrell sitting next to me at the opening party for my solo exhibition, ©*Murakami*, at the Museum of Contemporary Art in Los Angeles [in October 2007].

Pharrell offered the project to me. He had created the jewelry [with Jacob & Co.] and asked me to build a cabinet to hold it—a very simple offer. If we think in terms of master and servant, he was the master and I was the servant. The jewelry had already been finished so I designed the cabinet to match with what I saw. I also realized that if Pharrell had wanted to just build an everyday cabinet, there would have been no point in retaining me, and so I decided to go all in and make the cabinet into a true sculpture.

With that said, the production was really challenging. The light source had to be built into the sculpture itself so that the jewelry would be visible inside the mouth. With all of my previous sculptures, we only had to think about making the sculpture itself look good but for this one, we had to think about the relationship between the main elements and the supporting ones and there were a lot of parts that I had never had to incorporate before.

When I work with young artists, it's a lot like a karate dojo. The roles of master and student are clearly defined and I am the master. But as I already mentioned, for my collaboration with Pharrell, I was very conscious of the fact that I was a supporting player. I had a gut sense that we would get along well. He is a truly sincere person with a beautiful heart, and an insatiable, creative ambition.

But to be honest, this project began right after the Lehman Brothers crash, and I was very worried that during such unstable economic times, people wouldn't be interested in seeing an exhibition of something so extravagant. [*Editor's note: the objects are made of gold and encrusted with over 26,000 gemstones.*] But Pharrell had already finished the jewelry and Emmanuel Perrotin was very determined to see it happen. In the end, I decided to put everything else out of my mind and simply ran at full speed down the path that Pharrell had made with the jewelry.

I put aside all concerns and concentrated on ideas and technical details. It may be difficult to spot with an untrained eye, but for example, a lot of work was put into the shape of each tooth. Even in its final stage, the process involved twenty people working for two months straight to properly polish and paint the sculpture.

In that way, it was a purely creative project.

(pages 198–205)
Takashi Murakami / Pharrell Williams
The Simple Things, 2008–2009 Glass fiber, steel, acrylic, wood, LED and seven objects made of gold (white, yellow and pink) set with rubies, sapphires, emeralds and diamonds.
74 x 43.3 x 39.7 inches.
©2008–2009 Takashi Murakami/Kaikai Kiki Co., Ltd. All Rights Reserved. Private Collection. Courtesy Galerie Perrotin, Paris & Jacob & Co.

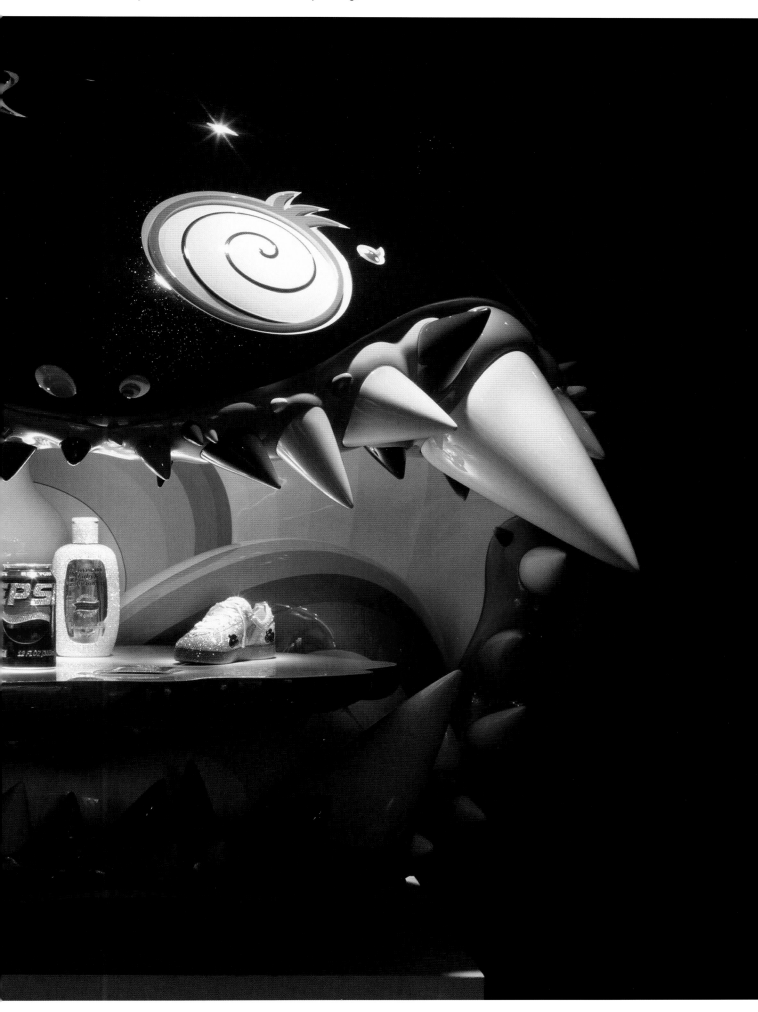

INSIDE OUT

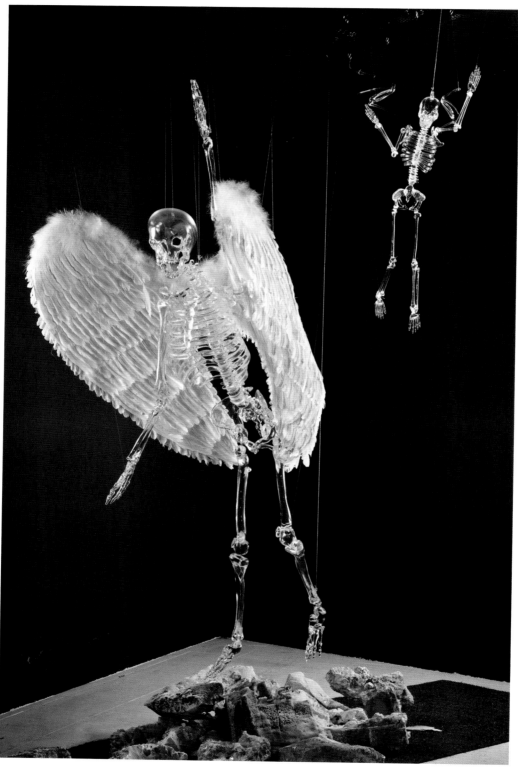

(above and opposite) Pharrell Williams, *Inside Out*, 2011.
Glass, feathers. 71 x 43 1/2 inches (big skeleton) / 35 1/2 x 35 1/2 inches (small skeleton).
Courtesy Venice Projects, Venice exhibited at Glasstress 2011, Venice.

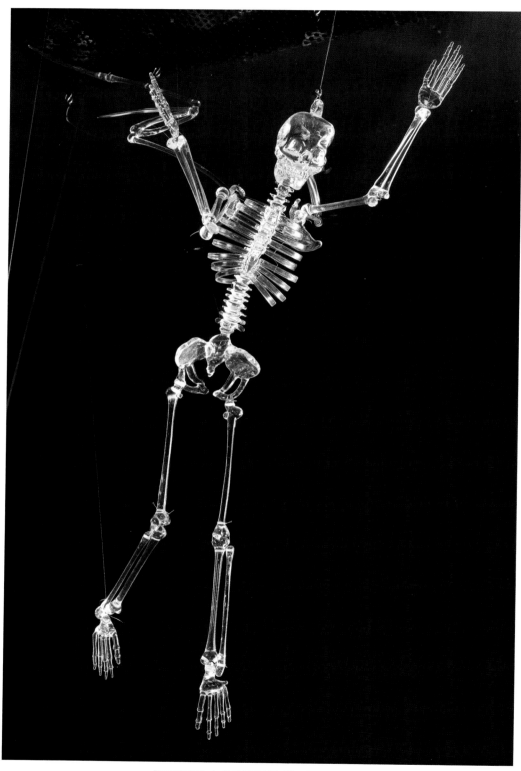

Pharrell Williams, *Inside Out*, 2011. 90 x 90 cm (small skeleton).
Courtesy Venice Projects, Venice exhibited at Glasstress 2011, Venice.

DIRTY JOBS

A conversation with Pharrell Williams and Ambra Medda

In June 2011, Pharrell Williams unveiled *Inside Out* at Glasstress, a collateral event of the 54th Venice Biennale organized by Venice Projects and held at the Berengo Centre for Contemporary Art and Glass in Murano. Produced using traditional glass-blowing techniques by master artisans under the supervision of Adriano Berengo, the installation is comprised of two skeletal "angels," one measuring over 6 feet tall, and the other 18 inches high. Fully articulated in glass, and with the larger, winged angel appearing to alight, Williams and his collaborators sought to represent human aspiration. His conversation with Ambra Medda began with a presentation of images from *Inside Out*.

Pharrell Williams: What did you think about it?

Ambra Medda: Well, I can only see from the pictures, but we were just talking before you arrived about how the experience of seeing how glass is made is magical. So I was wondering how this came about and how the experience was working with glass?

PW: Um... At this point Loïc [Villepontoux] is my right hand in all this stuff. So, I go to him and say: "You know today, I want to make the bones of the seven dwarfs and six of them will be cast in glass, not blown. And one I will have made in gold." So, seven dwarf skeletons. And he's the only one that looks at me and goes: "OK, so we have to go with this glassmaker..." So I have somebody that believes in me. And I will tell you that the key to any process is when someone believes in you. Belief, trust, and faith are like air to personality. When people say really nice things about my work, I'm always conscious and remind people that I am only as fast as the wind that's blown into my sails. That's it, 'cause without that, I can't—I don't—move. To answer your question, these things come about because I have people I can bounce it off to, who are very resourceful and make it happen.

AM: Yeah, and you're living in a time when, more than at any other time, we have the opportunity to engage design, fashion, art and architecture simul-

taneously, and as they are constantly interweaving, you end up participating and collaborating with people that are working in vastly different fields. I think that's the biggest opportunity that you have, you get to play around...

PW: Oh, absolutely. One of the fortunes of life is to experience the work of great minds that have done amazing things. To not only be able to enter a conversation with them but to do things with them and learn their process, learn what makes them tick.

AM: How *was* this, with Takashi Murakami?

PW: That was surreal. I still didn't believe that we had done that work together, even after we sold the piece.

AM: So you came to Miami and then had a relationship with Emmanuel Perrotin and then with Takashi Murakami, or was it the other way around?

PW: I met Takashi through NIGO® years ago.

AM: Ok, that makes sense.

PW: Then I met Perrotin through Sabina Belli.

AM: Ok.

PW: I was going through a really tough time—my aunt had passed away—and so Sabina had suggested that I go see some art. And she said there is a lovely man down there in Miami, a Parisian...

AM: In Miami.

PW: Yeah, she said he had a gallery and had some really interesting work there. She suggested that I meet him, but definitely go by—it would lift my spirits. So I went and bought like a ton of lithographs and afterwards he sought me out and he came to meet me at this little pool party my friend was having at his house. We sat and we talked and then he called me. And it is funny because she [Sabina] had suggested that I do a chair. She was like, "You have it. You know what you want. I've watched you work at so many other mediums. This will work for you." And, ironically, he asked me, "What do you think about making a chair?"

AM: Wow.

PW: It was so odd. So, I was like, "Ok!" So immediately I had an idea from years ago called *The Perspective*, where I wanted to know what it was like to "sit" between the symmetry of a man and a woman...that place where they are in love. So I made the physical representation of that. The seat and the distance between the feet of the man and the feet of the woman represented the symmetry, the connection, and you get to sit in it. In America we say, "I wonder what life is like in his shoes," or, "I wonder what it looks like sitting in that person's seat or vantage point." So that is where that came from. And that's how I met him [Perrotin] and how he ultimately ended up offering me the opportunity.

AM: So you had just arrived in Miami?

PW: No, I had been living there for a while.

AM: Why did you move to Miami?

PW: I still live in Virginia. It's just that Miami never really got cold. I just ended up staying. I used to just go—I would go from my house in Virginia and go stay in a hotel for two weeks at a time in Miami just to do it. I worked down there and I just got so hooked on all that blue water and those beautiful blue skies, the twice-a-day warm rain showers, and the beautiful white-cotton cumulus clouds.

AM: Yeah, it's unbelievable.

PW: It's like looking at pure white cotton. It's the craziest thing. And even the gray is like, a super-rich, satin, sharkskin gray.

AM: Yeah, the sky is really intense, every single day.

PW: Yeah, no matter the temperature.

AM: Yeah, the sunset! I mean in every single interview I've had, they would say, "So what's the best thing about Miami?" I was like, "The sky."

PW: Unreal... So eventually I ended up moving there.

AM: So you spend a lot of time there?

PW: Yeah, just having a place there too.

AM: How do you feel the city is changing? I remember moving there and just feeling like, "Wow this is so exciting, I get to be a part of a city that's actually changing." Which is really rare because I wasn't in Berlin when it got exciting. And I remember that.

I FELT HONORED TO SEE MIAMI TRANSFORM AND BE THERE WHILE IT WAS EVOLVING. AND NOW I HAVE LEFT, I AM REALLY CURIOUS TO SEE... I HAVE A LOT OF HOPE FOR MIAMI.

It is so Latin, you're almost not in America. It's very independent, in its own bubble... But I wonder for you, how you live it, do you feel like it is going to change a lot more? Do you have high hopes for Miami or do you feel like it is good the way it is?

PW: I love the way it is. Obviously there's always room for improvement with everything in the world. It will evolve, all things do. And I think it will evolve for the right reasons... Miami will probably be a different place in five years.

AM: Yeah, completely.

PW: Completely unrecognizable in ten. But in five years it should be really different. If I were [in charge] I would go ahead and change the building codes to green and I would enforce those codes. It's funny because I read through your questions and I think the skyline *is* going to change. And I think it is probably going to be a lot more like Tokyo and Hong Kong.

AM: It's really bizarre, I don't know why, but as powerful

Pharrell Williams for Domeau & Pérès, *Velo Bike*, 2011.
Utility airframe-grade steel and water buffalo leather. The bike was available in various colors.

as America is, it is a bit behind with green architecture.

PW: There hasn't been enough importance placed on it yet, but that will happen.

AM: Yeah, at least just build things so that they last. The plumbing is awful here. The walls are just ridiculous.

PW: Where, in New York?

AM: No, across the country. As a European, we often live in ancient buildings that last, I mean—that's green in a sense, because they last forever. I'm always a little surprised at how you just build things that last for five years or for however long and then knock them down. I guess it creates commerce. It creates jobs for people.

PW: Construction in itself is going to change across the board though, even the green standards.

AM: It's going to have to.

PW: And we are going to start using different materials. The problem is that the generation in power does not recognize change. They are often in denial and don't want change. But, building codes will change, in the same way that the record industry has had to kowtow to the new way we think about music, how we get it, and how music is disseminated. The value of music has been redefined. It's not really about buying albums. It's really about the music accompanying something else, some other sort of experience. In the way we build, we are, as a species, turning inwardly more and more, catering to our emotions, rather than doing things for the greater good ...We have no choice but to change, right? We weren't living in the houses and the spaces that we are now. [Many] people in the world now have those grandiose, unbelievable, jaw-dropping, take-you-an-hour-to-get-around-the-house, houses. There were people who had those things and those things were called palaces, but they were very few and far between. The opportunity to build this way still exists in America. But that's going to change.

AM: Yes, seismic shifts are happening everywhere. You referred earlier to the changes in the music industry. So how are musicians going to sustain themselves? The business has to adapt...

PW: They have to readjust.

AM: So I was wondering, how?

PW: There has to be a readjustment to what they feel like they should be getting paid, because you have to look at the numbers.

AM: The labels?

PW: No, the artist.

AM: The artist, ok.

PW: They can't. People in a recession, probably people on average, go to a concert once or twice a year. Right then and there you know that the numbers aren't the same anymore. The ticket is way more expensive and the artist wants this huge draw, but there's not enough people going to shows to sustain it. Now, in a recession, oh my god you have so many other things you can

do with that $85 nose-bleed seat, so many things you can do—maybe like fill your car up.

AM: Right.

PW: Ok, like depending what kind of car you have: you have a SUV you are done. So, the business is changing and music is being traded faster than a person could even concentrate to click and decide if they want to buy something. So right then and there it's changed. Now the industry had *every* warning. You know, like in the early 80's when Bill Gates and Steve Jobs were still figuring out what they wanted to do. Those guys, the music industry could have effectively gone to those guys, and said we'll fund you, we want X, Y and Z. Now...

AM: But that didn't happen obviously.

PW: Listen, that is the worst banana peel they could have ever slipped on. And so now, Bill Gates has given $40 billion away. That means he could have bought the music industry, the entire music industry. Modestly, modestly, five times over. He gave away what he could have purchased. The entire global...

AM: Can you imagine?

PW: ...music industry five times over. He could have bought it, gave it to people, bought it back and gave it to people again and bought it back again.

AM: [Laughs] No, it's true!

PW: Right?

AM: Yeah.

PW: All because they doubted the worth, the value, and all of that potential that rested in the ether that they couldn't see. So that was the worst lesson that they had to learn. The good thing is that the survivors in the music industry are those who are thinking forward.

THEY ARE STILL LOSING THEIR ASSES, BUT THEY'RE DOING IT WITH INTEGRITY AND THEY'RE STILL ALLOWING GOOD MUSIC TO COME OUT AND THEY ARE FINDING OTHER, INTERESTING WAYS TO SUSTAIN THEMSELVES IN THIS NEW WORLD.

AM: Yeah. Things had to go so wrong in order for a new generation to find a new way to make a living. The big record labels probably feel really dumb.

PW: Oh yeah! There is nothing they can do. And now artists are blowing up bigger and in a more viral way online than being with a record company.

AM: Oh yeah.

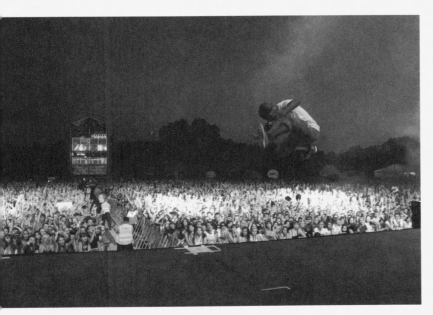

Views of Pharrell getting air at a number of N.E.R.D. concerts.

PW: Some of the best bands and best acts are coming out of nowhere.

AM: Well, yeah. My boyfriend and his band OK Go are huge believers in redefining the system.

PW: Which by the way, timing-wise was so tough. I really want to do something with those guys one day. It's amazing what they do. It's one foot in the music industry and one foot in art. I love it!

AM: Completely. And they left their record label, EMI and now they are independent. And they're just like, "We are going to make videos and write records and find new ways to put out our music," and I think that this is happening in architecture, I think it's happening in art, it's happening in design. When people question, "Why is Pharrell doing something in design—or art?" it makes me feel like they are not in touch with what is happening in the world, and what people are interested in, and how there are these different creative disciplines coming together and overlapping…

PW: So a person in my position, what was I going to tell Takashi? "No?" Fuck you! I don't care if it never comes out. I got to work with this guy.

AM: Yeah!

PW: Well, the next time someone asks you that question, tell them I am actually doing the fucked up thing. I am actually taking advantage of people interested in showing me shit and I'm just saying: "Yeah, I'm going to

listen." That's why I do it. So when someone presents me with an opportunity…

AM: Yeah, you jump if it's interesting and…

PW: Absolutely! That's why I do it. I don't do it because I think I am going to turn into a famous furniture designer. I do it because I'm actually interested in it. I got some ideas and I want to present them to someone who knows way more then I do and have them tell me it's a shit idea or it's an ok idea, but maybe you should try this. Or it's a great idea and I know exactly the way you can pull it off. My life's a workshop. I just keep going to these workshops and working with these amazing people where they teach me their trade. You know, I'm like a Mike Rowe. You know Mike Rowe from *Dirty Jobs*. There's this guy that does all these shitty jobs, he goes to a septic tank. He goes to a landfill—he has to do all of these shitty jobs. I love this thing because he's showing the world what it's like as a custodian, what it's like at a lot of these "undesirable" jobs. He goes and shows them how hard these people work and what it takes to get these jobs done. My point is that like he doesn't stay there, he goes and does it so he can learn how it works.

AM: We're not necessarily specialists, the world doesn't work that way any more. And so what's next?

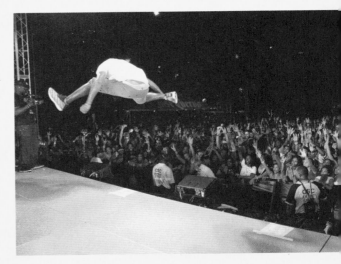

What does your life look like right now? You're engaged in all sorts of things. Like what are some of the projects you are doing?

PW: Musically? In the studio, producing acts. You know, that's the usual, all the usual suspense. I'm going to score another *Despicable Me*.

AM: That's great.

PW: Thank you. There is another film they want me to score as well, something to do with Africa. I am very interested in producing music all over the world. I'm interested to be the first global force in production, to produce music in the respective languages of those places. Truly international. You know, records that are in German, Japanese, native Taiwanese and

Mandarin... I just want to do what other people are not thinking about. Cause there's so much right under our noses. And it's cool because I produced a girl from Malaysia, and I've done a big pop artist from China.

AM: And how do you find these talents?

PW: I just go through the record companies and say, "Who do you have in this territory?" So by Christmas I'd like to know that I have twenty-five crazy international records that are just bubbling in their respective territories. That's important to me.

AM: Yeah it's good, having good instincts and being prepared to just follow your instincts.

PW: You can't acquire that. That's just something you carry inside of you. And to be able to trust that is half the job.

AM: And it's scary but it's also so liberating 'cause you just know it takes time. [Laughs] It's not easy, but when you get there it's such a good feeling. And then that gives you the energy. I saw pictures of you...jumping up on stage. You're not even running in the build-up to the jump. You're just jumping up into the air!

PW: Mmmhmmm.

AM: But is that from skateboarding? I mean...

PW: Yeah, I mean a lot of it.

YOU KNOW, BEING YOUNG POSERS WE USED TO WATCH SUICIDAL TENDENCIES AND THE DEAD KENNEDYS

and we used to watch a lot of old punk stuff too. So you'd see all those guys doing sky lobster dances and shit, and that's what we imitated. So when I brought that to the N.E.R.D. shows it was because we used to just only perform with rock acts. So we would go on a world tour and there would be nobody from hip-hop...

AM: Right.

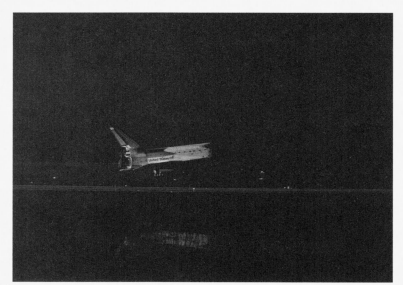

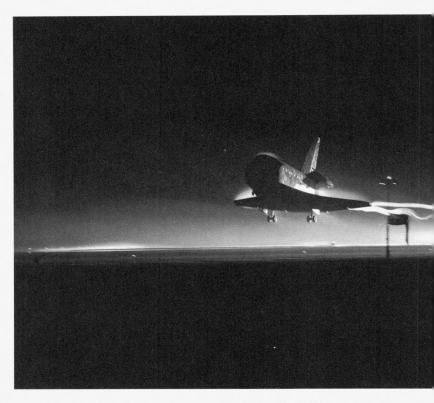

PW: On the days we were there. And we'd be like the only ones, and we'd come and perform, and then you look to the edge of the stage and the guys from KORN were watching, or the guys from Good Charlotte were watching. Just all these different arrays of bands would come and just watch our show cause we were these young, you know, black kids with all this angsty punk energy they could relate to. But it had just enough hip-hop in it that made it like a little different... So that stuff just sort of came natural because it just felt like the medium that we were in. It just seemed like a world where you express angst. It's funny too because I've been doing a retrospective on N.E.R.D. and what it's become. I veered away from what it originally started out as, but that's just my way. A lot of people really loved what it used to be— they loved the original layout.

AM: Yeah, that's normal.

PW: Take the first album. I've just been wrestling with whether I should continue to do stuff with it or just leave it precious as it was. You know what I'm saying? Cause I don't know if I still feel all that angst. I do, but I feel a different kind of angst. And I don't feel like an aggressive roar.

AM: Right, yeah.

PW: I don't know if I feel that. But when you're seeing that on stage, that's me living in the moment of what the first album was. So when

(this page and opposite) July 21, 2011. The shuttle *Atlantis* lands on the runway of the Kennedy Space Center in Florida for the last time. Mission STS-135 is the final mission of NASA's three decade-long space shuttle program; Astronaut Leland Melvin, 2006.

we play "Lapdance" and everybody's just losing it and going crazy, it's because we're celebrating what that was. But, I no longer have a President that I don't like. That song was written about George W. Bush being in office—you know, I thought politicians acted like strippers. They will do what you want for money, that was the statement. And even then they were censoring us, because I wanted to do the video and the record company wouldn't let me do it—I wanted all the strippers to have on Bush masks around us while we were performing. This was 2002 and they were like, "No." So my thing is that...

AM: Well, that tension is not there anymore so...

PW: Right.

AM: So you can't...

PW: That's not my fight.

AM: Yeah.

PW: That's why we did it...we did N.E.R.D. because we were given an opportunity to make an album and I was like, "Oh, cool, let me just make some political statements." Which were: "Fuck it!"

AM: Right, and that's what it was. It was heartfelt and genuine and that was the time for it.

PW: Right, so I've just been wrestling with that. You know, it's interesting now because we have a cartoon that we're working on, an animation, so it is now taking on another incarnation. I now realize all of the music should just be super hard cause they love that shit. Super hard and super jazzy, that's what our fans love. They love when the songs are crazy angst and when they sample weird jazz records.

AM: Like what?

PW: Like a song called "Am I High" or a song called "Baby Doll." I mean it's almost like if we made a Top 10 hit, they'd be mad. So, I don't know. It's interesting that I love it and I love my fans and I love their dedication. They've just been so dedicated to us since we've come out, but like I said, when you see all that angst it's me playing into the moment of what the song is. So to me that behavior on stage—that erratic, crazy, sporadic, jumping up in the air, inciting mosh-pits in the crowd. That is just as much a part of the song to me as the lyrics. So that is the physical...

AM: ...manifestation.

PW: ...of what the song is.

AM: Yeah, of course. Of course...Are you going to see the last spaceship?

PW: It just landed.

AM: Oh really?

PW: The shuttle? Yeah.

AM: Yeah I thought you were going.

PW: I keep missing it.

AM: ...the last one?

PW: ...yeah.

AM: Yeah, cause I asked Ian [Luna]: "If Pharrell goes, please send a photographer, even just for polaroids, anything low-key would be amazing."

PW: Yeah I'm really sad that I didn't get to see it. 'Cause I tried twice and the two days that I could go the weather was bad so it changed.

AM: And so what was your fascination, like how did you become fascinated with it?

PW: With space?

AM: Yeah.

PW: As a child when I was five or six years old my mom and dad would drive around—you know, coming back from a friend's house—and they'd be coming from Norfolk, which is a different city, so it's like a twenty to thirty minute ride home.

THEY'D LISTEN TO EARTH, WIND & FIRE AND WITH ALL THOSE SUPER JAZZY CHANGES AND THOSE LUSH CHORDS I WOULD LOOK OUT AS A CHILD, LOOK OUT THE BACK WINDOW AND SEE ALL THESE STARS, AND TO ME THERE WAS JUST A CONNECTION.

Then I realized when I was older I had synesthesia, so that's why the stars were such a close representation of how I see music anyway, when colors associate with chords. And notes.

AM: I didn't know you had synesthesia.

PW: Yeah. I think most musicians do, in some way, shape or form. Seeing that as a child it just always made me wonder. As you grow older and you learn about life and nature, you start to demystify things that you didn't understand as a child. You realize that stars are not a certain color because God plopped them that way, but because they are at a certain distance and light travels a certain way. And the twinkling just has to do with the light traveling [...] so that would mean that most of those stars that we're looking at now are long since gone. It made me think about time travel. It made me think about what that must really represent.

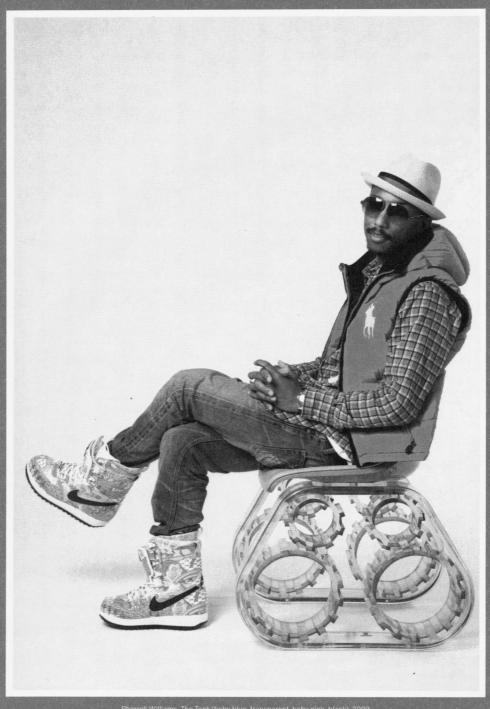

Pharrell Williams, *The Tank* (baby blue, transparent, baby pink, black), 2009
Plexiglas and different leathers 83 x 53 x 63 cm (x4) / 32 3/4 x 20 3/4 x 24 inches (x4)
Courtesy Galerie Perrotin, Paris

It represents something that we can't see. And there's a promise that there's more to come. If a lot of those stars have long since burned out, then what else is out there? I've often said that I would never go to space, but I think I would go now.

AM: Why?

PW: Because I just think it would change me for the better. Because my perspective is what it is already... When I talk to my astronaut friend Leland Melvin, and when I've had some of my conversations with Buzz Aldrin they would tell me how once you get up there it's different because you're seeing everything in 3-D. You're seeing these spheres, these planets levitating, not moving. It looks way different than anything you can ever see on the Discovery Channel. So then you begin to realize that you're not really as significant as you thought—

AM: So that's the big message, huh?

PW: Yeah, once you acknowledge that you're insignificant, that's when the world starts to speak to you. You start to realize, "Oh my god.

HOW COULD YOU POSSIBLY THINK ABOUT TRIVIAL THINGS ANYMORE? HOW COULD YOU POSSIBLY HAVE MENIAL ATTITUDES ANYMORE? YOU START TO JUST LOOK AT LIFE IN A DIFFERENT WAY.

And I know as a terrestrial creature I already think that way. So imagine once I get up there and start looking around. I'd come back and just be on some different shit. Hopefully not like Birkenstocks, growing a beard and eating trail-mix all day.

AM: You are beyond. You should go.

PW: Right?

AM: If anyone should go, yeah, I guess you should go. Although I don't know, do you feel like maybe it would take away some of the, some of the mystery? I love Paris, but I feel like if I lived there it would ruin it for me. I love going for four days. And I know that I'd never move there.

PW: I don't, I just don't think that I'm scared, I was scared because I...

AM: We aren't comparing Paris...

PW: Yeah. But I know what you meant. I was scared because mostly because of the two [space shuttle] explosions. That scares the shit out of me.

AM: Well, yeah.

PW: Cause they didn't all die up there, they died when they hit the water. That's tough for me. That was very...

AM: Yeah you have a lot of important work to do. You have a kid.

PW: Although I do think that those guys should be forced to wear something indestructible while traveling through the atmosphere.

AM: What are they wearing? I thought they were wearing them.

PW: No they wear suits when they go out [on spacewalks], but when they are on the shuttle they just have regular uniforms. But they should have something like body armor, so that if the thing explodes it has a chute... now mind you, I know what you're thinking, that you are going to burn up on reentry anyway. But there still should be some sort of indestructible... You know what I mean.

AM: Yeah.

PW: Just in case it blows up. Then I'd be really happy to do it, cause I'm like, fuck it, I'm scared of skydiving but it's better then flying...I don't know, I think I would go. I'd be scared to death.

AM: Have you spoken to Marc Newson about outer space? I know he has a lot of interesting opinions on it.

PW: Yeah, he's thinking about like what life is going to be like and how it can be better served.

AM: You know, I see you guys working together.

PW: Man, and we talked about it and then we kind of lost touch.

AM: I would love to see that happen.

PW: He's just so busy. I would love to though. That would be a dream. Him, and Jeff Koons.

AM: Really?

PW: Yeah.

AM: I don't get it. It doesn't touch me; it doesn't speak to me. I understand that the work is important, but it doesn't move me.

PW: See, but that's funny because it does move me. I sort of skip over the quote, "important artist." He made a big, blow-up balloon dog that looked like it was made out of foil balloons... and I was like, "That's fucking amazing." And then the balloons and—

AM: The monkeys...

PW: ...yeah and the blow-up pool inflatables that were made of steel and painted to make you feel like they were real. That fucked me up. That's weird. It was very *Twilight Zone*. They're made in steel—

AM: Yeah, yeah.

PW: You're looking at it and you have to wrap your head around the fact that that's not plastic. That blew me away, that was the thing for me. More than anything else.

AM: So I actually have one more question for you.

PW: Sure.

AM: Are your parents still alive?

PW: Yes, thank you.

AM: Were they collectors at all? ...it could be like fridge magnets, I don't mean like...

PW: Not in the least bit. My dad, maybe into auto parts, and shit to do with cars. He collects cars actually.
AM: Yeah, so...
PW: That, that's it. My mom doesn't really collect things...
AM: And what do you think are the biggest things that influenced you? Like your family, where you come from, music, high school...?
PW: Imagination.
AM: Yeah I feel like we are kind of killing that a little bit now; I feel like kids don't get to harness such a powerful imagination...

REMEMBER WHEN YOU COULD CREATE IMAGINARY LANDSCAPES OR EMPIRES WITH LEAVES... ANY SORT OF FOUND OBJECTS... SUPER-COMPLEX SCENARIOS WHEN YOU WERE WITH YOUR FRIENDS, YOU HAD A SHEET AS A CAPE...

PW: And it's tough because all of that stuff is fun, all of that stuff is worth it.
AM: Yeah, yeah I feel like we don't really encourage all that anymore...You should really check out Tokujin Yoshioka. He's brilliant, he's a Japanese designer. There is an installation he did in Miami where we had to...
PW: Oh yeah, I know him, he made those chairs. Those chairs that fold out, they're like paper.
AM: Yeah that's what I wanted to show you... *Honey-pop.*
PW: Yeah, yeah I have one of them. And I looked at those ice bars. [*the Water Block Bench*]
AM: And look, this is his new thing. I don't know what site we saw that on but basically it's like aluminum, but it's actually soft.
PW: I am so jealous I didn't think of that.
AM: And then you sit on it and it takes your shape.
PW: I'm jealous.
AM: You have to keep that *Honey-pop* chair Pharrell, because it's a fundamental project of his, you can't necessarily use it so much.
PW: Yeah, but it's amazing.
AM: Yeah.
PW: His idea!
AM: But his installations, this thing that he did with Swarovski...
PW: I was going to do something with them.
AM: Swarovski?

Tokujn Yoshioka,
Honey-Pop Armchair,
Structural paper, 2000.

PW: That was one of the things I was going to do with them. Which was going to be like... *Don't Ask, Don't Tell.* The basic thing was to show the rainbow but in all Swarovski crystal. So one would be red, one would be orange, and one would be yellow. And the whole thing was, *Don't Ask, Don't Tell.* So what does it matter, who's going to fight and protect your country? What does that matter to you? When you realize those certain colors also will align with your *chakras.* So it's red, orange, yellow, green, blue, indigo, and violet. Right? When you unify them that creates the clarity of bright, white light, which constitutes purity.
AM: But then that would be an installation.
PW: Yeah, yeah, that was going to be an installation.
AM: Ok. And they didn't respond?
PW: They did, but they just started getting quiet, then we would call, and then it would get quiet. It was so weird. And then we also had this chandelier and I still may do that. But a chandelier of colored grenades set up like DNA, and the whole point was, this is life, you know? Life destroying life. That was the whole thing... We should turn this off now.

Pharrell Williams with *Perspective Chair* (2008).

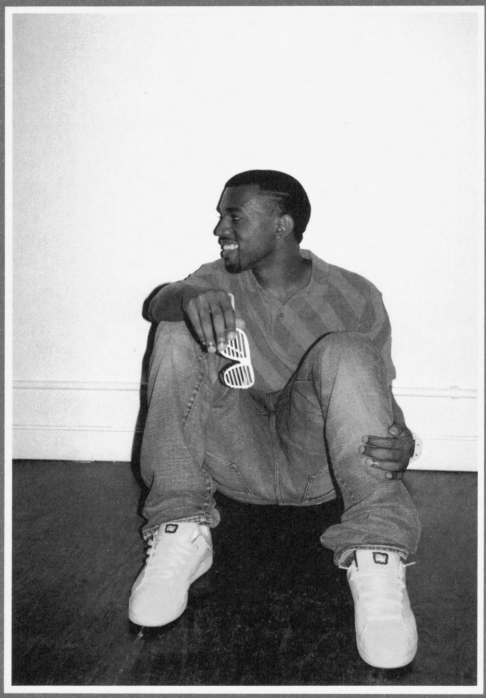

Kanye West wears BBC/Icecream, 2007.

MINK AND ERMINE

A conversation with Pharrell Williams and Kanye West

In this conversation, Kanye West and Pharrell Williams candidly explore the rewards and perils of a lifelong, perfectionist ethic. Best likened to a child's insatiable curiosity, they impute their compulsive, insistent tinkering to much lived experience, and even to obscure neurological phenomena. Their exchange lends precious—and comic—insight into a frightening capacity for invention, and a knowing approach to craft that is at once sure and relentlessly self-critical. They spoke in the wake of a minor controversy that followed the online launch of the single "Theraflu," which Kanye released through his G.O.O.D. Music label (in collaboration with DJ Khaled, DJ Pharris and the producer Hit-Boy). Predictably, the pharmaceutical combine Novartis objected to the title. The track also featured the lyric "someone tell PETA my mink is dragging on the floor," which drew immediate fire from the animal-rights group.

Kanye West: Yo yo, what's good?!
Pharrell Williams: What up, killer?!

KW: Shit, chillin,' vibin' about changing the name of that song and trying to figure out what the name of the song should be. You know, the "Theraflu" song?
PW: Yeah.
KW: Yeah, we're about to give it a new name.
PW: It's getting that big—they're going *that* crazy about it?
KW: Oh, yeah they have an issue. Just the title and there's still a window of opportunity for us to change it. "Oh, well, I don't want to call it 'Theraflu.' I'm calling the song this..." And then people are like, "oh, he changed the song to this," and then that's what it is, because when I did the song, I actually did not know that it would get to the point that grandmothers are talking about it, you know? Like why did I give them that level of promotion?
PW: Yeah, trust me, they're thankful. No matter what, they're thankful. This segues perfectly into what I wanted to talk to you about. Which is what is it like to be—and I know how I feel about it—but you're definitely one of my peers, and one that I look at and

say "He gets it, but I'd love to hear his take on why we aspire to be." It's almost a disease to be a perfectionist. Nothing is ever quite good enough. What is it like to look at things and say to yourself, "I know that they don't get it but maybe one day they will."

KW: It is *so* funny this is such an example of being a perfectionist, right? This song is out and I'm going to change the name, like I want to perfect this moment some more. Well, I think it's just if you're a perfectionist, that's just what you do. You know, there are slackers, there are people who are satisfied and then there are people who can only be satisfied by delivering everything that they have—with their knowledge, their financial situation, their level of exposure—to deliver the best product possible. I respect, look up to, and look to Walt Disney and Steve Jobs who dedicated their time, soul and energy to delivering the best product that they knew they could. There's a lot of psychology that goes into it. What can you give to human existence? How can you push the culture forward? And when you're a perfectionist, at a certain point you feel a responsibility in what you put out, and what could trickle down from it. If you put out things that are so over-the-top and magnificent, what trickles down from it could at least be good because there are more followers than there are leaders.

PW: Yeah, I agree... You know what the funny thing is that we've never done it on a Kanye West album, it might be time for that.

KW: Yeah!

PW: It might be time for that.

KW: Yeah, we started on that shit for *[Watch] The Throne.*

PW: Oh yeah! That was a very serious moment ...

KW: Yes!

PW: I'll never forget going to you and Jay's show, and just seeing those laser lights...

IT'S FUNNY BECAUSE I COULD FEEL THE PRESENCE OF YOUR PERFECTIONISM BY THE ACCURACY AND THE TIMING OF EVERYTHING. YOU KNOW, THERE WAS NEVER AN EMPTY BEAT DURING THE SHOW.

You addressed all the sensations, with the exception of smell and taste, I guess. Anything that you could control, the auditory and the visual, you curated—you made sure that it was a *curated* moment. And I'll never forget when the first bars of "Gotta Have It" started playing, that minor chord. It just hits you anyway but

it was just y'all talking on top of the track as it starts to come on, and the crowd started going nuts! And it's really because at the end of the day, as great as the track is as it is and as great as all of the stuff you guys did on top of it, it was how that moment was so set up. It was like an incredible layup, an alley-oop. Do people even say that word anymore, alley-oop?

KW: Yeah, it's only 'cause it happens.

PW: [laughs] Yeah, you know I don't know anything about basketball, but it was an amazing set-up. That was crazy, just to see the reaction to what a visual and music could do together, and those people going absolutely crazy I was like "oh, ok, well done man, well done."

KW: Yeah I definitely wanted to dial into that sound and mixing those textures together. I just want to dial into that more, I just want to set the note, like playing a few textures that I got for this new shit for the G.O.O.D. Music joint we opened up the album with this joint that me and Skrillex did together.

PW: Mmmmm. I like that!

KW: Just like that!

PW: Wow, I can't wait to hear what that sounds like. I know we are all shaped and molded by all that we've gone through, and by having spirituality—in whatever way you define it—it allows us to be bigger than our bodies, to be bigger than our essence. [But] there is something to be said for experience, being told "no" the entire time, when you wanted to get into an industry that you love. So, let me ask you, how much has this experience contributed to who you became as a person?

KW: Yeah, you know, I had to realize at what point to put off the real South Side Chicago mentality, that is what built me to deal with the amount of "no's" and deal with the amount of pressure and aggression, like I talked about on this Chicago song, "mink is draggin on the floor." That's one of my ideas for it [renaming 'Theraflu']. "Swag King Cole, mink is draggin' on the floor, fo' I embarrass you, but I don't like to embarrass you...'I Don't Like to Embarrass You'" as a title.

PW: Anticipating PETA.

KW: Yeah, so... when I say "I'm from where shorty's fucked up, double-cupped up. Might even kill somebody and YouTube it, so whoever thinks their words affect me is too stupid, and if you think you can do it better than me, then you do it."

PW: Yeah, "you do it!"

PW: [Laughs.]

KW: "I'm from Chicago." And that was just one of the best things to prepare me for anything. If you can make it out of Chicago, you can make it anywhere. That's what I'm talking about on this new song, that's what I'm talking about when I'm dealing with any business or creative processes. That's the stuff I'm talking about when I was dealing with people, from not wanting me

to rap, to [not] doing the tour with Jay, and being able to do the light show for it. It was like sit-ins, when we were going out to Paris. You know when we were wearing the outfits and people on the blogs were calling us names and all that, right? But then, once they got that Givenchy cover, and everybody's wearing Givenchy they're all like "oh this is cool."

PW: Right.

KW: But it wasn't cool when *South Park* was using the photo and dissing us and everything. And so many people dress like that now.

PW: [Laughs in agreement] Yeah, that's what we *do*.

KW: That was before everybody said *swag*, or when we were out in Japan. How could you communicate through people? We're not even understanding the language but we knew the visual language, we knew the spirit, we knew the ideas, we knew the reference points.

PW: Yeah, that's the thing, man.

THAT'S WHAT SEPARATES US FROM A LOT OF FOLK, AND NOT BECAUSE WE'RE BETTER BUT BECAUSE WE'VE DECIDED TO LISTEN TO THAT INNER VOICE, AND A LOT OF PEOPLE DON'T.

A lot of people go "man!" they do something and they go "shit you know what, and I'm totally not da-da-da-da [fill in the blanks]." People fail a lot of times doing that. Whereas we just trained ourselves to say "you know what, let me entertain this idea" and exhaust all the possibilities to make sure that it doesn't make sense because something good may come out of that and for every time that someone has ever told you no, you've always had that willingness to explore it. Um, and I've watched that by the way, it's been cool to see. How are you enjoying...

KW:—Enjoying what?

PW: I'm thinking of a way to put it... How are you enjoying this whole fame thing?

KW: [gasp] You know it's just a process of separating things, it's understanding how to exploit it to display amazing art. You know the whole trick is that I am a visual artist. To this day I can't play a piano. I've taken it up a couple times and I forget how to play the piano. And when I first wanted to rap, before I rapped, the first thing I did was actually draw my tape covers because that's back when people had tapes. I drew the cover before I even thought about doing music. Let's put this fountain in Vegas to music. So in a way I'll get the music but it was always about the fountain. It was always about the light show. It was always about the fashion show, it was always about that. Whether it is

the font that we pick for a single cover, or a video— I'm going to Qatar later tonight to shoot the film for "Cruel Summer," which is basically my second pop fairytale, like how "Runaway" was—it creates that kind of opportunity. When you see me design, and I'm not saying it's the best design or whatever, but you know, [in "Runaway"] I had my idea of how I wanted Selita [Ebanks] to look, and I wanted it to be Selita. I wanted to juxtapose minimalist, Vannessa Beecroft-like high art against unrealistic Victoria Secret-level beauty. They don't crash, those worlds are not in the same place. You've been to art parties before? It's different from a Victoria Secret's party. You know what I'm talking about!

PW: Right!

KW: That's right. Due to exposure, I'm able to have these things be seen by so many people. If Matthew Barney were more famous, then more people would see what Matthew Barney did. So it's that. When it comes down to it, what I enjoy about it is the opportunity to express art in high volume, literally.

PW: Did you know that you're a synesthete? That you have synesthesia?

KW: That's what it's called, that's what the film is about! You're talking about seeing sounds right?

PW: There are many different forms of synesthesia. There are grapheme synesthetes, people who see colors in numbers, letters in colors. But I believe most musicians and most artists are synesthetes.

KW: You know that's what this film in Qatar is about!

PW: Oh wow!

KW: It's called *Cruel Summer: The Legend of the Lamborghini Dons*, and it's basically the G.O.O.D. Music Lamborghini Dons. [Kid] Cudi, he's the main character and I'm just his boy, and in the beginning we're car thieves. There's this part where one character teaches another to see colors through sound.

PW: Oh wow!

KW: Yeah, the shit is dope. Matter of fact, if we could do work with you on the soundtrack. I mean I've got eight tracks for it, I just want to give it twelve. Basically it's the G.O.O.D. Music soundtrack that "Mercy" is the first single for. You're like next level with this type of shit like [sings] "Take me far away, as long as it's fun, fun, fun, fun, I wanna go." I'm talking to actually a film scorer at this point so—

PW: No! But dude...Nah man! It's funny that you picked that song out ["Fun, Fun Fun"]. That's funny, wow!

KW: I play that song real normal in the car.

PW: No way?!

KW: Yeah!

PW: That's crazy, that's crazy. 'Aight well say no more. I'mma holla at you. And you have a good time out there in Qatar. My man!

KW: Alright, thanks! Love.

Pharrell Williams, *Perspective (yellow, blue, black, red),* 2008
Resin and different leathers. 85 x 55 x 60 cm each. Courtesy Galerie Perrotin, Paris

THIRD CULTURE KID

Zaha Hadid, interviewed by Pharrell Williams

Pharrell Williams: I can relate to becoming a musician as an outsider. Early in your career, what was it like, being a woman of color, breaking into a traditionally male-dominated profession?

Zaha Hadid: Well, I learned my field when I was a student. Then, it didn't matter because I didn't know it was a problem. The "color" issue doesn't really equate in the U.K. But being a foreigner is more of a problem. I don't think they think of you in this [racial] category, but more as a "foreign" person. Look, in the beginning, I think as long as they considered that you were not serious or you were not a threat, I didn't encounter any problems. It was only later when your vision, your ideas could become true—then there was prejudice. And of course there was incredible prejudice against women. They didn't think women could do it. There were a lot of women artists—painters, and sculptors. They did well, but in architecture it was very difficult.

PW: You've since had a very successful career, obviously. In the moments that you encountered professional disappointment, what kept you going?

ZH: I have to say that I always believed in the work. Although people always said that it would never happen, I always thought in terms of reality [...] But I think it was really having many people around me, who supported me enormously, including family and friends. And the people in the office, who despite all the hurdles—not all of them but most of them—never hesitated to stay up all through the night, and I think that without their help none of this would have ever happened.

PW: That's awesome

ZH: But you have to have the confidence to push ahead.

PW: You have to. What is home to you, as a designer? Is it a state of being as much as it is tied to a place?

ZH: As you know, I'm always on the move so... I really don't know. I don't have to be in my flat, but now,

I do consider London home. But I've been to and lived in many places. So I don't mind transferring homes whenever I feel comfortable or happy in a place.

PW: But we live in a volatile time. Is home as much about security as it is about comfort?

ZH: No, I mean it's just somewhere you can go and switch off. My idea of comfort is obviously very different than many people. I don't mind the idea that in England, your home is your castle and you have to define your parameters, your space. But I've been happy whenever I'm somewhere with friends, and

I FEEL COMFORTABLE IN A SENSE THAT I ENJOY MYSELF. I'M NOT CONCERNED ABOUT THE IDEA OF SECURITY. LONDON IS QUITE OKAY BUT I SPEND MOST OF MY YEAR IN A HOTEL, AS YOU KNOW.

PW: Right.

ZH: ...And some hotels are more comfortable than others. But it is sometimes I wish I could just go back to my bed.

PW: Yeah, I agree.

ZH: Home is really my bed. It's where I can just crash out.

PW: [Laughs] That's so funny. I feel the same. So what defines good space? Good architecture? Good urbanism?

ZH: Well I think in terms of urbanism you need to really create a level of complexity on the street that allows a diversity of space, so you can have many different adjacencies. I mean it's not like you walk down a street and it's only private housing or one other kind of space, but rather a diversity of spaces. You form that formally and spatially as an urban domain. In our work I always try to carve out a space where the public can make a space for themselves. And good architecture? I mean, again spatial experience is very important. It doesn't have to be very big. It could be very small, but very well articulated. We can talk about proportion, but I think it really is about how you construct the space. So architecture is made of so many components, and I think the overall has to work. It can't just focus on architecture as one aspect of the project. It can't say architecture only with materials, or only with detailing, or that it has to have very large spaces. It has to be all-together. An *ensemble*. It has to work together.

PW: I like that. And who among your peers do you have an affinity and respect for?

ZH: Well there happens to be a lot of people who are very good. I mean I happen to be close friends with people I've known for a long time, whether it's Rem Koolhaas, or Frank Gehry, Peter Eisenman, or Coop Himmelb(l)au... the "high-tech" people... Norman Foster, Richard Rogers. They are very different [from me] but contribute tremendously to the profession. Then there are the younger people who you work with and teach with, like Greg Lynn in America. There are other people with whom you just have some sort of an understanding. I think there is great talent around, but unfortunately in architecture, it's not always those who have great talent who build, so it doesn't always manifest. They don't have the chance to express their ideas, so it's very difficult for them—as it was difficult for me. People think there aren't many great people but there are.

PW: Well you happen to be my favorite architect.

ZH: Oh, thank you so much!

PW: And favorite designer, I love everything you do—

ZH: Well we should do something together, Pharrell.

PW: Oh please, I would love to, love to, love to, love to. Even down to the shoes that you designed for Melissa. Those were amazing. [*Editor's note: Hadid's studio designed shoes for the Brazilian label in 2009.*]

ZH: Yeah, no they're nice, well you know we work hard. We work very hard on our—let's say—*repertoire*. All these years, even when it was difficult, it sort of somehow paid off in a sense because you have a repertoire, you can tackle different problems and so I think that was very important.

PW: With my next project, after my next chair, I would love to do a prefab house. Have you ever done a prefab?

ZH: No, but I've done temporary structures. So I think the prefab could be interesting.

PW: The average single-bedroom trailer or mobile home is somewhere between $40,000 to $70,000, and two bedrooms range to about $99,000. They say that we are bouncing back from the recession, but in a lot of areas, especially the housing sector—

ZH: It's not coming back...

PW: ...at all. So I felt that if we would make something that was about $75,000 to $100,000 that we would, could do something really fun and really next-level that could change the game, you know?

ZH: No, of course.

PW: So if you'll be into it I'd love to talk to you about doing prefab houses together.

ZH: That would be very exciting.

PW: First of all, I'm super excited. I'm not going to jump up and down and run out of breath. Then we won't finish the interview. But when we finish I will do that...Because I'm a big kid!

ZH: [Laughs]

PW: What are your own personal views about fashion?

ZH: Well, I like fashion because I think—especially in London in the 1980s, where everyone could express

themselves with a costume—it is a form of personal expression. Even when you buy clothes done by other people, the way you wear them is different. And also it reflects the mood of that moment and what was exciting about it. That's one side. The other side of course I'm interested in clothes because I'm intrigued by the way these things are cut and fit, and you know, all that. And the technology behind it.

PW: And that's so funny because I was going to say, that like architecture it engages both form and materiality. I was going to ask if you consider it another means to express yourself? I know I do.

ZH: Yeah, I think it is. I personally do. I used to have more time before to dress up. I used to kind of construct all my clothes, pin them on me. I think it also depends entirely the way you interpret the way you wear them. They'd look different on other people.

PW: Yeah, because the body is a canvas.

ZH: Yeah and I agree, I think fashion is fantastic. Everyone says it's superficial, but it's not. You have to wear something.

PW: That's right, you do. It's not really a matter of choice.

ZH: I mean depending on where you live, of course! But most of the time you do have to wear something.

IT'S LIKE WHEN PEOPLE TALK ABOUT HOUSING. YOU KNOW, THE BASIC THING IS, ARCHITECTURE IS SHELTER. BUT DIFFERENTIATE IT, FROM A HUT TO AN ARTICULATED SPACE, AND BECOMES ARCHITECTURE.

PW: I agree. And what do you like about the work of Issey Miyake?

ZH: I still like his work but I think he's not designing anymore, unfortunately. I think his work is really interesting. You saw these features which were like a flat sheet, and when you wore them they transformed. That was very exciting at the time, all this pleating and folding. And he managed to do that in fabric before it was done in other material.

PW: Yeah, and are you pleased with the popular association with you and his clothes?

ZH: Yeah, even when I wear someone else's they think it is him, but sadly he doesn't design very much anymore so I don't find too many things.

PW: Maybe you should do something with my line at some point, BBC?

ZH: Yeah, that would be nice.

PW: Yeah, that would be super cool.

ZH: I mean there are lots of really good designers. I think he is very special, because him, and at the time, Romeo Gigli, they did very stunning pieces.

PW: And that's funny, I was going to ask you who do you admire in fashion?

ZH: Well I do like Miuccia Prada, to be honest, because she does very elegant stuff. I think [Azzedine] Alaïa is utterly brilliant...

PW: Brilliant.

ZH: Because of the technology and the beautiful fit, I mean, it's incredible stuff. I mean all of the Belgians, I like all of the work of the Belgians. And the Japanese! Rei [Kawakubo] and Yohji [Yamamoto] do masterpieces...really superb things.

PW: Oh yeah, Rei is a complete genius. And I really like Yohji, and and I like [Junya] Watanabe too.

ZH: Yeah, they have beautiful stuff. Just incredible.

PW: Sheer genius, just like you.

ZH: Awww, your're sweet! I think about ten years ago, Yohji did dresses, which were like *haute couture*. Black dresses...the kind that have not been done in forty years. It was stunning stuff.

Sidney Poiter in *The Lost Man* (1969).

THE SLENDER THREAD

Anna Wintour, interviewed by Pharrell Williams

Pharrell Williams: Being British but having lived so long in the U.S., how would you define American elegance?

Anna Wintour: I think of American style as refined and classic. Everybody always conjures up images of Ralph Lauren or Jackie Kennedy, which is a rather obvious sensibility, but having come out of London in the late 1970s, where everybody was inspired by the originality and creativity of the kids on the street, I realized that as wonderful as that look is, it is a little bit stereotypical. What is so fantastic about America is its eclecticism. Yes, you have all those terrific girls who look like they live in Maine or Palm Beach, but you also have imagination and inventiveness coming from music and film and the street, obviously influenced by people like yourself.

PW: What would you say is the difference between style and elegance?

AW: Elegance is more timeless—think of classic movie stars like Katharine Hepburn, Cary Grant, or Sidney Poitier. Style is more individual and personal. I was on a flight coming back from Los Angeles and saw a superchic woman wearing a classic navy Chanel suit and pearls—and bright, bright yellow nail polish. That is style.

PW: And what would style be for American men?

AW: Right now, so much of it comes from music, whether it is you, or Jay-Z, or Kanye West. I think of Jon Hamm and *Mad Men*, which has been unbelievably influential, and again, classic actors like Clark Gable or Paul Newman. The power of sports is also huge, with stars like LeBron James, Amar'e Stoudemire, Carmelo Anthony, Tom Brady, or Eli Manning. I was at a Knicks game the other day, and so many men were wearing Amar'e's glasses and LeBron's earrings.

PW: And your thoughts on Robert Redford?

AW: He can do no wrong. I admire him enormously, not only for his acting and directing career but for what he's done for film. He started Sundance when nobody understood how influential a small film festival could be, supports independent film, and believes in the artists rather than just making money.

PW: Yeah, he's awesome. What would you say about Steve McQueen?

AW: He [and Redford] are two of a kind. I think George Clooney is probably today's Steve McQueen. If you look at designers like Michael Kors or Riccardo Tisci, they're still influenced by the images that we have of McQueen. What is that famous movie? The one where he's running around on a motorbike during the war and ends up in the barbed wire—*The Great Escape* (1963), right?

PW: Yeah.

AW: That his leather jacket and khakis were every American man's dream. And going back to the present day, I think that the President and Mrs. Obama have so much influence on the way people dress. Washington, D.C., which is frightened of fashion, has been so far behind in terms of style. To finally have somebody in the White House who enjoys and embraces it is a huge step for those of us who like fashion, and makes it more accessible to those who might be intimidated by it.

PW: My last question started out as, "What is it like to be you?" but you know what? I have a better, more refined question. How does it feel, when you know that a judgment or a criticism you made, which may not have resonated with people at the time, ended up being proven right later? How does that feel?

AW: Let me see if I can answer your question this way.

IMPORTANT DESIGNERS WHO ARE MOVING FASHION FORWARD STAY TRUE TO THEIR VISION AND DON'T WORRY ABOUT WHAT'S GOING ON TO THE LEFT OR TO THE RIGHT OF THEM. THEY'RE FEARLESS, AND THAT IS A STRENGTH THAT COMES FROM WITHIN.

Like anything else, fashion needs the shock of the new, otherwise nothing will change. If you look at Karl Lagerfeld or Marc Jacobs, or Phoebe Philo or Miuccia Prada, they bring a strong point of view to what they do. You may not like or agree with it, but you can't ignore it. Sometimes its importance is not recognized for years; sometimes, especially given the Internet, its influence is felt immediately. The other thing to remember is never underestimate the public—they are the ones who lead the way by celebrating something because it's new and different and exciting and energizing.

PW: I know you really don't like to talk about yourself, but it's my book and you're so dear to me and I would never have any other platform to ask you this question, so . . . when did you realize . . . how young were you when you realized that you had that kind of opinion, that you were willing to stand up to whatever most people thought?

AW: When you're young, you don't worry so much about what people think. Young people are the ones instigating change in society and politics and culture, perhaps because they are less interested in the opinions of others and more in abiding by their convictions. I see that in young designers, even in places like London where they've always sort of managed with nothing. I don't think that I had a "Oh, God, I'm good at this" moment myself. My father was a fearless newspaper editor who changed the way British journalism operated. I had a great role model at home, so working in magazines just came naturally to me. My father taught me that you have to take risks without being overly concerned about criticism or approval or failure. Your voice has to be your own, Pharrell—you understand that better than anyone.

PW: You are far too kind, and thank you so much.

AW: I really look forward to seeing your book. Are you coming to the Met this year?

PW: Of course I am.

AW: Great, I'll see you there.

PW: Yes, ma'am.

AW: Okay, much love!

Steve McQueen in Paris, September 1964.

Cary Grant in London, April 1946.

Robert Redford on the set of *The Great Gatsby* (1974).

The following pages are images from magazine editorials featuring Pharrell Williams.

(pages 226–229) Pharrell Williams with Catherine Deneuve,
Paris, for *Citizen K*, Winter 2005

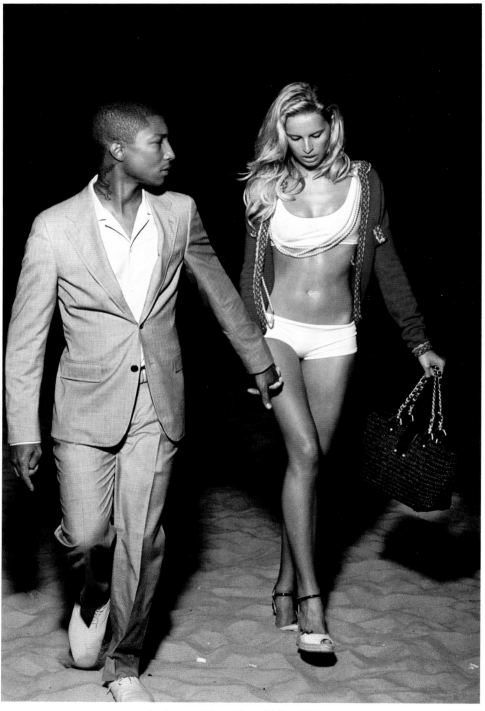

(previous spread, above and opposite) Pharrell Williams
with Karolína Kurková, for *Vogue* US, April 2006.

Shot in the garage of NIGO®'s house,
Tokyo, for *Common Sense Man*, October 2007.

Shot in the garage of NIGO®'s house, Tokyo, for *Common Sense Man*, October 2007

(following spread) Cover image for N.E.R.D. album *Nothing*, 2010.

Vogue Men, March 2004.

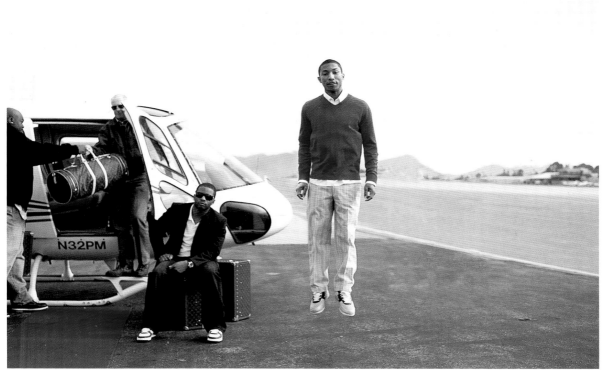

Vogue Men, March 2004.

(following spread) *Vogue*, April 2006.

(opposite) GQ, July 2008

(following spread) Pharrell Williams at the Trump Club, Tokyo, 2011.

ILLUSTRATION CREDITS